ART & LIES

ALSO BY JEANETTE WINTERSON

Fiction

Oranges Are Not The Only Fruit
The Passion
Sexing the Cherry
Written on the Body
Gut Symmetries
The World and Other Places
The PowerBook
Lighthousekeeping
Weight
The Stone Gods
The Daylight Gate

Non-Fiction

Art Objects
Why Be Happy When You Could Be Normal?

Comic Book

Boating for Beginners

Children's Books

Tanglewreck
The King of Capri
The Battle of the Sun
The Lion, the Unicorn and Me

Screenplays

Oranges are not the Only Fruit (BBC TV)
Ingenious (BBC TV)

JEANETTE WINTERSON

Art & Lies

A Piece for Three Voices and a Bawd

VINTAGE BOOKS

Published by Vintage 2014 2 4 6 8 10 9 7 5 3 1

Copyright © Great Moments Ltd 1994

Jeanette Winterson has asserted her right under the Copyright, Designs and Patents Act 1988 to be identified as the author of this work

This book is sold subject to the condition that it shall not, by way of trade or otherwise, be lent, resold, hired out, or otherwise circulated without the publisher's prior consent in any form of binding or cover other than that in which it is published and without a similar condition, including this condition, being imposed on the subsequent purchaser

The Trio from *Der Rosenkavalier*:

Music by Richard Strauss, Libretto by Hugo von Hoffmannsthal
Copyright © 1910 by Adolph Fürstner Ltd
Copyright asserted 1943 for all countries except Germany, Danzig,
Italy, Portugal and Russia to Boosey & Hawkes, Ltd
Reproduced by permission

First published in Great Britain by Jonathan Cape 1994
Vintage
Random House, 20 Vauxhall Bridge Road,
London SW1V 2SA

www.vintage-books.co.uk

Addresses for companies within The Random House Group Limited can be found at: www.randomhouse.co.uk/offices.htm

The Random House Group Limited Reg. No. 954009

A CIP catalogue record for this book is available from the British Library

ISBN 9780099598282

The Random House Group Limited supports the Forest Stewardship Council® (FSC®), the leading international forest-certification organisation. Our books carrying the FSC label are printed on FSC®-certified paper. FSC is the only forest-certification scheme supported by the leading environmental organisations, including Greenpeace.

Our paper procurement policy can be found at: www.randomhouse.co.uk/environment

Printed and bound by CPI Group (UK) Ltd, Croydon, CR0 4YY

for Peggy Reynolds with love

My thanks are due to Don and Ruth Rendell whose hospitality gave me the space to work.

To Philippa Brewster and Frances Coady, and to Caroline Michel and Rachel Cugnoni who arranged things.

Thanks for their advice to Angela Leighton, Harriet Marland and James Marland, Caroline Bloch.

and especially to Dr Anna Wilson.

The nature of a work of art

IS to be not a part, nor yet

A copy of the real world

(as we commonly understand

That phrase),

BUT A WORLD IN ITSELF,

INDEPENDENT, COMPLETE, AUTONOMOUS;

AND TO POSSESS IT FULLY

YOU MUST ENTER THAT WORLD,

CONFORM TO ITS LAWS,

AND IGNORE FOR THE TIME THE BELIEFS,

AIMS, AND PARTICULAR CONDITIONS

WHICH BELONG TO YOU

IN THE OTHER WORLD OF REALITY.

(OXFORD LECTURES ON POETRY: PROFESSOR BRADLEY: 1901)

Handel	ı	
picasso	35	
SAPPHO	49	
Picasso	77	
Handel	95	
SAPPHO	127	
Picasso	151	
Handel	169	

Handel

ROM A DISTANCE only the light is visible, a speeding gleaming horizontal angel, trumpet out on a hard bend. The note bells. The note bells the beauty of the stretching train that pulls the light in a long gold thread. It catches in the wheels, it flashes on the doors, that open and close, that open and close, in commuter rhythm.

On the overcoats and briefcases, brooches and sighs, the light snags in rough-cut stones that stay unpolished. The man is busy, he hasn't time to see the light that burns his clothes and illuminates his face, the light pouring down his shoulders with biblical zeal. His book is a plate of glass.

I was not the first one to find the book. There were notes in the margins, stains on the pages, a rose pressed between leaves 186 and 187. Cautiously I sniffed it. La Mortola. There was a map of The Vatican, a telephone number scribbled down the blade of a sword, a letter, unopened. A feather had been used as a bookmark or perhaps the book had been used as a feather store. There was a drawing of an ugly man, face like a target, nose like a bull's-eye, and, on the corresponding page, a quick pencil sketch of a beautiful woman, the flesh braced against the bone.

The pages were thick, more like napkins than paper, more like sheets than napkins, glazed yellow by time. The cut pages had tattered edges but not all of the pages had been cut. In spite of its past, this book had not been finished, but unfinished by whom? The reader or the writer?

The book had no cover. While sleeker volumes cowered inside their jackets, this one lifted its ragged spine to the sun, a winter sun of thin beams and few hours. A sun that sank red disc of hosannas.

I untied the waxy string and the book fell over my hands in folds of light. My hands shook under the weight of the light. Those heavy yellow squares saturated my palms and spilled down on to my trouser legs. My clothes were soaked in light. I felt like an apostle. I felt like a saint, not a dirty tired traveller on a dirty tired train. It was a trick, of course, a fluke of the weak sun magnified through the thick glass. And yet my heart leapt. In the moment of the moving pool my heart leapt. I put my hand on the book, it was warm, it must have lain in the sun. I laughed; a few lines of physics had been turned into a miracle. Or: A miracle has been turned into a few lines of physics?

I turned to see my own reflection in the black window . . .

300 BC. The Ptolomies founded the great library at Alexandria. 400,000 volumes in vertiginous glory.

The Alexandrians employed climbing boys much in the same way as the Victorians employed sweeps. Unnamed bipeds, light as dust, gripping with swollen fingers and toes, the nooks and juts of sheerfaced walls.

To begin with, the shelves had been built around wide channels that easily allowed for a ladder, but, as the library expanded, the shelves contracted, until the ladders themselves splintered under the pressure of so much knowledge. Their rungs were driven into the sides of the shelves with such ferocity that all the end-books were speared in place for nine hundred years.

What was to be done? There were scribes and scholars, philosophers and kings, travellers and potentates, none of whom could now take down a book beyond the twentieth shelf. It soon became true that the only books of any interest were to be found above shelf twenty-one.

It was noticed that the marooned rungs still formed a crazy and precarious ascent between the dizzy miles of shelves. Who could climb them? Who would dare?

Every boy-slave in Alexandria was weighed. It was not enough to have limbs like threads, the unlucky few must have brains of vapour too. Each boy had to be a medium through which much must pass and yet nothing be retained.

At the start of the experiment, when a book was required, a boy would be sent up to get it. This could take as long as two weeks, and very often, the boy would fall down dead from hunger and exhaustion.

A cleverer system seemed to be to rack the boys at various levels around the library, so that they could form a human chain, and pass down any volume within a day or so.

Accordingly, the boys built themselves eyries in among the books, and were to be seen squatting and scowling at greater and greater heights around the library.

A contemporary of Pliny the Younger writes of them thus:

Fama vero de bybliotheca illa Phariaca, opulentissima et certe inter miracula mundi numeranda, siparis ventisque mercatoriis trans mare devecta; nihil tamen de voluminibus raris ac pretiosis, de membris scriptorum disiectis fractisque, de arcanis Aegyptiacis et occultis devotis, quas merces haud dubio sperarent nostri studiosi, renuntiabant nautae, sed potius aulam esse regiam atque ingentem, tecta ardua et cum solo divorum exaequata ut dei ipsi tamquam in xysto proprio vel solario ibi gestare possent; quibus in palatiis tecto tenus loculamenta esse exstructa et omnes disciplinas contineri, nec tamen intra manus studentium venire sublimitas causa. Maxime enim mirabantur tantam illam sublimitatem quantam nemo vel scalis vel artificiis machinarum evadere posset, nisi tantum turba

innumera puerorum, quibus crura liciis tenuiora, quibus animus ceu fumus in auras commixtus, ut Maro noster, per quos denique multa transmittenda sed nihil retinendum. Illi enim circum bybliothecam in tabulatis semper in altiora surgentibus collocati, ratione propria quadam ac secreta inter se mandata permutare poterant et intra tam breve tempus unius diei quemlibet librum demittere.

There is no system that has not another system concealed within it. Soon the boys had tunnelled behind the huge shelves and thrown up a rookery of strange apartments where beds were books and chairs were books and dinner was eaten off books and all the stuffings, linings, sealings, floorings, openings and closings, were books. Books were put to every use to which a book can be put so long as it is never read.

'And whilst a book is nothing to me but a box of dainty handkerchiefs to wipe myself against once off the pot,' said Doll Sneerpiece, 'I darken that gentleman's merits if I call him anything less than a Walking Library.'

'Very Right. Very True.' said her companion, Miss Mangle, who had lived so long beneath the bells of St Paul's that she could hear nothing at all. Having an ordinary desire to appear both sociable and wise, she answered any address to her with the words 'Very Right. Very True.' In this way she retained a large circle of friends, none of whom guessed that their tolerant confidante was stone deaf.

'And if I were to say that I would care to turn the pages of that gentleman one by one, and to run my fingers down his margins, and to decipher his smooth spine, and to go on my knees to enjoy his lower titles, and to upturn that one long volume that he keeps so secret to himself, what would you say?'

'Very Right. Very True.' said Miss Mangle.

'You are a broad-minded woman and a proper friend,' said the Doll. 'I tell you, if my clothes were vellum, and my flesh, parchment, he would take me in both his hands, he would press me against his lips. Yet, when he sees my poor silks and lace, when he smells the passing of my perfumed body, what does he say? He says, "Madam, Madam, do you not yet repent?" '

'Oh repent! repent! I do repent a thousand times. I repent that I was not born a book and comfortable in your library right now Sir, this very morning. Already perhaps you would have lifted me down and laid me out on your little table with a pot of coffee standing by.'

Doll Sneerpiece suddenly stoppered her flow, for the man of whom she spoke passed by the window.

'It is his hat,' she cried, 'and his dear head beneath it.' She rushed forward and flung her upper parts out of the frame so that her breasts took leave of her bodice.

'Ruggiero!' she cried, 'Ruggiero!' It was his fitted coat, his slender back, his emphatic leg.

'Very Right. Very True.' said Miss Mangle.

I shut the book against her cry. That was too purple and exotic for my taste. My tastes have always been austere. I prefer to be slightly cold, slightly hungry, to spend less on myself than I could, more on others than I should. I do not think of myself as a masochist, not even when I rise in the early morning dark to run my blue body through a mile of frost. Such habits, and a contemplative nature, have not fitted me for a world that knows neither restraint nor passion. The fatal combination of indulgence without feeling disgusts me. Strange to be both greedy and dead.

For myself, I prefer to hold my desires just out of reach of appetite, to keep myself honed and sharp. I want the keen edge of longing. It is so easy to be a brute and yet it has become rather fashionable.

Is that the consequence of leaving your body to science? Of assuming that another pill, another drug, another car, another pocket-sized home-movie station, a DNA transfer, or the complete freedom of choice that five hundred TV channels must bring, will make everything all right? Will soothe the nagging pain in the heart that the latest laser scan refuses to diagnose? The doctor's surgery is full of men and women who do not know why they are unhappy.

'Take this,' says the Doctor, 'you'll soon feel better.' They do feel better, because little by little, they cease to feel at all.

When I was a young medical student at Seminary, like most of the other students, I tried to use the brothels. We were vowed to chastity, of course we were, but not until we were ordained. It was a regular trip after Sunday lunch, St Agatha's Day, we called it, in honour of the wobbly brown crème caramel served with a cocktail cherry on the top. Later, as a surgeon, I wondered why only Agatha was fit to be a saint, when so many women freely lay down under me and let me cut off their breasts. I suppose that to be a martyr, one has to suffer for something in which one passionately believes, and they weren't suffering for anything in which they believed. We were the ones who believed. We were the ones in ritual gloves and masks carrying the sacred surgical steel. So passive, not a spark of resentment, they were grateful to me for throwing their tits into the incinerator.

We don't do it anymore, the treatment has changed, we regret that we did it so much, but when you tell people you know what's good for them particularly if you are a doctor, they will believe you. Having no beliefs of their own they believe. It's a truism that as faith in God has declined, belief in science, especially medical science, has increased. Yet most people know even less about science than they did about God. Science is now incomprehensible to the layman but the layman accepts it, even though one of the

arguments against God is that He doesn't make sense.

'Come on Handel, get your rubbers on.' The rallying cry of the operating theatre was the jest of the brothel. We had to protect ourselves. We had to be careful of the body beneath. Protection always involves some sort of loss. Hold back, watch yourself, wrap up, look for cuts, mind the blood, don't exchange fluid, Now Wash Your Hands Please. The riskiest thing you can do is to be naked with another human being.

I like to look at women. That is one of the reasons why I became a doctor. As a priest my contact is necessarily limited. I like to look at women; they undress before me with a shyness I find touching. I try to keep my hands warm. I am compassionate. I do care. If a woman is particularly young or particularly beautiful, I treat her as softly as I know how. I am very clean, my cologne is sandalwood and olives, and I know that my astringent, ascetic face is reassuring, tempting even. Am I tempted? Perhaps, but I would never break my vows, professional and religious. Isn't that enough?

When a woman chooses me above my numerous atheist colleagues we have an understanding straight away. I have done well, perhaps because a man with God inside him is still preferable to a man with only his breakfast inside him. I am not a fanatic. I am too cerebral for that. The scholarly doctor, fingers long, voice musical.

I remember my first consultation. The patient and I were the same age: thirty-one. She was nervous I was calm. She was afraid and I was confident. I asked her to undress behind the thin white screen that did not quite reach the floor. I watched her slip off her shoes, lift each foot to take off her stockings. Her feet were bare then, her broad strong feet, ankles slim. Her legs were shaved. I turned to look out of the window.

'I'm ready,' she said.

'Then won't you come here?' She came out in the silly paper robe

we used to supply in those days. I was the first to offer my patients a full silk dressing-gown. Dense raw silk with my initials embroidered on the pocket. I know that women appreciate small courtesies.

'Would you prefer the nurse to be present while I examine you?'
No, of course not, they rarely do. Another pair of prying eyes,
another intrusive presence on a body too much intruded upon. And I
am told that women hate to be stared at by other women.

I examined her thoroughly and took her breast in my hands. Her breast was small, dense, weighted, taut to the touch. Pale and with a single fair hair by the nipple. I ran my clean inquisitive fingers over her. She was trembling.

I would have been glad to have trembled too. Suddenly I was afraid of her Irish beauty like a tightened bow. I had my thumb on her nipple. I smiled.

'There's nothing to worry about. Go and get dressed.'

She looked at me. I held her breast.

'Go and get dressed.'

I sent her for a mammogram. In those days we screened women for what we still call 'Their Own Good'. We made them feel irresponsible if they refused. The Good doctor. The Difficult patient. It wasn't until 1993, that the best of us admitted that for women under the age of fifty, a mammogram is notoriously unreliable, and that it might even serve to spread any few malignant cells deeper into the body. It's the way the plates compress the breasts. We did a lot of damage but it will be impossible to prove.

She kept her breasts. I saw her with them from time to time, and too often I saw them on their own, floating towards me in a horrible mixed-up nightmare of Seminary and raucous priests and the mutilated Saint Agatha lying on a silver platter . . .

'Come on Handel, Push it in will you? Push it IN man!' My senior

wielding his wild syringe above the torpid body on the slab. We had to administer a muscle relaxant before we could make the first cut. I hate injections.

The patient can hear everything under general anaesthetic. The ripping, snipping, severing, squelching, dripping operation. Our Surgeon liked to listen to opera while he worked but he insisted on Madam Butterfly or La Bohème. He liked to sing the part of Mimi in a cracked falsetto.

'I get upset when she dies,' he said, cutting through the pectoral webbing.

The sun had dropped on to the roof of the train and bloodied the grey metal. They were travelling slowly to save fuel. The man twisted his head to watch the spilt sun trickle down the window. The train that had been grey was sheathed in light. The sun made a wrapping of light that gave the dead grey bullet dignity and a purpose other than its destination. The man thought of the prophet Ezekiel and his chariot of cherubim: 'Go in among the whirling wheels underneath the cherubim; fill thy hands with living coals and scatter them over the City.'

Shall I tell you something about my City? My City, and long trains leaving.

The First City is ceremonial. Ceremonies of religion, monarchy, law. There are palaces in planed proportion built by the Golden Mean. Urgent steeples, pennants, weathervanes, an upward rising of assumption and power. This is the old city and it has been the most destroyed. The churches are empty and many are ruined. When the Church of England was disestablished it was a clever way for a government to ignore the crumbling beauty of a passion no longer

felt. The old city was built on faith, vanity, and fabulous piles of cash. We have none of those and the poor in spirit must learn to be humble.

We still build. We build mean houses with low windows resentful of light. An architect can be judged by his fenestration; let it be grand, profligate, various, bold. No, his windows are as regular as clipboards, dull as computer screens, we have no architects now, we have little men who like to simulate. Smart models, they call it, and it has nothing to do with long-legged ladies with degrees, those are still avoided after hours in favour of the dumb kind. No, smart models are a way of constructing the building on a three-dimensional screen. A Virtual Model allows me a tour of the building before the first navvy gets out his spade.

'Bring me the drawings of the ground plan and front elevation will you?' I asked the bright young architect in spotted braces. I was in charge of the detail for the new private cancer hospital we were building.

'Drawings?' he said, as though I'd asked him to empty bedpans. 'Here, have a look at the preliminary video, I'll give you the data-line on the headphones channel and if you get hot about the concept, we can build up a few simulations on the edit channel.'

What?

I saw him later, swinging through the double doors in his American trenchcoat and trilby.

'How's the Brief?' asked his friend.

'Having a bit of trouble with the old crocodile that's all.'

The old crocodile. I suppose he means me. Do I look like a Leviathan? Do I look like Hobbes? I hope not. It might be flattering to have a philosopher's jaw but I'd rather be mistaken for Descartes.

I know you'll think that is because he was a Catholic, it's not, it's because he did his best thinking inside a stove. I've never had much patience with Hobbes. I can work with a man who is a) an atheist, b) a monarchist, c) a nominalist, d) a materialist, but I can't work with a man who is all of these things at the same time.

Well, Hobbes's bastard shade is having its day out in the City. We are all atheists, materialists, nominalists, now. Oddly, we seem to be turning into monarchists too, there's nothing as effective as abolishing a King to bring out the worst of royalist sentimentality. The antique shops are crammed with fading Union Jacks and coronation mugs. The richer men buy gewgaws from Windsor Castle. It's too late, can't turn the clock back, ticks the cliché, although, God knows, we turn it back day and night when it's a matter of prejudice. No, in the dreary Hobbes world, where religion is superstition and the only possible actions are actions of self-interest, love is dead. That young man in the spotted braces thinks me a fool to listen to opera, to go to Mass, to sit quietly with a book that is better than me. What use is it? What use is it to love God, to dig my hands in the dark red soil of my home, and feel for it a passion which is not possession but recognition? What use is it to believe that beauty is a Good, when metaphysics has sold her in the market-place?

Of course we have romance. Everyone can see how useful romance is. Even the newspapers like romance. They should; they have helped to create it, it is their daily doses of world malaise that poison the heart and mind to such a degree that a strong antidote is required to save what humanness is left in us. I am not a machine, there is only so much and no more that I can absorb of the misery of my kind, when my tears are exhausted a dullness takes their place, and out of that dullness a terrible callousness, so that I look on suffering and feel it not.

Isn't it well known that nothing shocks us? That the photographs

of wretchedness that thirty years ago would have made us protest in the streets, now flicker by our eyes and we hardly see them? More vivid, more graphic, more pornographic even, is the newsman's brief. He must make us feel, but like a body punched and punched again, we take the blows and do not even notice the damage they have done.

Reportage is violence. Violence to the spirit. Violence to the emotional sympathy that should quicken in you and me when face to face we meet with pain. How many defeated among our own do we step over and push aside on our way home to watch the evening news? 'Terrible' you said at Somalia, Bosnia, Ethiopia, Russia, China, the Indian earthquake, the American floods, and then you watched a quiz show or a film because there's nothing you can do, nothing you can do, and the fear and unease that such powerlessness brings, trails in its wash, a dead arrogance for the beggar on the bridge that you pass every day. Hasn't he got legs and a cardboard box to sleep in?

And still we long to feel.

What's left? Romance. Love's counterfeit free of charge to all. Fall into my arms and the world with its sorrows will shrink up into a tinsel ball. This is the favourite antidote to the cold robot life of faraway perils and nearby apathy. Apathy. From the Greek A Pathos. Want of feeling. But, don't we know, only find the right boy, only find the right girl, and feeling will be yours. My colleagues tell me I need just such a remedy. Buried up to my neck in pink foam nothing can hurt me now. Safe to feel. All I can feel is you darling.

I was standing at the station waiting for the train, when a woman approached me, with a wilting red rose in a plastic wrapper.

'Buy it for your lucky day.'

'When will that be?'

'The day you fall in love. I see romance for you. A tall blonde lady.'

'Romance does not interest me.'

She stared at me as though I had uttered a blasphemy in church, and I suppose we were in a church of a kind, the portable temple of sentimentality that can be flapping about your head at a moment's notice.

She walked away, hawking her exhausted roses around the others, some of whom were glad enough to buy. I don't blame them, the dead world greedy of feeling, but there must be another way.

My own austerity, some might say severity, is like those magic girdles that knights used to wear when fighting dragons. Irrelevant, certainly, but it protects me by reminding me of what things I value. And the things I value are not the fake attentions and easy affections of a world unmoored from its proper harbour. I too long to feel, but feeling genuine and deep. My colleagues think me a remote sort of man, but, if I do not know what feeling is, at least I have not yet settled down into what I know it is not.

My thoughts were lost in the Byronic roar of the 325. The \$50,000,000 bullet train braked by permanent oil shortages to a stately fifty miles per hour. Still, it has a romantic pathos, don't you think?

The man knew that the train was travelling steadily towards the sun. His arms and face were burning. He was becoming the thing he feared. He feared the red rays, the swabs of heat, he feared the scalding tongs on his temples. He feared the hot hard hands pulling him out, pulling him out of the dark carriage, where he had been safe.

He heard the clatter of tin trays and the tinny voice of the obstetrician splitting his mother's legs into two metal tracks. There was no escape, only the boom boom of the blood in his ears and the blood red sun overhead.

He fainted.

The baby was translucent when born. The doctor held him up against the window and watched the light dappling the tiny liver. The baby was beautiful and for a moment the doctor found himself looking through a lens into an unacknowledged world. But the sun was too bright and he was obliged to close the curtains.

One night I was called out to a mother in labour. It's not my field. I don't care for the stirrups and razors, forceps and condom-thin gloves. I had to go, I have an obligation to a charitable trust I try to help, I had to go. It was late, I had returned from the opera, foolishly I still wear white tie.

It was winter. The Clean Air Act stops where the slums start. The slummers burn what they can; rags, tyres, bodies. The crematorium is very quiet. I crossed the river at Tower Bridge. The great paved jaws of the bridge had been opened to let through an invisible fogbent boat. I heard the clang of the bell and the slow clatter of the bridge on its huge chains. I thought I heard drumming, drumming, footsteps marching in dead motion to the Tower. I could see the thin grills fixed in the thick stone. Did I see a face?

Underneath, the river ran in grey floods, thumping against the abandoned wharves. I knew my way well enough. My mother had often taken me to the Tower in my school holidays. One of our ancestors was executed there, like me, he was a Catholic.

I knew my way well enough, but the roads, like all the roads in the City, were under constant repair. When they were not being repaired they were closed in case of demonstrations. Closed in case of bombs. Closed for the Public Good. There was so much good being done to the public in those days that I am surprised we are not all saints.

I have no celestial power and I had forgotten my street atlas. Finally, out of tiredness, finally, out of despair at another fluttering orange ribbon, another set of abandoned cones, I turned the wrong way into a one-way street where the narrow houses loomed like cudgels. Darkness, fog, squalor, an old woman pushing a high-wheeled pram. I swung to avoid her and beat the car into a brick wall. Never mind, it's only a Daimler.

Never mind, within the blank uncurtained windows, spattered with television light, I found the rooms I wanted. Electricity is expensive but you can still see to make a cup of tea by the flicker flicker flicker of the TV screen.

'When you grow up Handel, you must do some good in the world.' I held my mother's soft hand and ran beside her cuban heels. I saw her only once a day for our walk at three o'clock. She was a tall column of silver fox. My father was a monument of tweed. I had no idea that there was such a thing as vulnerable flesh.

The woman lay uncovered on the bed. She had torn off her cotton dress. The man with her was using it to wipe her head. The room was unlit but for a smouldering kerosene flare. The kind they use in garages.

I asked for hot water. None.

I asked for clean cloths. None.

I wanted to scream at them 'What do you think this is? Dickens?' They were both staring at my evening dress. What do I think this is? Dickens?

I took off my jacket and starched tie, my waistcoat and stiff shirt. I cut the shirt into six clean squares and gave the man money to buy hot water from a neighbour. He left, the room was quiet, the woman looked at me.

'It's stuck.'

'Yes.'

I knelt down and let my hands across her triumphant belly. Why doesn't she split? I know why she doesn't split, I'm a doctor, but why

doesn't she split? Her skin was stretched over her with upholstered zeal. She was smooth, perfect, no frills, no tucks, only the supple leather of her body, tobacco pouch round, tobacco pouch brown.

She opened her legs, I knelt between them, unhappy. I have never seen a woman's a woman's . . . what shall I call it? Vagina? The endless cross-sections, the exploded diagrams, the formaldehyde specimens, the shrunk-up sun-dried vagina. Beaver? No good. It looks nothing like a beaver or a pussy or a fox. Cunt? Is that the best I can do for those delicate labial folds and the monkish cowl that hides. . . , that hides. . . , a bead, a pip, an acorn, a pearl, a button, a pea . . .

'Please hurry.'

To engage the head I must enter her but my hands are not clean. What if I infect her? What if she infects me?

She started to cry out as the baby tried again to force itself round. If I took her to hospital they would certainly take the child from her and she was probably illegal.

There was a bottle of vodka on the floor. Thank God it wasn't gin. Too Dickens.

I held it up quizzically. There was an inch or so left in the bottom.

'That's mine for the pain.'

I poured it over my hands and washed them together.

'Are you Jewish?' she said.

'Just be glad I'm not an obstetrician. I'd have slit you down the middle by now.'

That shut her up and her screams too. She was quiet while I pushed my hand into the blood-packed warmth of her body. Quiet and dignified and wide. I was the one bent over, sweating, my back arched, my head down. My hair fell forward on to her thighs.

She began to give birth. It was a gift, a gift of life in that cold dead room, on the cold dead streets. The baby was ready. The baby was skimming down the birth canal and into the windy world. Gently, gently, I brought her forth as if she were my own. I felt that she was

my own. I cut the cord that moored her and she was free, her own, laid on her mother's belly in a little coat of blood.

The man came back with a washing-up bowl of lukewarm water and two bottles of vodka. To his intense horror I took one bottle and poured it into the bowl down to the last drop.

'He is Jewish,' said the mother.

Carefully I washed her thighs and the long dark stretches of her cunt. I dried her with the rest of my shirt and covered them both in a blanket from the car. I was going to wash the baby and then I thought, 'The smell is all she knows, the smell is all she has, go away now Handel.'

I put on my jacket, collected my things and closed the door, promising to return in a couple of days. I left them some money.

The moon was up and the cold had frozen the fog into brown slabs. I reversed the car down the slimy street dark under the unlit lamps.

The Second City is political. Politics of slums, apartments, mansions. The correct balance must be maintained. On no account should there be too many mansions or too few slums. Apartments hold the balance; the rich are terrified of being reduced to one, the poor dream of owning their own. The political city thrives on fear. Fear of never owning an apartment. Fear of owning merely an apartment.

Homelessness is illegal. In my city no-one is homeless although there are an increasing number of criminals living on the street. It was smart to turn an abandoned class into a criminal class, sometimes people feel sorry for down and outs, they never feel sorry for criminals, it has been a great stabiliser.

I parked the car outside my house and pushed through the thick sticky fog thinking of old ladies' curtains. Where the fog parted, the tarry light still lay on the city, dirtying it, exposing it, the harrowed city, beauty pawned, and irredeemable.

I threw myself into my white bed and fell into a troubled sleep. I dreamed that my body was transparent and that the sun drummed on my liver and tuned my spine in yellow octaves that I could play with both hands.

A few days later, as I had intended, I went back to the house. On the opposite side of the street a bunch of squatters were watching the security patrol welding a steel door over the slumped entrance. I walked up to the patrol and asked one of them what had happened to the people who had been living there. He shrugged and carried on with his work. I realised that, like all security men, he had long since lost the power of speech. He pointed his oxyacetylene torch at a closed blue van.

There were two men in the front of the cab, feet on the dashboard, bodies sagging into the sagged seats. They stared unblinkingly through the filthy windscreen, the radio on full volume, they were both about twenty-five. They appeared to be dead. I tapped on the window and one of them turned his head slowly, slowly, and looked down at me as though I were a human being. I flashed my medical card and slowly, slowly, he wound down the window.

'I wonder if you can help me? I'm trying to find the people who used to live in that house.'

'Got nothing to do with me.'

'Do you know where they are?'

'No.'

He raised the window, but then his mate said something to him, without moving his lips, and the window was speedily lowered again.

'You from the Pest Destruction Office? Were they an 'Elf Azzad?'

'I beg your pardon?'

'Did they have the fucking pox?'
'No, but one of them had a baby.'

I'm not a sentimentalist. Every week life and death passes under my hands and that has given me a certain serious reserve. Intimacy with death has produced, in some of my cruder colleagues, a kind of danse macabre. Daily contact with what seems to them a horrible fate, horrible because unrelieved by any spirituality, fate because inevitable in the chanciest, cruellest ways, has grown in them a love of the grotesque. There is something of the Middle Ages in these modern men, who must be forever caricaturing the suffering they fear. Morbid practical jokes and a pleasure in the corrupt is the hallmark of many of my eminent colleagues. I look at them and I see, not the confident wonders of modern science, but a fearful fourteenth-century face carving a Death's Head in a gloomy village on the Rhine.

And for myself? I, who have often leaned over the lifeless body, when all was at length quiet and smoothed out. After death, the traces in the face of what was slight or mean or superficial, begin to disappear; the lines become more simple and dignified; only the abstract lines remain, and those in a great indifference. It is possible to be comforted by death in its distinction. Pause now, before this transitory dignity breaks up, and there is left, not horror, not fear, but profound pity. The pietà of the Virgin Mother over the dead body of Christ. Madonna of the Sorrows. The pity of the mother for the child.

The Spanish girl in the upper room was not a virgin and I have to confess that babies do not move me much. That is, not those healthy hospital lines of crocheted flesh, the mother and baby unit, factory and farm of the future. And I notice too often that the most unfeeling of people relieve their shuttered hearts by cooing over babies, who

when grown, will be by the same people exploited or ignored.

But when she took the child to her breast, it seemed for a moment that the desolate space budded, and that what had been harmed was given back undamaged. The grim room softened and the crack in the window was filled with stars. The baby could not see the stars but they fell on her little body and made a blanket of light.

Now, with the ugly steel door nearly fitted, I had to insist my way up the wormy stairs to the abandoned room. The kerosene flare and the curtains were gone. The winded mattress was bloodstained from the birth. Nothing remained except for a piece of my shirt. I picked it up and put it in my pocket.

Outside, the graceful yellow fountains of the arc welder threw down the light into the oily pavement puddles. The light struck off the welder's metal boots in glowing chips. He wore his halo around his feet.

I questioned him again but all he said was 'People vanish everyday.'

He sealed the door into the frame.

People vanish everyday . . . The Third City is invisible, the city of the vanished, home to those who no longer exist.

This part of the city is far larger than you might think. Easy to target squatters and immigrants, black marketeers and tax dodgers, call girls and mad men released into the community. The list of official disapproval is heartily pinned up in every law-abiding square. We know who's hiding and why, we are the clean outdoor types, we don't go in for night work.

People vanish everyday, but it's not you and me, is it? We are solid and confident, safe and strong, we can speak our minds.

Can I? Can I speak my mind or am I dumb inside a borrowed

language, captive of bastard thoughts? What of me is mine?

I have an affection for the mediaeval period, perhaps because I am a man of shadows, and the glorious lights of the Renaissance bewilder me a little. Perhaps because, in the mediaevals, with their love of systems and hierarchies, I find the fullest and most human outworking of the old theory of 'Kyndly Enclyning'. A theory that starts with Plato and runs in a many-coloured current through Boethius, Chaucer, all the thinking of the Middle Ages, and is still lively in both Shakespeare and Bacon. A truth, still apparent, though disregarded, that things move violently to their place, but calmly in their place. To put it another way, everything has its right home, the region that suits it, and, unless forcibly restrained, will move thither by a kind of homing instinct. But how will I find my 'right home', that house not built with hands, unless I am in my right mind? Every day, in my consultancy, I meet men and women who are out of their minds. That is, they have not the slightest idea who they really are or what it is that matters to them. The question 'How shall I live?' is not one I can answer on prescription.

Most common are the retired or fired businessmen who develop cancer. They come to me in broken health, in fear for their lives, and the phrase I hear first is 'I'm not the man I was.' As we talk it becomes clear that he is the man he has been always, yes, well-off, yes, respectable, but immature, without self-knowledge, a man without breadth or depth, but shielded from this lack by his work, by his social standing, by his loving wife, by his young mistress, by his slap-on-the-back pals. Often, as we talk, he tells me that he has never liked his work, hates his family, or that he has lived for his work and that without it he is a child again and what should he do in the mornings?

Saddest of all are the women who were brought up to believe that self-sacrifice is the highest female virtue. They made the sacrifice, often willingly, and they are still waiting for the blessing. While they wait their cancer does not.

It's awkward, in a society where the cult of the individual has never been preached with greater force, and where many of our collective ills are a result of that force, to say that it is to the Self to which one must attend. But the Self is not a random collection of stray desires striving to be satisfied, nor is it only by suppressing such desires, as women are encouraged to do, that any social cohesion is possible. Our broken society is not born out of the triumph of the individual, but out of his effacement. He vanishes, she vanishes, ask them who they are and they will offer you a wallet or a child. 'What do you do?' is the party line, where doing is a substitute for being, and where the shame of not doing wipes away the thin chalk outline that sketches Husband Wife Banker Actor even Thief. It's comforting, my busy life, left alone with my own thoughts I might find I have none. And left to my own emotions? Is there much beyond a childish rage and the sentimentality that passes for love?

A friend of mine whom I treat informally, he is not my patient, came to me after his second heart attack and said 'Handel, I want to think about my life.' I gave him Pascal's *Pensées*, he was delighted and stuffed the book into his bulging briefcase. 'Just what I need,' he said. As he was hurrying off to pick up a cab, he turned back to me and said 'Handel, I've been so much better for our chats, and I have realised that you are right about the importance of the contemplative life. I'll try and fit it in.'

From my window I watched him disappear into the busy street that used to be flanked on either side with self-distinguishing little shops, each with its own identity and purpose. Each with customers it knew and a responsibility towards them. Now, the unflanked street has been widened, for a road too dangerous to cross, that roars between plate glass multi-national stores, that each sell the same goods, from the same markets, but in different packages and according to the rules of price war.

How shall I live?

The question presses on me through the thin pane. The question tails me through the dense streets. In the anonymous computer-face of the morning mail, it is the question only that I read in red ink, the question burning the complacent page.

'How are you Handel?'
(How shall I live?)

'What are you doing these days?'

(How shall I live?)

'Heard about the merger?'

(How shall I live?)

The question daubed on the door-posts. The question drawn in the dust. The question hidden in the bowl of lilacs. The insolent question at a sleeping god. The question that riddles in the morning, that insinuates at noon. The question that drives my dreams to wakefulness, the question physical in beads of sweat. 'Answer me' whispers the voice in the desert. The silent place where the city has not yet come.

In the invisible city, the city incapable of being seen for what it is, the vanished souls pass their ghostly way, making no impression, leaving no mark, a homogenous people who act, dress, talk and think alike.

My own mind?

My right mind?

My true home?

Long trains leaving. The square light in the windows. The yellow

light on the black train. The reptile train with yellow scales. Yellow and BLACK yellow and BLACK yellow and BLACK chants the train.

The light was fretted around the border of the train; decorative light that made a cornice for the unrelieved metal, pale patterns worked against an austerity of line.

Had the light been fixed in Victorian embellishment it would have tired the eye and not refreshed it. Its charm was in its movement, the play of light, beautiful and surprising, new. New light escaped from an ancient sun.

Sun-yeared light.

In its effect the light was choral. Harmonies of power simultaneously achieved, a depth of light, not one note but many, notes of light sung together. In its high register, far beyond the ears of man, the music of the spheres, vibrating light noted in its own frequency. Light seen and heard. Light that writes on tablets of stone. Light that glories what it touches. Solemn self-delighting light.

The train crawled on beneath the speeding light that had already belted the earth. The scientific train and the artful light.

I, Handel, doctor, Catholic, admirer of women, lover of music, virgin, thinker, fool, am about to quit my city, never to return.

This action, my friends conclude, comes out of an excess of what the French call *La Sensibilité*. Too much feeling is not welcome in a man and it is unhelpful for a doctor. Catholics, it is true, are encouraged to express their emotions, providing that the emotions they express are Catholic ones.

I saw a Confessional box for sale yesterday. It was eighteenthcentury, Irish, portable. Made of dark heavy oak, with a half-gate and curtain across the front, inside, a warm wooden bench worn smooth by countless clerical bottoms. On either side were its little lattice grills, placed at just the right height, for whispered agonies and burning bodies.

'Father, I have sinned.'

'Sins of the flesh or sins of the conscience my child?'

'Sins of the flesh.'

'Begin.'

I went to the brothel this afternoon, there were six of us, all Seminarians. While my companions were flirting with the girls, I received a note to go upstairs, where a lady was waiting for me.

I went into her room. It was white. White walls, white rugs from Egypt, stone-whitened sheets and a deaf white cat. She was a famous courtesan, an adherent of Rome, and a friend of a man I once knew very well, but that was when I was a boy. She was wealthy, still lovely, utterly corrupt. She fascinated me but this was the only time that we had spoken. The room smelled of Madonna lilies. Downstairs, in the stalls, I could hear the boys impatient to be gelded.

'Take off your trousers,' she said. There were tusks on the wall. I have very little body hair. I looked at myself in the mirror, so obvious under my short shirt, and I could only think of mandrake roots. I could see her behind me, quizzical, appraising, and I had an idea what it was that interested her so.

She ran her hands across my buttocks as a dealer does with bloodstock. I saw her, through the silver mirror, into the white room, a looking-glass fantasy, a reversed image of reversing rules. I was there for her.

'Did you penetrate this woman?'

'No father.'

'Proceed.'

She stood behind me as I stood in front of the mirror and she flattered me with her hands. She had strong brown hands, calloused on the pads, hands I didn't expect on a woman. She handled me like a bunch of sticks, my five tough skinny limbs, all hard. And then she turned me to her and bent down.

'Did you ejaculate?'

'Yes father.'

'In what part of the woman?'

'In a bowl on the floor?'

'Proceed.'

'She had a piece of porcelain decorated with Greek heroes. She told me to kneel and I went on all fours like a Passiontide donkey and when she dug her heels into my groin I came over Odysseus. She said she called it her Scholar's Bowl . . .'

Doll Sneerpiece was not a scholar but fond of gentlemen, although to dub her a limmer, would have been to do her a wrong. Her mother, on her death bed, had taken the young Doll's tiny hand and given her this advice, 'Never sell property.' The Doll had taken this to heart and applied the lesson to her other more merchantable parts.

She was not for sale, she was for hire only, and the rate was steep. She was rich. Rich on her round breasts. Rich on her curved belly. Rich on the peaches of her buttocks. Richest on the fleece of her triangle. 'My Euclid' she called it, offering geometric proof to those bogged down in algebra.

Ruggiero, whom she loved, as a bird loves flight, was bookish, high-minded, chaste. When Doll Sneerpiece flaunted her mathematical credentials, Ruggiero fled into the ivory tower of art. Odysseus-like he lashed himself to his desk and plugged his ears against her siren-song. This was difficult because he loved opera.

He had never seen a woman's . . . a woman's . . . what should he call it? Inkpot?

He fingered his pen and thought of Doll Sneerpiece full of red ink.

It was Ruggiero's life's work to reconstruct an index of those manuscripts likely to have been stored in the Great Library at Alexandria. He was a scholar, and like other scholars, he believed that his work, however arcane, would be of estimable value to human kind. Ruggiero hoped that the estimate might be a pension. It is impossible for a man to read and earn money at the same time, unless he is a reviewer, and Ruggiero prayed never to fall so low.

Doll Sneerpiece, who had fallen low on so many occasions that she had made falling into a gracious art, knew exactly what her labours were worth. She had found that by arching her bottom in a calculating manner, she could prop her forearms on the bed and continue to read undisturbed by the assaults on her hypotenuse. It was in this way that she had come to delight in the elevating works of Sappho. Her own copy, in its original Greek, had come from a one-eyed trader in antiquities, who claimed to have stolen it from the Medici themselves. It had come to them by way of Alexandria. When Ruggiero had asked to inspect it, the Doll had pointed to the fork between her legs, where, she said, such things were kept.

A fiction? Certainly, although I see from the extravagant and torn frontispiece that it parades itself as autobiography: 'The Entire and Honest Recollections of a Bawd'.

Entire? Honest? I doubt it, but why should I? Even science, which prides itself on objectivity, depends on both testimony and memory. Scientific theory has to be built up from previous results. Scientists must take into account what others have recorded and what they themselves have recorded previously. Science deduces and infers from past explanations, past explorations, the investigative technique that tests its theory against all known facts.

But not all facts are known and what is known is not necessarily a fact.

There is a further trouble; no matter how meticulous the scientist, he or she cannot be separated from the experiment itself. Impossible to detach the observer from the observed. A great deal of scientific truth has later turned out to be its observer's fiction. It is irrational to assume that this is no longer the case.

Part of the problem with the neutral observer, who is in fact romantically involved with his subject, is that some time must always elapse between the experiment and the record of the experiment. Infinitely tiny, perhaps, but even without a lover's gaze, how many fantasies can force themselves into an infinitesimal space?

I know how difficult it is to say exactly what happened even a moment earlier. If someone were with me, their testimony might corroborate my own, or it might not. And if there is a photograph? The camera always lies.

The most awkward fact in all this doubt is this: remembering, which occurs now, at this split second, does not prove that what is being remembered actually occurred at some other time. I may be convinced that it did, especially if a number of others, the more the better, are convinced too. When I am alone, and the experience, the emotion, the event, was mine and mine alone, how can I say for certain that I have not invented the entire episode, including the faithful memory of it?

It could be that this record set before you now is a fiction.

On what can I depend, if not my past, if not objectivity, if not the clean white coats of science? Should I acknowledge the fiction that I am? A man made of nothing but space and light, a pinpoint on a pinpointed planet stitched among the stars? Le silence éternel de ces espaces infinis m'effraie. A man caught on Time's hook.

What can balance the inequity of that vast space, which never ends, and my bounded life? Bounded yes, but not by mortality, which is not what I fear, but by smallness, insignificance, which is what I do fear. The unlived life. Life in its hard shell safe from the waters above and the waters below. The home-and-dry life. Sound. Dependable. True?

The train had reached the coast. The sea-light crept in tentacles along the floor. Long waves of light that atomised the solid seats and rigid tables. The train itself wavered.

The man shut in the bright aquarium floated on his own thoughts. His thoughts bubbled out of his head in cartoon exuberance. He caught them, blew them, burst them. He dived down through the layers of light to his shipwrecked past. He had sunk himself so often that he found a whole fleet of boats, ghostly, unattended, changed by the pressure of the water and the work of time.

How much of any value could be raised?

The man forced open a small door. There were his toys, his narrow bed, the place where no light had ever seemed to fall. When he remembered his childhood it was dark, except for a short space in the afternoons between three and four o'clock. Except for two years coloured red.

Above him the water shifted in chessboard squares of dark and light.

How many fantasies in an infinitesimal space?

The sun has turned the sea to diamonds. Behind me, the roar, roar, roar of the motorbikes on the motorway. The definite world of flywheels and tarmac is only the sound of bottled bees.

The dirty sea is changing. It is no longer grey, no longer blue, no longer green, but white and white in peaks and troughs that shape themselves to the curve of my eye.

I confess that I am frightened of the sea. There is the sailor sea and

the commercial sea, the oil-well sea and the fishy sea. The sea that tests the land through sub-lunary power. The rise and fall of the harbour sea and the sea that exists to make maps look prettier. But the functional sea is not the final sea. There is that other sea simply itself. A list of all the things that the sea does is not what the sea is. Today, the sea has jewelled its surface, and silvered its fish under a band of beaten gold. Those who know it well will admit that they hardly know it at all. No-one has been to the very bottom. Except by inference we do not know that there is a very bottom. We do not know it from observation.

And myself? Observe me. There is something to be gained from my surface uses, and perhaps a little more from my lower depths, but my very bottom? That's where I am alone, the observer and the observed.

I descend, I try to tell the truth, but the primitive diving-bell that I call my consciousness is a more fallible instrument than the cheap thermometer in my fish-tank. I may not have a very bottom, I may be much shallower than I like to think, or I may be a creature of infinity, for now confined. My real world, as I fondly call it, may be the necessary cable that holds me in waters I can manage.

I, Handel, ask questions but can't answer them, I'm not a hero, only a chessboard knight hoping to be swifter than the game. While I kept my life to a series of clever moves, I felt well, almost happy, I left no time for reflection. I didn't want to see myself in the mirror. The tight chain of events began to separate, not physically, I was as busy as before, but emotionally, spiritually. I began to slip between the gaps, the reassuring stepping-stones were pushing farther and farther apart. Handel, holding himself above the water with a pair of forceps, Handel, whose faith did not prove to be a life-belt. When I could no longer cling on, I let go, with some terror and yet some

relief. Let go into unknown currents, a voyager through strange seas alone.

The train was hosed in light. Light battering down on the roof. Light spraying over the edges in yellow bladed fans. Light that mocked the steel doors and broke up the closed windows into crystal balls.

The dull straight lines of the dull straight station bent under twists of refracted light. The station buckled. The small smug cube of the ticket office shattered. The man waded over to it, he thought he was in a field of buttercups, the light up to his knees and rising. He tried to buy a ticket, but the confident coins melted under the heat of his fingers. The man wrote on golden paper and gave it to the golden clerk. He trod through the light and on to the golden train.

Picasso

Picasso, easel, brushes, bags, waited for the train.

On the dark station platform, lit by cups of light, a guard paced his invisible cage. Twelve steps forward twelve steps back. He didn't look up, he muttered into a walkietalkie, held so close to his upper lip that he might have been shaving. He should have been shaving. Picasso considered the guard; the pacing, the muttering, the unkempt face, the ill-fitting clothes. In aspect and manner he was no better than the average lunatic and yet he drew a salary and was competent to answer questions about trains.

Picasso decided to ask him one.

'What time shall I expect the arrival of the 9:15?'

He looked at her with undisguised contempt. It was his duty, she was a passenger, he was a guard. He held up his hand in an authoritative STOP sign, although he was the one moving. Picasso waited patiently until he had walked the twenty-four steps that reunited them. She repeated her question. Dramatically he lowered the phone from his upper lip and pointed to the passenger information board.

'Yes,' said Picasso. 'The board tells me that the 9:15 will arrive at 9:20. It is now 9:30.'

The guard looked at her as a priest looks at a blasphemer. His answer was spiritual and opaque.

'When it arrives you'll know what time it's due.'

He began again, pacing, muttering, pacing.

Picasso went over to the refreshment kiosk. 'NOW SERVING FRESH COFFEE.' What had they been serving previously?

Her father had said, 'A woman who paints is like a man who weeps. Both do it badly.' He had a right to call himself a patron of the arts. He had commissioned fifty-five pictures over the years, all of them self-portraits.

'Don't talk to me about art,' he had said, although Picasso had never tried, 'I know about art.'

Sir Jack had refused to send Picasso to art school. On her eighteenth birthday he had given her a pair of beige rubber gloves and a long beige apron.

'You can start in Mustard,' he said.

Picasso did. Denied paints she painted in mustard. At night, when the last shift had gone home, Picasso had the run of the giant factory. She switched off the heavy neon lights and rigged up a couple of inspection lamps above the small circle of her ambition.

She was ambitious, but she did not confuse her desire to paint with an ability to do so. Under her own cruel inspection lamp she questioned herself without remorse. She could learn, she could learn all there was to learn and be a modern Landseer. Talent and application could pitch her in the Royal Academy, genius was certain to bar her from it. She knew she could never be satisfied by approximation. Either she was an artist or she was not. She had no patience with notions of fine art or popular art, second-rate art or decorative art. There was art and there was not-art. If she was to be not-art, she would prefer to be something else, someone else, altogether, she would fall on her own sword.

Against the blank crates, plastic-wrapped pallets and vinegar vats, Picasso painted. The factory clock ticked factory minutes. She hardly slept. Her nights were spent in a white disc of light, a supplicant on a Communion wafer, and outside, the vampire dark.

She went to look at paintings. She looked at them until she could see them, see the object in itself as it really is, although often this took months. Her own ideas, her own fears, her own limitations, slipped in between. Often, when she liked a picture, she found that she was liking some part of herself, some part of her that was in accord with the picture. She shied away from what she couldn't understand, and at first, disliked those colours, lines, arrangements, that challenged what she thought she knew, what she thought had to be true. It was an ordinary response to an extraordinary event. The more she looked at pictures the more she saw them as extraordinary events, perpetual events, not objects fixed by time. In the rambly old text books there was talk of 'The Divine'.

There was a day when Picasso understood. The only comparable day had been when she was a little child learning to read. The forms of the letters had hurt her eyes, she found them ugly, crude, arrogant, nothing. She longed to be out in the sun. She was good at games, the form of her body was a form she knew, it had shape and meaning. When she jumped and ran and swung herself in wild surprises, she was a young cat in summer. When she had to return to her desk, she was only an awkward child, with a wintry face.

She stared at the page. It meant nothing to her.

She stared at the page. It meant nothing to her.

She stared at the page, and, without thinking, she read it. The harsh closed letters sang into being. Sang into her being. She could read.

After that, she could not be separated from her books. Her mother, who had worried that her agile child might be backward, now fretted that she would lose her looks behind thick spectacles. Her mother tried to get her interested in fabrics, but Picasso cut up

the gingham and chintz and floral and fleck, and used them as rags to wipe her brushes. When she could not read about painting, she painted paintings, copying carefully the things she loved, learning through sincere imitation.

Colours became her talismans. At the end of each black and white day she dreamed in colour. At night, she soaked her body in magenta dyes, scrubbed herself with pumice of lime. The pillow was splashed in crimson by her black hair. She slept under a cloak of Klimt.

She pulled down her mother's ruched blinds, and put up a plain canvas blind, on which she painted from time to time. 'It's so crude' complained her mother, who believed in Good Taste the way Sunday worshippers believed in the Immaculate Conception. She wasn't quite sure what it was but she was sure it was Important.

Picasso's father didn't mind how much his daughter read. It was the painting he disliked. He felt it revealed an excess of testosterone and he wanted his daughter to be well balanced like himself.

When Picasso looked at a Cézanne apple, she felt all the desire of Eve standing on the brink of the world, paradise falling away.

'She lives in Paradise,' said Sir Jack, whenever he thought of his daughter. 'You live in Paradise,' said her mother, when Picasso told her that she was leaving home to paint. 'What's wrong with this house?'

The past stands behind me as a house where I used to live. A house whose windows, from a distance, are clear and bright, but strangely shaded as I come near. A friend says, 'Show me where you used to live' and we hurry, arm in arm, to that street, to that house, to that time, which no longer exists, but which must exist, because I can find it again.

My past, my house, is linked by two staircases; the one I use, and

the one other people use. My private staircase leads me from the low basement of my infancy, through small bare rooms, rooms with only a table, rooms with nothing but a single book. Rooms soaked in colour, heavy with red, fierce under chrome yellow. Winter rooms of polar white, summer rooms, where the fireplace is crammed with flowers.

The public staircase is a broad certain sweep, that moves in confident curves upwards, from the ground floor. It is made of reclaimed oak. Not a single tread of this easy public route has been laid by me. My mother, father, brothers, uncles and aunts, have laid it over the years, and literally laid it over the years, so that time is trapped beneath the smiling polished boards. They have climbed it step by step and they do believe that it is the only way up through the house.

'You were always a difficult child,' said my mother, leaning over the firm banister rail. She strained her eyes to look back into the dim vanished kitchen where we used to spend our days. She saw herself, young, kind, overworked, patient, neglected by her husband and abused by a silent toddler who would not understand that bananas are the only fruit.

'I did everything for you,' she said, and suddenly, she was back on her hands and knees, and I, a grown woman, was back in the hated high chair, swinging impotent legs above a shiny floor.

'You'll never know the sacrifices I had to make,' she said, as she prepared to tell me about them once again. She ran up the complicit stairs and into one of her favourite memory rooms, the family parlour.

It was here that Sundays were played out with magnificent genteel sadism. Here was the shuttered room, obscenely clean, the Dresden shepherdesses leering at one another, across the backs of prim sheep. There was an oil portrait of my father in military uniform, there were

no portraits of his mistresses. The clock tick-tocked the tortured minutes into columns of despair. My brother and I, counting, counting counting. On the hour, it chimed its lecherous gurdy music, and out shot a soldier, drum propped on his swollen penis. My brother kept his hands in his pockets.

'And you smashed that beautiful clock,' said my mother. It was here that I had begged her for my own bedroom.

'When you get older,' she had said, throwing paper flowers on to the fire. Until I was fifteen, my brother used me, night after night, as a cesspit for his bloated adolescence. That place is sealed now. My own narrow stair stops outside the door and begins in a new direction. My mother's staircase sweeps past the door without stopping. There is no door there, she says, no room beyond.

'Why don't you go and visit your brother and his wife?' and then, 'You were always difficult.'

I have tried to follow her as she passes from room to room. I have tried to remember the things she sees with self-justifying power.

At Christmas, when all my family line up for the annual guided tour of the house, I try to keep up, but I fall further and further behind. When they gather on the bottom step of family life, to weep a few tears over the babies they used to be and the mother and father they used to be and the dinners cooked and squabbles mended, it's easy to be drawn in. They do draw me in, they scribble me in all their pictures, then lose their temper when I don't recognise myself.

'Wasn't she pretty?' (my mother again). 'Of course in those days she had long hair.'

My brother likes to get roaring drunk on Christmas Day, and when he's drunk he begs his little sister to come and sit on his knee. 'Get lost Matthew,' has been my seasonal reply, which might have been a mistake because, no sooner have I said it, than my entire family of uncles, aunts, cousins, in-laws, charges up to the nursery,

headed by my father. My mother, sentimental on sherry, tells everyone how her children used to play together like puppies, even fall asleep in the same bed. She wipes away her twelve-month tears. 'We were a happy family,' she says. 'Take no notice of Picasso.' As if any of them ever did.

Late at night, when each member of the family had gone to sleep in their rightful family bed, Picasso crept out on to her narrow stone staircase and felt the cold under her feet. Cold not comforting like the broad wooden boards her family trod upon. Cold not comforting, the way lies are comforting, so long as they can be believed. Solid, honest, private cold. She was away from the humid babble of voices. She was out of the stoked-up conspiracy to lie. The fantasy furnace, where truth was chopped into little pieces, and burned and burned and burned.

She climbed the stairs. She hated her brother. She climbed the stairs. She loved her mother. She climbed the stairs. Who were those loud fat people, who filled the spaces so that there was never enough air to breathe, never enough light to see by? Who were those people who used the past like a set of rooms to be washed and decorated according to the latest fashion? Who were those people whose bodies were rotting with lies? They were her family. She climbed the stairs.

She was out now, over the slates of the house, out beyond the silent chimney pots and the crackle of the satellite receivers. Out past the upper branches of the huge plane trees that had fronted her house for more than three hundred years. She was way out past good behaviour and common sense.

She was level with the crane that hung over the stockyard. Every day, in hard hats and goggles, men welded at impossible heights. The air hissed, gold sparks spat the silver steel, the smell of burning skin. Every day there was a little more of the cancer hospital, a little less of the stockyard.

The crane waited. Tomorrow it would bend down its yellow arm and scoop up the blue cattle gate. The gate was blue, but for the top bar, worn shiny through years of forearms. It was a blue cattle gate painted with history, not war or politics, but blood stock, beer prices and the occasional broken heart, 1710–1995. Since then, the yard long abandoned, the gate had been alone. Not tomorrow. Out now, over the steel, the concrete and the dumper trucks, carefully into the back of the lorry, and away to the agricultural museum. The grid beneath would be recycled.

The city recycles everything, but, it has not yet found a way to separate the materials from the memories. As houses have been demolished to make way for more and more roads, people have begun to roam in posses, looking through the city skips for a part of their past. For many, the new developments hardly exist, the people look through them into lost terraces and low tenements, where they were happy.

Men and women who used to live nearby, before the Compulsory Purchase Orders, like to walk back on a Sunday afternoon to point out their ghostly homes. Nobody knows why. Psychologists suggest a medical parallel; those who lose a limb, either through accident or amputation, continue to feel pain in the non-existent part. Some claim that their vanished arm is still hanging by their side.

People have found it hard to live without the personal landmarks they recognise. They can't say, 'Look, this is where it happened.' Now, they have no means to the past except through memory. Increasingly unable to remember, they have begun to invent.

Picasso climbed the stairs. There was nothing solid under her now. She was balanced on the girders of her imagination.

I was on the roof. My hair was lank. My skin dull from ill-use. Only my eyes were bright. I thought I was standing on a cliff top waiting for a ship to pass under the white clouds. I had feared all the ships were gone, everyone travels by aeroplane these days, I had feared all the ships were gone, this high dizzy place the last standing room of my heart. Then I saw a mast and gay sails. Your firm sides, your hold stashed with cargo. You were a deck of colour in a pale world. Red lipstick, green eyes, hair swarming bees. You were a spice ship and I could smell you on the wind.

Your scarf fluttered out like a pennant. You were wearing a canvas jacket and I wondered if I could paint you, but already you were the colours of the rainbow, your purple hat cocked. You told me your name was Nelson, but that was much later, long after I knew mine was Hamilton. I knew that night that I wanted to be your mistress and sail the seven seas in your little coil of rope. I put my eye to the telescope and regarded you. A minute can still alter a lifetime.

'Victory' I said that night.

'Victory' as I climbed the long climb back to my studio.

'Victory.' The word undressed me. The word took off the neat blazer and low shoes I wore to family parties. I looked at my body in the mirror. It was not pukka-proud the way you strutted yours. It was a body unused to light.

My shoulder blades were sharp rebukes. My belly was an unploughed field. Weeds had grown over my pubic hair. I was a nun among nettles.

'Victory.' I picked up my paint brush and began.

I painted my uncertain breasts with strong black arrows and ran a silver quiver down my spine. I took out my lipstick and drew my lips into a red bow bent. You were my target.

I painted my legs with dangerous yellow chevrons and bathed my heels in mercury. I would need to move fast. I circled my buttocks with gold rings and gave my navel its own blue diamond. Thinking of your Victory hat I dyed my hair purple. As I painted, intent on umber and verdigris, cinnabar and chrome, the colours, let out from their tight tubes, escaped under the studio door and up and down the public staircase to the black and white family rooms. My mother broke from her flannelette sleep to cry out the name of a man she hadn't seen for twenty years. She reared up from her matrimonial sheets, infidelity colouring her cheeks. My father slept in purple.

Matthew, slug-fat, snail-slow, worm-pink, had a nightmare. He was walking down a busy street looking for a pick-up. He saw a woman he liked, chocolate nipples and race-track thighs. He crossed towards her, his wallet sticking out, she touched his face and said, 'Hello dear, you're Picasso's sister aren't you?' He looked down at himself, and saw that he was wearing nothing but a tutu, dyed envygreen. He reached frantically for his wallet but it had gone.

Uncles, aunts, cousins, in-laws, all the weights and ephemera of family life, were dreaming in colour that night. Fawn carpets turned to blood and all the beige bedding there was couldn't suppress a single sheet of crimson. Even my younger brother Tommy, who had medals to protect him, woke in a blue funk.

In the morning, it was raining, and the rain fell in orange points on their cream flesh. They were spotted with guilt, each could see in the other, the patterns of infection. They ate their family breakfast in solitary silence. Unclean, leper-spotted, found out over night.

They wore their darkest clothes, their soberest expressions, they whispered like church wardens. They colluded in their grey, upright vanity, but when their eyes met they saw the stain.

My mother poured the tea with trembling hands. Concentrate, concentrate, one cup, two cups, safe, safe. She dropped the pot. The white china shattered on to the white tablecloth and spread the tea in a five-point star of plum.

'Why is the tea that colour?' demanded father.

'There's no colour there father, no colour, just tea.' She dabbed at it with the corner of her white handkerchief. She might as well have dipped it in blood. The family stared at the stain and the stain stared back. Impudent with summer, rich with fertile swelling, the plum stain on the Christmas tablecloth.

'Go upstairs, why don't you?' My mother pleading, wringing her spotted hands on her spotted apron.

They went upstairs. They went upstairs, two by two, to the comfortable ark of the Sunday parlour.

'It's raining,' said Matthew, standing at the long window that overlooked the long garden. He saw his mother in the rain, orange arrows tangling in her hair. She was struggling to hang out the tablecloth.

'Mother will get wet,' he said to no-one.

'Bit of rain won't hurt her,' said father.

'It's orange,' said Matthew.

'It must be the power station,' said father.

Picasso painted. She painted herself out of the night and into the circle of the sun. The sun soaked up the darkness from her studio and left a sponge of light. The light illuminated the four corners of the floor and the four corners of the ceiling in an octave of praise. As Picasso painted she sang in eight points of light. She opened her back to the sun and let it key her spine. She opened the window and the sun scaled her. She had the sun as a halo behind her head. She shone. The sun was in her mouth and it burned her lips. She held the sun between her teeth in a thin gold disc. It was winter but the sun was hot. She looked like a Buddha in gold leaf.

Without thinking, Picasso ran into the parlour, into the newspapers, into the best clothes and the dead air. She was painted from head to foot. 'Self portrait,' she said to their astonished faces.
'Call the doctor Matthew,' said her father.

The doctor packed his stethoscope, his gloves, his warrant and his syringe. The doctor got into his car and set off. The smooth powerful car purred underneath the purple clouds.

'For God's sake Matthew, the snow is NOT purple. Where is your sister?' (Hello dear, you're Picasso's sister aren't you?)

Picasso packed her easel, her brushes, her paints, her bags. She packed her canvases and left her reviews. Outside, the sun had made a pole of light that struck through the cloudy hide. Picasso, in her camouflage, swung down it and on to the road.

'It's all over the tablecloth,' whimpered mother.

Picasso was wearing her deep boots, her leather jacket and velvet hat. She was warm because she had had the foresight to paint herself in for winter.

'The central heating has broken down,' said Matthew, kicking the white radiator.

Outside, the snow was clean and fresh, it fell on her lightly like the touch of an old friend. She threw back her head, but when the snow touched her lips, it melted. She had the sun in her mouth. She smiled and walked through the silent city.

On the way, after she had been walking for some time, a man skidded up through the breaks of snow, and asked her for help.

'I am a doctor,' he said.

'Sorry,' said Picasso. 'I don't take drugs.'

She walked on, past his purple face in his snow-shot purple car, through the silent city and into the railway station.

SAPPHO

AM A SEXUALIST. In flagrante delicto. The end-stop of the universe. Say my name and you say sex. Say my name and you say white sand under a white sky white trammel of my thighs.

Let me net you. Roll up roll up for the naked lady, tuppence a peep. Tup me? Oh no, I do the tupping in this show. I'm the horned god, the thrusting phallus, the spar and mainsail of this giddy vessel. All aboard for the Fantasy Cruise from Mitylene to Merrie England by way of Rome and passing through La Belle France. How long will it take? Not much more than two and a half thousand years of dirty fun and all at my own expense.

Am I making any sense? No? Here's a clue: Very Famous Men have written about me, including Alexander Pope (Englishman 1688–1744 Occupation: Poet) and Charles Baudelaire (Frenchman 1821–67 Occupation: Poet). What more can a girl ask?

I have a lot of questions, not least, WHAT HAVE YOU DONE WITH MY POEMS? When I turn the pages of my manuscripts my fingers crumble the paper, the paper breaks up in burnt folds, the paper colours my palms yellow. I look like a nicotine junkie. I can no longer read my own writing. It isn't surprising that so many of you have chosen to read between the lines when the lines themselves have become more mutilated than a Saturday night whore.

I've had to do that too; go down on the cocks of Very Famous Men, and that has put me in a position to tell you a trade secret: Their dose tastes just the same as anyone else's. I'm no gourmet but I know a bucket of semolina when I've got my head in it. You can lead

a whorse to water but you can't make her drink. My advice? Don't swallow it. Spit the little hopefuls down the sink and let them wriggle up the drain. No, I'm not hard-hearted but I have better things to do with my stomach lining. And I have another question: When did he last go down on you?

So many men have got off on me. Large men, small men, bald men, fat men. Men with a hose like a fire-fighter, men with nothing but a confectioner's nozzle. Here they come, poking through the history books, telling you all about me.

I was born on an island. Can you see the marble beach and the glass sea? Both are lies. The white sand damp-veined is warm underfoot. The sea that softly reflects the hull will splinter it soon. What appears is not what is. I love the deception of sand and sea.

'A Deceiver.' 'A notorious seducer of women.' 'A Venom.' 'A God.' 'The Tenth Muse.' It is the job of a poet to name things, blasphemy when the things rise up to name the poet. The praise is no better than the blame. My own words have been lost amongst theirs.

Examine this statement: 'A woman cannot be a poet.' Dr Samuel Johnson (Englishman 1709–84 Occupation: Language Fixer and Big Mouth.) What then shall I give up? My poetry or my womanhood? Rest assured I shall have to let go of one if I am to keep hold of the other. In the end the choice has not been mine to make. Others have made it for me.

In the old days I was a great poet but a bad girl. See Plato (Greek 427-347 BC Occupation: Philosopher) then, Ovid came along in the first century AD and tried to clean up my reputation with a proper tragic romance. Me, who could have had any woman in history, fell for a baggy-trousered bus conductor with the kind of below-the-waist equipment funsters put on seaside postcards for a joke. Fuck him? I couldn't even find him. He said I must have bad eyesight, I said it must be because of all those poems I was writing, late at

night with only a tallow candle to keep me company. He said I should give it up, it was ruining our sex life.

SEX AND THE SINGLE POET. Look at her, my sweet bird of prey, sleek head and gold-tipped feathers. She sits on my wrist while I stroke her. She makes a perch of me. She calls me her little perch and is glad to use her claws. I have all the scars of my art.

Am I her keeper? Who cails whom? Does she hear my cry or do I answer hers? She hunts. She hunts me. I have soft fleshy parts for the pleasure of her beak.

She is acute, high-pitched, wind-formed. Invisible lines bring her back to me. I need not jess her. It is my legs that are strapped apart, restrained from false modesty by angles of desire, we are crosswise on the same current, falcon and falconer, falconer and falcon, in single prey.

This is the nature of our sex: She opens her legs, I crawl inside her, red-hot. I crow inside her like Chanticleer, red coxcomb on a red hill. She says, 'My little red cock, crow again,' and I do, with all my pulmonary power. I crow into the faint red-rising sun. I crow into the dew-wet world. I split her with the noise of it, she shatters under me, in a daybreak of content.

'My little red cock' she calls me and I am glad to be a small domestic fowl who lives in Aesop's bliss. The Tale of the Falcon and her Cock.

'The Works of Sappho,' said Doll Sneerpiece.

The excellent lady was dressed in red. Red from the ruby comb that pinned up her henna hair. Red at her throat in a slash of agate. Red lips in cherub bows. Red beneath the pinnacle of her bosom, and, below her waist, a parting Red sea, that fell on to Turkey slippers, snug on a Turkey rug.

'The Works of Sappho,' said Doll Sneerpiece.

'Very Right. Very True.' said Miss Mangle, who had at last seen the Doll's lips move.

'The greatest poet of Antiquity,' said the Doll. She drew on her bubbling hookah until the narcotic calmed her. She was not calm, she was boiling with love, she opened the book.

'Love has taken me captive.

I tremble with desire acid now now sweet.'

She closed the book. She closed her eyes. Behind her eyes Ruggiero's face.

'I long for him as a hind longs for a belling stag.'

She imagined Ruggiero's antlers.

In another room across the city Ruggiero stared at the inkpot.

'I am sick of love,' said Sappho. She laughed and picked up her suitcase. Sick of love was surely better than sick with love?

In the past, she had been glad to get aboard any vessel that pulled alongside, show her a fat hull or a slim keel and she stashed her baggage in the hold. When her new quarters had become too cramped she had jumped ship. That had been Sappho and a pile of papers to prove it. Why was it that the Church of Rome had burned her poems and excommunicated her? Galileo has had his pardon but not Sappho. Galileo is no longer a heretic but Sappho is still a Sapphist.

'Know thyself,' said Socrates.

'Know thyself,' said Sappho, 'and make sure that the Church never finds out.'

The Word terrifies. The seducing word, the insinuating word, the word that leads the trembling hand to the forbidden key. The Word

beyond the door, the word that waits to be unlocked, the word springing out of censure, the word that cracks the font. The Word that does not bring peace but a sword. The word whose solace is salt from the rock. The word that does not repent.

The words come at my call but who calls whom? The shriek on the wind is ages old, the cry that comes before meaning, the cry that comes out of the wilderness without food or drink. The ragged prophet in burning clothes.

Day and night stretch before the word, hunger and cold mock it, but the Word itself is day and the Word itself is night. The word Hunger the word Cold. I cannot eat my words but I do. I eat the substance, bread, and I take it into me, word and substance, substance and word, daily communion, blessed.

Who calls whom? The word shaped out of the substance as the sculpture is shaped from the stone. The word imposed upon the substance as the wind reforms the rock. The clashing made and making words. The Word out of flux and into form.

On the barrel of the wind the falcon.

I love the deception of sand and sea. What appears is not what is. The long reaches of uncertainty draw me out, barefooted, half-dressed, when there is no colour in the sky. White skin in a white dress along the white edge of the sea.

She carried white roses never red.

As Apollo dragged the stars through his wheels she picked up the petals at her feet. Above her, the full moon like a clear coin, and in the water her reflection, horn slender horn white.

She wore the moon behind her head as a saint wears a halo.

She threw the petals in the water and stirred the stars.

This was what she wanted; to shift the seeming-solid world, to

hang over it as the moon hangs over it, casting it according to the hour. To carry white roses never red.

The Wise Sappho. Am I wise? Was it wise to fall in love with Sophia, one of nine children, and if not the most chaste, the most difficult to please?

My Muse.

There was a time when she was courted by every poet and philosopher, even Socrates. She chose me. I was writing in those days, writing out of beauty, out of love, and because of her, out of wisdom. The wisdom of the body.

Our feet were bare, the sun was hot, there was no thought unpassed through the sun. No thought not pressed underfoot with the harvest grapes. Thoughts transformed by heat and weight until they no longer resembled the thinkers. Intoxicating thoughts, and we were drunk on the beach, Sophia and I, drunk on words and resin wine.

I put the words into a flask and flung them out to sea. Flung them far out from me, made through myself, but not myself. Only a fool tries to reconstruct a bunch of grapes from a bottle of wine.

The world is packed tight with fools.

Here, today, spread out in front of me, in numerous learned tomes, is a record of my supposed love-affairs, as construed from my work. Atthis, Andromeda, Gyrinno, Eranna, Mnasidika. They sound like precious stones. They were precious stones but not studded in my heart. They were studies of the imagination. The wind on that day, the purple sea, the copper drum flashing a message off a lovely face, were as much to me as that face. Some I loved, some I dreamed of loving, some were names carved roughly into the rock. It doesn't matter, not now, not then, I was and am still moved by things remote from me. Things demanding words, things whose life I understood so well that they seemed to be my own. They were not

my own. Not one flesh but one image and the image more potent than the flesh.

My Muse. Sophia and a passion that does not pass.

Love me Sophia, in my foolishness, love my words and not my mortal remains. Be tidal to me in the constancy of change. Break over me where I feel most safe, be a shore to me, when I fear I am wave in the water, endlessly slipping away. Lift me up like a shell from the beach, now empty, now full. Lift me up and there are still songs.

Across the burning beach a man bright-haired. His camel was the colour of washed sand. His hands and his face were golden. The light struck his shoulders and flinted away. He was run through with the sun. He carried a lance under his arm, and held, in either hand a shell and a stone.

He stretched out his hand and from the shell I heard the long poem of the world. I closed my eyes to find them full of starfish where the sun beat on them in steady rhythm.

My friend told me that it was his task to bury the shell and the stone before the end of time. They were all of art and mathematics. The pith and marrow of us before the end. I looked behind him and saw Time churning the sands in pyramids and river beds. The caravanserai of civilisation and the patient desert.

'Dust to Dust,' he said, 'and the sun herself obscured.'

He turned away and I turned with him in vivid heat to look on the sun-dried world. The groves and towers were gone. The Word was gone. The sea had shrunk away leaving only the blue mist of afterrain. Ignorant of alchemy they put their faith in technology and turned the whole world into gold. The dead sand shone.

'And what good are the treasures of Egypt,' said Doll Sneerpiece, 'if I never again see his sweet face?'

I am a Sexualist. Casti connubi? (as the Pope says). It's all Latin to me. Why marriage? Why chaste marriage? Is there nothing else? Nothing more? An alliance of love.

What marries me to you? Is it a piece of paper? Then I am not married to you. Is it Church approval? Then I am not married to you. Is it the fact of a roof, the fact of a bed, the fact of two keys in one lock? Then I am not married to you. Is it the Eye of the Law? Then I am not married to you.

If it is the daily pleasure in your face. If it is the quickening of my spirits at your face, if it is your face I seek when I seek no other, if it is the love of you that is consent, if it is consent to be of the same mind, then let me not to the marriage of true minds admit impediments. There is some Latin that I understand; Consensus facit matrimonium et non concubitus.

And what about copula?

Read between the lines and there's nothing but dirt. Dirt under my fingernails, dirt in my mouth, dirt between my legs where the pleasure grows. Don't trust Rome. It was Savonarola (Florentine 1452–98 Occupation: Martyr and Zealot) standing in the courtyard of the Medici who denounced me as a corruptor and a devil and had my work burned.

My work. My work. The words spitting upwards in tongues of flame. The words smoking the clear uncritical air. The words curling off the manuscripts. The manuscripts cracking in the fire.

Sophocles (Athenian 496-406 BC Occupation: Playwright). 'Gods, what impassioned heart and longing made this rhythm?'

My heart, my longing, the heart at bay where you hunt me. The heart that runs through the wood, sees a stream, crosses it, takes the cut against the cliff, and comes cornered to the sea. Where now? Where now, with the beating blue water behind me and your voice at my head?

Who calls whom? You call me your True Hart, a five-year stag with a beginning crown of surroyal antlers. Is it my hart-horn that pleases you? Is it your horn, brassy in the frost, that wakes me from quiet ease into this frothing chase?

This is the nature of our sex: I take bread from your hand. I take you on my horn. You skin me and call me 'your little red deer'. You are fond of my haunches, I am fond of the flat of your hand. My heart. My longing. As the parched animal is slaked at the rich pool, I have satisfied myself with water from your well. My mouth knows the shape of you. My mouth overflows.

Out of my mouth, the words in frothing chase. The words that are spoken before they are written. The words that fill up the air and name it. Taking names out of the air I have pressed them on to the page. Atthis, Andromeda, Gyrinno, Eranna, Mnasidika. The burning and the burnt. The words that scorched my mouth and immolated themselves. The burning book that all the pyres of Time have not put out. Sappho (Lesbian c. 600 BC Occupation: Poet).

Doll Sneerpiece was a woman, and like other women, she sieved Time through her body. There was a residue of time always on her skin, and, as she got older, that residue thickened and stuck and could not be shaken off.

Her breasts, her thighs, were stippled with time. From her nose down to the corners of her mouth, were two river-bed creases where time flowed in obedience to gravity, a gravity Doll Sneerpiece denied by smiling at Newton in the street.

She waited for Ruggiero. Time mocked her.

Ruggiero didn't love her. She looked in the glass.

'Tar and Dross,' she said to herself. 'He is only a creature of Tar and Dross.'

'And you?' asked the glass. 'What are you?'

She did not listen to the timely replies of scholarship and scripture. Had she, she might have been downhearted to find that every villainy in the world since Eve, was either from her or for her. The clock struck. Ruggiero was late. The clock struck again. The Doll answered the glass. 'I am a woman who does not repent.' The clock was silent.

She did not repent her past, she did not repent her years. She did not repent her gold, she did not repent the getting of it. She did not repent her lust for young men, her contempt for older ones. She did not repent her sex.

She reddened her hair, she rouged her cheeks, she bloodied her lips, she whetted them. That Time, the Destroyer, was a man, she had no doubt. She thought bravely about his indifferent scythe and that led her to think of Ruggiero, her own young blade, green as grass. Among the campion she would have him, chain him with daisies, prick him by the briar rose. She would roll him in buttercups until he was spread with her. There would be no clouds that day, and if the bells tolled, she would not heed them. She would be sweet in the meadow of her love.

Ruggiero was nervous. He had been sent a note from Doll Sneerpiece to meet her in her rooms in one hour. The clock struck. How could he go? He was a scholar. He gazed at his strong straight body in the glass. The clock struck again. It was true that he did not look like a scholar. He was neither hunched nor whiskered, he did not smell, he kept no noticeable stains upon his clothes. He had good eyesight and he was not ill-tempered. His nose and his ears were clean. No-one would have taken him for a scholar.

'But women,' he said, 'Women are venom and rot. Women are the sweet painted screen around the night-soil trough. Women are the lure of passing flesh stretched over the everlasting carcass. Their end is food for worms. There is no sin that a woman does not know, no goodness that she knows of her own accord. She tempts me as a feed bucket tempts a hungry horse. She plagues me out of Egypt with locusts and honey. Her mouth is a wound. Her body is a sore.'

If the clock struck again, Ruggiero did not hear it, perhaps he was a scholar after all.

To carry white roses never red.

White rose of purity white rose of desire. Purity of desire long past coal-hot, not the blushing body, but the flush-white bone.

The bone flushed white through longing. The longing made pale by love. Love of flesh and love of the spirit in perilous communion at the altar-rail, the alter-rail, where all is changed and the bloody thorns become the platinum crown.

Crown me. You do. You weave the budding stems, incoherent, exuberant, into a circle of love. I am hooped with love. Love at my neck, love at my heels, love in a cool white band around my head. The bloody beads are pearls.

This love is neither wild nor free. You have trained it where it grows and shaped me to it. I am the rose pinned to the rock, the white rose against the rock, I am the petals double-borne, white points of love. I am the closed white hand that opens under the sun of you, that is fragrant in the scent of you, that bows beneath the knife and falls in summer drifts as you pass.

Cut me. You do. You cut me down in heavy trusses, profusion, exhaustion, and soak me in a stream of love. Love runs over me. Love at my breasts, love at my belly, my belly heaped with petals, a white hive of love. White honey at your hand.

Who calls whom? Do I call you my rose? Do you call it me? Do we call it the love that grafts us twice on one shoot? Muser and Muse. Out of those two, the mysterious third, two spirits, one word . . . (tertium non datum). The Word not given but made. Born of a woman, Sappho 600 BC. The Rose-bearer and the Rose.

In the sea-green hall where the colour slapped against the walls in shallow wash, she held me against the rocks, she kissed me. Her mouth was full of little fishes that swam into mine. Little fishes between tongue and teeth, little flicks of sex.

There was salt on her hands, salt rubbed into the wounds of me, wounds of waiting, wounds of pain. Wounds in need of salve yet fearing it.

'Kiss me,' she said. I did. Kissed her mouth where the sea was, kissed her mouth where the ship was waiting, kissed her mouth on a flotilla of time, jumping, ship to ship, mouth to mouth, all the mouths kissed through time.

I knelt at the V of her stomach muscles lifted up, two hands in prayer. I sang the long praise of her belly. Her fingers coraled my hair. Love me Sophia, on the narrow band of white sand, that separates us from the sea.

In the dark places that do not need light, where light would be a lie, overstating what is better understood invisibly, it is possible to resist Time's pull. The body ages, dies, but the mind is free. If the body is personal, the mind is transpersonal, its range is not limited by action or desire. Its range is not limited by identity.

I need the dark places to get outside of common sense. To go beyond the smug ring of electric light that pretends to illuminate the world.

'Nothing exists beyond this,' sings the world, glaring at me from its yellow sockets, 'nothing exists beyond now.'

I challenge the stale yellow light to a duel.

Fight me. Fight me now. Hand to hand combat between the living and the dead. The optimistic flesh and the spanner-twist of mortality. One full turn clockwise and the rusted bolts seal the lid. Ashes to ashes, dust to dust, the tick, tick ticking, and the ghastly fingers creeping round the smug enamel face.

Time and the bell. The sea-bell through the sea-fog. The warning bell at night-time, the waking bell at day. The wedding bell and the final bell. The black-clappered bell and the broken day.

Under the black bell, lie the bodies in single file, one behind the other. One hard on the heels of another, one by one, the fall, the clang, silence.

Time and the bell. The sun dial on my chest. The breast plate that is my inheritance. The sun makes his circuit and drags me with him, traces his journey over my body, leaving deep ruts where the shadows collect. Time passes over me, the shadows lengthen, the dial darkens.

What time is it? Look at my body and you can tell. Count the rings as you would on a tree. Count the ridges on the cumulus of my skin. I am my own burial mound and the ancient pit of my end.

I am a warrior. I wear my breast plate proudly. The beaten gold plate protects my heart from all ravages but those of time. Time, my old enemy, who has built his sombre castle out of my ribs. Time, whose thing I am, writes on me.

What to do with the parchment? What to do with the bloody ink? What to do with the lines on my body?

The lines around my eyes are in terza rima, three above, three below. There is a quatrain at my chin and a sonnet on each breast, Villanelle is the poise of my hands. (Thankfully, there is still no trace of vers libre.) What to do with these lines?

I have raided my own body and made my poem out of his. Split Time's metre and snapped his smooth rhythms. I have learned his forms and mastered them and so become mistress of what is my own. I am a warrior and this is the epic of my resistance.

That which is only living can only die.

The spirit has gone out of the world. I fear the dead bodies settling around me, the corpses of humanity, fly-blown and ragged. I fear the executive zombies, the shop zombies, the Church zombies, the writerly zombies, all mouthing platitudes, the language of the dead, all mistaking hobbies for passions, the folly of the dead.

When all speak the same speak the poet can no longer speak. The language is rich when it is fed from difference. Where there is no difference there is no richness. There is no distinguishing among the dead.

Eat the same apples, day comes, night falls. Read the same newspapers, day comes, night falls. Turn on the television, day comes, night falls. Assert your individuality with one voice. Day comes night falls.

The world is a charnel house racked with the dead. The dead have no need of words, no desires that appetite cannot satisfy. The dead, their greedy mouths, empty, their tongues torn out and hung up to dry. The dried-out shrivelled-up babble of the morgue. The sealed room where the same old words are everyday tortured and killed. They are happy with their dead words. What words they cannot kill they can ignore. The Word ignored. The Word unspoken and unheard. The unknown word that is, in its own tongue, a foreign tongue. The word in exile, locked in the crumbling palaces of the past, its glories faded, its supporters few. The word woven in the

tattered arras, a royal motto in a republic. The word was dressed in gorgeous stuffs, the word due homage. The word that walked ahead of princes, the word of power; Bible and Law. The ennobling word fit to dub a mouth a poet.

Delicate words exhausted through over-use. Bawdy words made temperate by repetition. Enchanting and enchanted words wand broken. Words of the spirit forced into the flesh. Words of the flesh unlovely in a white gown. Slang in a sling shot hurled and hurled and hurled. That is the legacy of the dead.

The dead are on their way to work, grey limbs rubbing together in an open grave, stack on stack in the metal containers of car, tube and train. The grisly carriages are painted bright colours, guillotine colours of tumbril and blade, execution-bright. Each man and woman goes to their particular scaffold, kneels, and is killed day after day. Each collects their severed head and catches the train home. Some say that they enjoy their work.

Time mocks them but they do not hear. Their ears are full of the sports pages and the index of the *Financial Times*. Time sits in their ribs and mocks them but his language is old and they do not hear. Time does his work and leaves his manuscript for the worms.

Why do the dead give up life? Pawn the hours that cannot be redeemed?

FOR SALE: MY LIFE. HIGHEST BIDDER COLLECTS.

Hand to hand combat between the living and the dead. Mouth to mouth resuscitation between the poet and the word. Kiss me with the hollow of your mouth, the excavation where the words are dug, the words sanded under time. Kiss me with the hollow of your mouth and I shall speak in tongues. Her kiss; to caress or salute with the lips; of billiard balls that touch while moving; a drop of sealing wax.

Her lips are grape-red, not ready, always promising. The full harvest is still months away. I fear frost, I fear hail, I fear mildew and blight. I fear I will be sleeping when the sun rises. Let the sun rise. Let it be the day when she ripens at my hand.

Why do I long for another turn of time? Why do I want the clock to go faster when my life depends on holding back the hands? Why? I want to kiss you.

Kiss me with the hollow of your mouth, the indentation of desire. Kiss me with the pulled-apart open space, demolition of propriety, rebuilding of a place of worship among an upright people.

Kiss me on the green baize where I play you like a game.

She kisses me. The words that there are, fly up from her lips, a flock of birds cawing at the sky. An engine of wings migrating through the world but she makes her home in me.

Her lips form the words. She scalds me with them. The cold, clear mould of her, melts, and gives way, she pours the warm honey of a long night's work.

The word and the kiss are one.

Is language sex? Say my name and you say sex.

Say my name and you say white sand under a white sky white trammel of my thighs.

My mouth on yours forms words I do not know. Shall I call your nipples hautboys? Shall I hide myself in the ombre of your throat? The rosary I find between your legs has made a bedesman out of me. What of the Hermes of your Ways? I part you like a crossroads and fear the god of eloquence and thieves. When you kissed me, my heart was in my mouth, you tore it out to read it, haruspex you. Leave me as a sacrifice to the rhytos of your hair.

Time: Change experienced and observed. Time measured by the angle of the turning earth as it rotates through its axis. The earth turning slowly on its spit under the fire of the sun.

Time has skewered me through. I am the shadow that marks the sun dial. I am the hands of the clock. I am the clapper on the bell, the tiny body thrashed from side to side, clinging to the swinging wild bell. Dizzy overturning Time, giddy, leering fairground Time. The pleasures and illusions of the free ride on the Ferris wheel. The view from the top in the painted car, the sick drop down. The wheel turns. Roll up! Roll up! one place left! The people in front wave at me and plunge away. The people behind I hardly know. Do they see me? I doubt it. The cars are hinged from view. Get in with me. Hold my hand. Does that help? Not much.

The fairground man has a familiar face. 'I'll see you at the other side,' he says, and shuts the metal bar across the cage. THEY'RE OFF! His upturned face blurs. For those of us on the wheel there is only the wheel. The swinging up, the long deceitful pause, the sudden falling away. That which is only living can only die.

Time turns me under the sun but I can turn the sun through time. Here, there, nowhere, carrying white roses never red. Mitylene 600 BC, the city 2000 After Death. All art belongs to the same period. The Grecian drinking horn sits beside Picasso's bulls, Giotto is a friend of Cézanne. Who calls whom? Sappho to Mrs Woolf – Mrs Woolf to Sappho. The Over-and-Out across time, the two-way radio on a secret frequency. Art defeats Time.

I get caught in my own past. I see other people acting out long dead roles. I want to put out my hand to stop them before it is too late. Too late. Does my hand pass right through them? They can't read my work and they don't notice me. There are problems with being a long dead poet; not least being still alive. The artist dies but not the art, not even when so much of it has been destroyed, word of

mouth passes it on. Impossible to silence me. I have been speaking through so many life-times and I will speak through so many more.

Go home Sappho? Jump into the wide-necked funnel of the present and slip through the gaps in history. Go back to the high harbour rocks. Go back to the flat sea. Go back to where the words began and throw them up through time until they catch in a new mouth and speak again.

GO HOME SAPPHO. The graffiti on my house wall. I live in a bullet. That is, a house locked in a tough steel shell, to keep out squatters, like myself. A steel door, steel windows, steel plates padlocked over the toilet and the sink. A steel clamp round the water main and a steel box guarding the electricity supply.

Where there is no ugliness there is no fear and this city thrives on fear. The city is old and patched. The city is modern and brash. The genteel city in quiet decay and the bully boy city, not alive, but hyperactive.

There is another city too, but we don't like to mention it, because officially it doesn't exist. People vanish everyday. That's where I live.

The invisible city is a monkey's collage of materials that don't match; concrete blocks and corrugated roofs, Georgian brickwork painted orange to show that it has been condemned. There are walkways fifty feet in the air, wind traps, death tunnels, rat connections to monoliths made of mono-stone. Where there used to be narrow streets and roomy squares there are now the favourite throwaway lines of People's Architecture.

The plate-glass obsessions of smart retailers have had to give way to boarded-up hatches crude-nailed below dead neon signs. I buy my goods (goods, what's good about them?), through a plywood hole from a severed hand. The hand takes the money, passes out the frozen meat, the dead go and eat it to nourish their frozen hearts. I work hard to keep warm.

GO HOME SAPPHO. It's true, I do have a lot to answer for, all those imaginary seductions in the flesh and on the page. Don't you call me a Sexualist? Then I have to practise what I preach. I call myself a poet, I have to invent what I practise.

After loss of Identity, the most potent modern terror, is loss of sexuality, or, as Descartes didn't say, 'I fuck therefore I am.'

Why do you ask me about my lovers, one, two, twenty?

Why do you visit a lost island looking for me?

Why do you say 'When was that day when the sun splintered the clouds and broke the light in shards on her head?'

There's no such thing as autobiography there's only art and lies.

Sappho, passing through the dark streets, leaving no footprints, no trace, looks ahead and doesn't see herself, sees no evidence of self. There are no plaques to say where she has been. Where has she been? Here? There? Nowhere? Carrying white roses never red.

Her body is an apocrypha. She has become a book of tall stories, none of them written by herself. Her name has passed into history. Her work has not. Her island is known to millions now, her work is not.

Sappho, passing through the dark streets, leaving no trace, no footprints, looks ahead and does not see herself. The history of the future has been written and her work isn't in it. Where are her collected poems, that once filled nine volumes, where are the sane scholarly university texts? Sappho (Lesbian c. 600 BC Occupation: Poet).

It was a long time ago. The fish-swelling sea and the boss of the sun. Between her eyelids the sun is still caught. When she presses her fists against her eyes, the sun prints starfish on her retina. She can see herself reflected in the water, the waves breaking up her image, carrying it in pieces across the sea.

It was a long time ago. Longing belly-swelling under the sun. She had a daughter called Cleis. She lay on your sunned body as a lizard lies a rock. She didn't blink, she never closed her eyes, she kept her eyes open while she loved you. Did she write to please you? She wrote to please you as the sun pleases the water where it falls.

Shine on me Sophia, purge me clear and white, burn the dead places and quicken the live. A fish jumps in the pool.

Love me Sophia, through time, beyond the clock. Help me forget my life.

Sappho, passing through the dark streets, leaving no footprint, no trace, saw two women embracing in a doorway. What were their names? Andromeda, Atthis, Dicca, Gorgo, Eranna, Gyrinno, Anactoria, Micca, Doricha, Gongyla, Archeanassa, Mnasidika . . .

It was a long time ago.

I thought I saw something tonight. It was some time between 4 and 5 am, after the last drunk and before the first bird, the happy hour when even the supermarkets observe a small raft of silence. I like to walk through the city then, square-inch-packed with wasted life, mile by mile government deserted. This is a place to be alone.

Nobody talks, and if they do, it's knife talk or money talk, please don't cry for help. Please don't cry.

You won't will you? It's a physiological fact that under torture it is not possible to cry. 'She shows no remorse. Stab her again.' This is the desert. The damned circle of the dry. Please don't cry. The government has offered the private sector a gold-plated watering-can to refresh the city. Over there, by the last Queen Anne house, marooned by the stockyard, gaoled by the crane, they're going to build a cancer hospital and forty-five period residences for the terminally ill. Wonderful. Think of the jobs. The cleaners, the patrol guards, the night staff, the bedpan swillers, the dog handlers, the driver that brings the sterilised dressings, the operators that hygienically dispose of pancreas, bowel, stomach, voice box, liver, bone. One man's raddles are another man's pay. They are calling the scheme Prometheus.

I looked at the house, dark, a face turned away, but then I thought I saw a face turned towards me. A woman, slender, without means, balanced on the thin ridge of the house. Beside her, the winking red warning lights of the stockyard crane, behind her, the rose white moon.

Sappho, standing under the street lamp in a wide skirt of light, thinks she hears the sea dashing at the kerb, thinks she hears the wind through threadbare sails. But it is only the wind blowing the litter, only a leaky cistern above her head, what will remain? What she hears or what she thinks she hears? What she sees or what she believes she sees? After all, what does she see, but an arrangement of molecules affected by light, what does she hear but a story of her own?

This is what I saw. A woman, naked-painted, in camouflage colours. Orange against the sodium lights, purple against the livid sky, gold against the lure of money, silver-dabbed for luck.

At her head, the band of Orion in three stars, faithful dog-point, alert at her heels. She broke up the flat land in rock-erupted earth. She stood over me in judgment. Her hair a flaming sword.

She was branched as an olive tree, the weight of her, the spread of

her, arms outstretched, the much supported on the little. She was half-turned, the trunk of her smooth-whorled. Her hair was thick with leaves set fire. She was Daphne in green flight. She was Apollo in golden pursuit. The Chaser and the Chaste.

Aphrodite, goddess of desire, rise naked from the foam of the sea and riding on a scallop shell, come here, where grass and flowers spring from the soil at your feet. Doves and sparrows accompany you in the air.

Sappho hears the sea, hears the wind in threadbare sails. She travels time in a new-moon boat.

Sappho knows desire, knows the blood-abandoned body, knows the loss of courage in her limbs. She knows the single look that bids her gaze.

Down on the dirty pavement Sappho looked up. She was looking at a cliff bent over the sea, she was looking at her body bent over the cliff. The hard white drop and the unforgiving sea. Not for love of you Phaeon but for loss of her. Not once, but many times, for loss of her. ('The poet Psappho, for love of Phaeon the Ferryman, who spurned her, flung herself from the cliffs of Lesbos, into the dark Aegean sea.' Ovid, Roman 43 BC – AD 17 Occupation: Poet.)

The bone-white body broken beside the cuttle-fish sacred to Aphrodite. The bone-white body and the white cuttle bone. Bone and black ink and the dry sands of time. The writer and what is written. Sappho (Lesbian c. 600 BC Occupation: Poet).

This is what I saw.

A woman balanced on the edge of a parapet, her arms pulled out in long wings. She had feathered her fear, wrapped a borrowed plumage around her heart. How else could she escape when her dark house was fastened and guarded, deception of windows and doors?

She had been bricked around with lies, cemented in with falsehoods, the wide wooden staircase had rotted at her feet.

There was no escape except by the route which could cost her life. Accordingly, she costed her life, and found it to be worth more than deep carpets of lies and the airless rooms, she called Home.

She made wings out of feathers she found. There was nothing in the house that she could use. She made wings and strapped them to her, a fancy dress of bravado, war-paint against fear.

Jump. She must jump. The heavy body in the unweighed air. She would use her own heart as a baroscope. Calcium and water v. Nitrogen and Oxygen. The inhospitable element and the object of her desire.

Her opening aileron makes a pause in the too smooth current that bears her down. For a moment she can hover à la belle étoile. She told me her name was Montgolfier but she spelt it ICARUS.

Wind enwomb her. Make her a thing of air welcome in air. Make her bones breath, make her liquids into vapour. She must take the current on a confidence of wings.

If I call her will she answer in a long swoop through the trees? Fold her glory at my wrist? If I call her will she fly in equidistant mean, not risk the burning sun, nor the swamp of the sea?

Balanced on the primaeval ledge she waits for the gift of tongues. She is a howling belly before the coming of the Word. She has no name for night, no name for day, no name for the things she fears. Nameless things possess her.

The Word calls her. The word that is spirit, the word that is breath, the word that hangs the world on its hook. The word bears her up, translates the incoherent flesh into an airy syntax. The word lifts her off all fours and puts a god in her mouth. She distances up the shrunken world in a single span of her tongue.

The wingèd word, Hermes, god of Eloquence and Thieves, Mercury, to give him his Roman name. The fleet-footed spreading word that learned divination from the Thriae on Mount Parnassus. The word amongst the pebbles in a pool. The male drill in the female stock, the art of making fire, fire by the rapid twirling of a stick in a stone. The word made out of fire and fire from the word, Sappho, 600 BC, or call her Hermaphroditus? The boy-daughter, girl-son, the male drill in the female stock, born out of a night of lust between Hermes and Aphrodite. The boy-daughter, the girl-son, the union of language and lust.

This is the nature of our sex: She takes a word, straps it on, penetrates me hard. The word inside me, I become it. The word slots my belly, my belly swells the word. New meanings expand from my thighs. Together we have sacked the dictionary for a lexigraphic fuck. We prefer to ignore those smooth, romantic words, and dig instead for a roué's pleasure. The mature word, ripe, through centuries of change, the word deep-layered with associative delights. The more the word has been handled, the better we like it. For me, the perverted challenge of re-virgining the whore. Aren't we a couplet? Two successive lines of verse that rhyme with each other? Press your eye to the keyhole and you can see us, one on one, swiving at the perfect match of dactyl and spondee. The coupling-box where we must make ends meet. My well-coupled filly, me, her rider in mid-air.

See me. See me now. I'm not a r(R)omantic, I'm a true C(c)lassical. I don't believe in love at first sight. I'm not falling for you, but one step forward, and you might fall for me.

What things fall?

Once, an angel, leaping out of heaven to find new worlds, his hands snagged on a zigzag of stars. Lucifer, whose cuts bled light . . .

The thunderbolt, Zeus-hurled, through the timid clouds, the comet's head, nuclear discus gold-thrown.

The Dead, down to Tartarus, black poplars by a black stream. The black shaft smooth-sided and the jag-toothed dog.

Icarus, the flying boy, his body sun-glazed. His sun-glazed body that shattered the glassy sea.

Autumn. Long leaves of bright undress.

Hermes. Star-spurred.

Fall for me, as an apple falls, as rain falls, because you must. Use gravity to anchor your desire.

She fell like a choirboy on a stave of lust. Head back, throat bare, breaking body, breaking voice in an ecstasy of praise. Praise out of the mouth and out of her thighs, aesthetic and ecstatic in a garment of flame.

Pull the shirt over your head, drop it, drop into my arms, lovers have no need of time. Aphrodite murders Cronos. Drop through the long cylinder of our hours. Ours this time not Time's. Here, there, nowhere, carrying white roses never red.

There was no colour in the sky when she walked along the beach.

The white shells sea-glazed shone. She put one to her ear and heard the strange moaning of the sea. She looked out to where the light skimmed the water. The light that balanced on the narrow crests of the waves. The light that tumbled in the water's concaves.

The light whipped up the dull foam and threw it in petals over her feet, her feet glassed in by the shallow water. The water, dashing the past at her feet, the water dragging her future behind, the hiss and pull of the waves.

Driftwood on the sands. She picked up a wedge, too light for its size, its substance beaten away. It was only the past, a hollow thing in her hand, only the past, but a shape and a smell that she recognised. The comfortable old form its uses dead.

Clouds in the sky. She wanted a view but the clouds were pretty. Vague, pink, well known. Weren't driftwood and clouds enough? Memories, and what she still had, enough? Why risk what was certain for what was hid? The future could be just as yesterday, she could tame the future by ignoring it, by letting it become the past.

She began to run. She ran out of the day that coiled round her with temperate good sense. She ran to where the sun was just beginning the sky. A thin rung of sun within reach. She leapt and grabbed the ladder bar with both hands and swung herself up into the warm yellow light.

The train was crowded. Is that Sappho, both hands hanging off a neon bar?

Picasso

P 'Ruggiero, surely, he is not a Gentleman of the Back Door?'
It was night, Doll Sneerpiece sat by the candle. Ruggiero had not come. Why had he not come? There could be but one explanation and the Doll was explaining it.

'If his pintle will not stand for me then for whom?'

The Doll had seen Kings and Bishops stand before her and she had most submissively knelt before their stand. She had held the royal sceptre and the less seen crown. She had pumped the Bishop's Pomp. Her skilful fingers were as celebrated as Arachne's. Her Top and Bottom hatches the toast of His Majesty's fleet. In her presence there was not a man whose nethers stayed unmoved.

'Not a man' said the Doll, 'But a Molly?'

Lady Cleland, the Doll's friendly rival, ran a Molly House in Gun Street. At The Cock and Gun, dress code was strict; bosoms, bodices, laces and stays disguising the breeches beneath. It was a pleasure house for those whose delight was not found in the opposite sex.

Ruggiero in a Buggering Den?

Slipping aside the young lad's shirt, he exposed to the open air those Mount Pleasants of Rome and all the narrow vale that intersects them. First then, moistening well with spittle his instrument, to make it glib, he pointed it, he introduced it to writhing, twisting and soft murmuring complaints from his young sufferer. At length, the

first straits of entrance being got through, everything seemed to move and go pretty currently on, as on a carpet road, without much rub or resistance; and now, passing one hand around his minion's hips, he got hold of his red-topped ivory toy, that stood perfectly stiff, and showed, that if he was like his mother behind, he was like his father before. This he diverted himself with, whilst with the other he wantoned with his hair, and leaning forward over his back, drew his face, from which the boy shook the loose curls that fell over it, in the posture he stood him in, and brought him towards his, so as to receive a long-breathed kiss. After which, renewing his driving, and thus continuing to harass his rear, the height of the fit came on with its usual symptoms, and dismissed the action.

Doll Sneerpiece closed the book. Ruggiero, a Gentleman of the Back Door? Ruggiero, preferring a leg of lamb to proper English beef? Ruggiero, importing Turkish wares to an honest English stall?

'Well then,' said the Doll, 'If it is Sodomy he wants, then a Sodomite he shall have.'

'Very Right. Very True.' said Miss Mangle sucking on the Hookah.

This was a breeches Doll, a periwig Doll, a Doll with a flowing shirt, a turned-leg silk-stocking Doll. A tri-corn hat and buttoned Doll. A Doll with a fine moustache and a military swag. A well-packed codpieced dildoed Doll.

'I am ready for that Reversing Buck,' and she left the house as midnight entered it, both by the back door.

'Now,' she said 'I am a proper Bradamante' and without a second thought she swung through the gateway to The Cock and Gun.

Picasso closed the book and put it down quickly. It belonged to the man sitting nearby. He had fallen asleep and she had seen the strange

fat square volume that attracted her hand with a power of its own. It had no cover, it was not a book she recognised. What was it? Eighteenth-century pornography? The man stirred, Picasso moved back to her seat.

She looked at him. He was perhaps fifty, a man who carried his age rather than bore it, and what he carried he did not try to hide. He was white at the temples, creased in face, his closed eyelids slightly thickened, a purple sheen over the brownish skin. But he was delicate, haughty, light-looking, a Purple Emperor butterfly asleep on a grey seat.

His hands were conical-shaped with long thin fingers that betrayed unusual strength against the obvious sensitivity. His fingers twitched as he slept and Picasso thought of snakes.

His body, even beneath his shirt and loose trousers, was more of bone than of flesh. He was anatomical, an object lesson on the rough bench of the human frame. She thought of him at the autopsy; the neat fibrous squares being cut away from the simple skeleton. The teeming symbiosis of muscle and nerve, tissue and fluid, hung in complex on that obvious rack.

The bolts of his collar bone moved her. What if she drew back that tight throat to expose the thyroid cartilage, his Adam's apple, that warned them both that he and other men had been vulnerable before? If she stretched out her hand to offer him fruit would he take it?

They stood in the garden together looking at the tree. The green tree lit with red globes. She said, 'Eat it and you eat the light it gives, a lantern in the gut of Man to read himself thereby.'

She held it out in her glossy fingers and he thought of snakes.

Handel struggled in his dreams.

His throat was emphatic, bare-cast. He had a singer's throat, self-expressive, the arrogance of something well-done and beautiful. He

was not beautiful, he was too spare and restless for that, but his throat and his hands were his advocates. A woman could love him. She guessed he was desirable to men. She sighed. What was desire? Certainly not the safe excursions into family life. Had her mother ever desired her father? Was her father, fat, greedy, cruel, desirable? He had had nine mistresses and was active with his tenth. Did she put out her hand, glad only of his skin? Did she loathe his text-book six inches wedged in his spreading mottle? Picasso thought of her brother and his angry Prod that punished her for being lovely, clever and quick. Under his insistent tutelage she had learned to be shy and slow. She had learned to hate her body because he said he loved it.

She did not hate it now. She feared it, was a stranger to it, but she did not hate it and she wondered if she would ever feel the acute sensuality she saw in pictures. Things of canvas and paint, not flesh and blood, they told her of a fire she did not know. She would find it or light it in herself somehow even if the coals were her bones and her heart the kindle. What was it St Paul had not said? 'Better to burn than to marry.'

She imagined making love to this man, his gentle weight and stringed fingers, she wondered if she would enjoy his clean, shaved skin sanded with expensive astringents? He was very smooth and she sensed this was an effort. Was he a vain man? Would he be vain in loving her and need to prove himself and his superiority with each careful move? Making love. Another of the sick semantics of family life. What had the love to do with sex and what had the sex to do with love? She felt lust for some people, affection for others (disgust for even more), but even when lust and affection grew together was that love? And if they were apart did it matter to pretty up one and overstate the other? She had been told that many women looked at a man and wanted to have his children. She could understand that but then marriage became survival and economics with a dash of

primaeval mystery thrown in (or genetic recognition as the scientists call it). Could genetic recognition and a bank account truly be hailed as the cornerstone of all that is Good?

Through the train window Picasso saw the cemeteries of the Dead. The box houses in yellow brick, each fastened against its neighbour. In the cold air the sulphurous walls steamed. There was no sign of life. If she could have looked in what would she have seen? Rows of scuffed couches identically angled towards the identical televisions offering, courtesy of the bold white satellite dishes, 45 different channels of football, news, comedy, melodrama and wildlife documentaries. Her own mother and father were no better, only, their sofa was leather and their television was concealed behind a sliding panel in the wall. The panel was a mural of Christ turning the moneychangers out of the Temple. Sir Jack never took his wallet to church.

Although there were many more divorces than previously had been known there were many more marriages too. No sooner had one pair hastily slashed the knot than both parties were rushing to re-tie it with a new bit of string. Down the aisle they went, for better for worse, for richer for poorer, in sickness and in health, 'till Death us do part'. Death did part them; dead to feeling, dead to beauty, dead to all but the most obvious pleasures, they were soon dead to one another and each blamed the other for the boredom that was theirs.

In the new Church-abandoned morality, a curious hierarchy of values had asserted itself. The serially monogamous, as the magazines called the marriage junkies, were a step up in virtue from any couple who either would not or could not marry. The unmarried, however faithful, were at least two steps down from the man who kept his wife but enjoyed his mistress(es). He in his turn believed himself superior to the divorce statistics. The Church looked on.

Under the firm hand of the new Archbishop, himself a twice-married accountant, the fully privatised disestablished Church of England charged for weddings, funerals, communion, counselling etc. They were doing well. Picasso had sometimes gone to church to sit in an empty pew to listen to the God-fled monotone of the anecdotal vicar. The hail-fellow-well-met-shallow-hearted-dull-brained-cost-effective-worldly-wise-over-weight-ill-read-ill-bred-golfing vicar.

She remembered the time when she tried to speak to him, and tried for two weeks before she could get an appointment, and the day and the hour had come and he was busy. She had gone over to the lectern and read the Lesson, and read on past John, 14 through chapters 15 and 16, while the Vicar talked fund-raising with his Bank Manager. She was afraid.

(Let not your hearts be troubled. Neither let them be afraid).

Yes, he had five minutes to spare before his dinner, would she like to tell him her little problem while he got changed?

(Come unto me all ye that labour and I will give thee rest).

Would the Vicar ask her brother Matthew to stop molesting her? (Ask anything in my name and I will do it).

Horseplay? The Vicar couldn't interfere in a bit of horseplay . . . she had a loving family, she should be careful, very careful what she said . . .

(Indeed, the hour is coming when whoever kills you will think he is offering service to God).

She showed him her bruises.

(A new commandment I give unto you; that you love one another as I have loved you).

He patted her on the back. He understood. Every family has its problems. She should talk to her mother, yes, talk to her mother. Matthew was a good boy at heart. He played the organ.

Picasso had a slight limp. Years ago she had thrown herself off the parapet of her house. It had been Christmas and she had been saved from death by a deep bank of snow. Still she looked down and remembered it. How could she forget when the day and the hour were written on her body?

Couldn't she have talked to her mother? Couldn't she have talked to her father? Her father had said 'You must earn my love' but no matter how hard she saved up she could never afford to buy it. The opening price had been steep enough; but, Sir Jack was a man of business and the price grew steeper as the goods were more desired. He wanted her to long for him.

She wanted to love him but when she ran to him with her arms open his hands were full. 'I'm busy' he said 'Can't you see I'm busy?'

She dropped her arms and learned to keep them by her sides.

'If only you were more affectionate,' said her mother, buttoning the rigid body into a stiff frock.

At night her mother pecked her on the cheek as hens peck at their food. Her face was a dirt yard where hens peck.

'Why don't you smile like other little girls?' Her mother's beak came towards her, 'Come on darling, do smile.' Picasso did smile. She learned the rictus of the jaw that indicates pleasure in the female sex.

Years passed.

One night, after Matthew had torn at her body as crows do lambs, attacking the soft fleshy parts and leaving the creature alive, she had got out of her wet bed and tried to dry herself in the night air at the top of the house. She was naked. Naked when the ambulance men found her. Naked she remained for most of her stay in the psychiatric unit of St Sebastian the Martyr, private hospital for the mentally ill.

Matthew went to Sandhurst.

It was morning. The pale light behind the pale blind stretched the woven fabric. The woman could see the nicks in the canvas and the flaws of the stitching and behind the blind the frantic shadow of a bee.

The pale light warmed. The pale light became yellow of primroses, became deep daffodil yellow, easter yellow in ovals on the floor.

It was spring. The light blared out of the trumpets of the daffodils and ranked the path with tulip horns. The birds sang through the light but the light was louder. There were drums of light in the room. The naked woman watched the uncontained light. Loose unshaded light that fell out of the sun on to the houses into the gutters over the streets to slab the pavements yellow. A man walked by in a golden suit.

The light unpeeled the brown streets. There was new paint on the doors, men came and swept and swept and swept. The woman took a brown broom and swept her room. As she swept she painted. Each stroke of the brush drew the yellow up against her feet. Her body, in graceful motion, pulled the light with her as she went. Was she sweeping or painting or punting down a yellow river with the sun on her face?

It was a long time ago. Picasso had been released into the community, welcomed back into her family. Her mother cared for her. Together they went shopping in the village.

Les hommes sont tous condamnés à mort avec sursis indéfinis. Picasso had come back from the dead and she wanted life. She wanted to force life through the hour, to make it yield up its secrets, to waste no days of her reprieve in a self-built tomb. How much time did she still own? One year, twenty, fifty? The clock ticked as it

always had but now she could hear it. Would it make any difference to her if the fiery finger on the wall wrote, one year, twenty, fifty? If she knew the date and the hour would it alter what was left? What is left? What was ever there? Is life any more than a slop bucket of accident and confusion? The freedom of the individual is the freedom to die without ever being moved by anything. What can pierce the thick wall of personality; your voice, your hand, a picture, a book, the sweet morning air? Myself imprisons me. The lead shield of my habits, that heavy, soft bluish-grey dead defence. pb No 82 of the Periodic Table, that useful list of contents that includes at no 26, Fe, the iron in my soul.

How to escape my element? First, run away. Objections from Family Life as follows:

- 1) You'll be back.
- 2) Don't think you can come back.
- 3) Running away never solved anything.
- 4) You can't manage on your own.
- 5) Where are you going to go eh?
- 6) I suppose you think it's different out there?
- 7) What's wrong with this house?
- 8) Not good enough for you here?
- 9) What's wrong with you?

Answers to the above.

- 1) no.
- 2) no.
- 3) yes.
- 4) yes.
- 5) ?

- 6) yes.
- 7) this house.
- 8) no.
- 9) Pantophobia.

Fear of everything. Fear of everything keeps me sealed up against everything. I fear the coloured world on my neutral body. I fear the bright red sun and grass matt green. I fear the cows whose black hides reflect purple. I fear the brimming blue that bees love. I fear the thirteen yellows and the madness of Van Gogh. I fear the sunflower, the straw chair and the boots donkey brown. Every moment intensity collects on the tip of experience as leaves collect rain. The moment swells, bursts, is gone, and passes unnoticed. Intensity dripping away, the moment gone. Isn't that the science of life?

I do notice but I turn away. I turn away from the sharp points of beauty that arrow me through. Sharp beauty able to pierce the thick purple hide. I am in hiding from the slings and arrows of outrageous beauty. It is outrageous that there should be the sepia fox on the tones of snow, his brush sudden-red, his brush shed-blood red on the unmarked snow. Behind him, the Chase, the horses in thick vapour, their mounts half risen in perpetual action, the pink coats and the golden horn that lose their colours in the early setting sun. Dusk frees the fox. The badger wears his night-stripes and snouts among the stars.

Nature is excess. She is beyond the mean. A single rose-hip bursts in praise. What to do with rain, with snow, with sleet, with leaves, with comets, with hail, with lightning, with apples, pears and plums, nature shaking out her excess, the gravity-delighting objects that spill around my head?

Get an umbrella. A folding pocket-sized all weather friend to

bounce off the booming world and keep me dry when I should be drenched through. Shall I be dry? Dust-dry, dried flower neat, pressed and labelled, in the right section, saved from moisture and rot. I can live like that, under the rim of consciousness, in the nylon shelter of my own thoughts, safe from beauty's harm. I think therefore I am. Does that mean 'I feel therefore I'm not'? But only through feeling can I get at thinking. Those things that move me challenge me. Only a seismic shock can re-order the card index of habit, prejudice and other people's thoughts that I call my own.

In spite of fear, there are talismans I keep, pebbles I turn over in my hand. Remembered stones whose mineral surface is pocketed with gold.

Autumn in a London square, the still-hung air round the Yew, pink-barked. A terrier routs the leaves. The black-yapping dog and the Yew pink-barked. Dog, Yew, the plane tree leaves in piles of tan and the café where the coffee steams.

I bought a cup, burnt myself, but glad of coffee and money to buy it. Glad of the cardboard smelling steam and this small space on this wooden bench.

A woman passes and is gone. The birds take turns at the fountain. I have taken my turn at coffee, at bench, both remain, not me. Even now, when I know the moment, the moment is gone. The clock won't stop, though I do, or seem to, holding the coffee as a shield against time. I want to walk so slowly through the square, to be continually walking through the square, the dog still yapping and the Yew pink-barked.

The tourists queued outside the British Museum.

The soft air and the hard path. The air caught on the wrought-iron railings and the path buried under the leaves. An old man spiked

them away. Familiar in London squares, leaves and soft air, the last roses splashed upon the stem. A dun sparrow snatched a crimson worm. Why is it painful to me, that day, though long gone and unreturnable? Painful, so that I slow my steps on the busy streets, pausing as one who has forgotten something important. I have forgotten something important; forgotten how to look at pictures, the unpainted beauty of the everyday. This now, the quality that the artist can take, but which is always visible, if I will see. This now, itself, not the shock of the new, but the shock of the familiar, suddenly seen.

Long trains leaving. The cathedral vault of the station used to receive an incense of steam, now it makes a living sacrifice out of pigeons caught in the electricity terminals. No-one looks up at the blackened birds voltaged out of life and remnanted among the girders. Underneath the dead birds the passengers to and fro. The to and fro of tired bodies pushed on invisible lines.

But outside the train takes the cutting in a scythe of light. The crescent curve of the train mows the houses as it passes, the houses disappear behind the moon metal blade of the silver train.

The train, vibrating in its own power, as gun dogs do, rushes for the bridge as the signal goes, and splashes through the tracks in a siren of joy. A little boy leans out of the window, shouting with the double bell of the long train.

The train passes, a yellow band pulled through a black cloth. The houses spring back and take up their rightful place in the darkness. There's nothing here but bricks and dirt, but metal and dirt but habit and dirt. The 5:45 to the suburbs.

There is more; a lean of beauty as the train judges the bend; an arc of mechanics that allows 180 degrees of admiration between the hard metal and the curve it implies. The simple clash between subject and

style is a painterly one; the uncompromising line is made to yield to a curve. Only this defeat makes movement possible.

The curve seems to be so many afternoons, travelling slowly to the sea, the silver train towards the gold coast. The long wind back to childhood through memory, the romance of the train not killed by the 5:45. Each carriage articulated to its next, takes the bend, the vertebrae of the train that runs through my past like a rosary. So many afternoons travelling slowly to the sea; the rocking train and the rolling water. My mother smiling at the sea.

The smiling of women and the motion of great waters. These things moved Leonardo. Both at once mysterious and transparent, he took them into his paintings as things and meta-things: Madonna of the Balances, Madonna of the Lake, Madonna of the Rocks, La Gioconda, Saint Anne, Medusa, whose snake hair parts in reptile waves, sea-hue on her dead cheeks.

Leonardo who knew neither Latin nor Greek, and who described himself as an unlettered man ('omo senza lettere'), loved words and fought with them, receiving many wounds. Love wounds. There is no love that does not pierce the hands and feet. No love that leaves the lover unmarked. In later life, Leonardo, branded by words, gave up painting and worked only on his fugitive manuscripts, writing from right to left. Who knows what he hoped to find? For me, it was found already, in the fearful face of Mona Lisa, corrupt crimson on lips and cheek, faded now into a modest blush, that rises so strangely beside the sea.

The train had reached the sea. The sea caught between two legs of concrete where the ferries unloaded their blunt cargo. The convenient sea, still as a child's pony, but further out, past the hobbled water, the white-maned waves hurdled the buoys.

The unsaddled sea twice daily ridden by the moon. The 239,000 mile distant moon that daily rides the sea. Outrageous, the connections of the natural world; the planets in musical intervals around the sun. The canyons here that have made the mountains there. Even the flowers in my garden seed themselves in yours. The moved and still moving world rotating on its axel-tree. The daily death and resurrection of the self-renewing world.

I wanted to open the window to hear the sea no longer glass-paned. The tenor of the sea and the pitched gulls. The beauty of the sea in its movement and mass. The deep tidal swirls that cease as soon as it is contained.

What contains me? Fear, laziness, the opinion of others, a morbid terror of death and too little joy in life. I am shuttered at either end, a lid on my head, blocks under my feet. The stale self unrhythmed by art or nature.

Does it matter? Yes, to me, who suspects there is more than the machine-tooled life offered as a nice copy of millions of others. Won't a reproduction do? Who can tell the difference these days? There's no such thing as art. Settle for a designer suit to throw across your carcass. No-one can tell the difference between the living and the dead. And who are you to judge? This is a democracy isn't it? We're all equal now, apart from the money, all equal now. One size fits all.

It doesn't fit me.

'Why blame yourself? Why blame yourself?' the liberal consolations of the anecdotal Vicar who's missed his birdie putt.

Who else shall I blame for this drought stricken life? My mother? My father? My brother? The world?

I've been unfortunate, it's true, hard-hurt and despised. But should I tell that tale to every passer-by? Should I make my

unhappiness into a placard and spend the years left decorating it?

There is so little time. This is all the time I've got. This is mine, this small parcel of years, that threatens to spill over on to the pavement and be lost among careless feet. Lost. The water out of the sieve and the river run dry. The quietly contained sea where the waters don't break.

I want to run up the hill in the freedom of the wind and shout until the rains come. I call the rain with my head thrown back. Fill up my mouth, fill up my nostrils, soak the parched body, blood too thick to flow the channels. I will flow. Flow with summer grace along a crystal river. Flow salmon-flanked to the sea.

Why dry? Why dammed up when the hidden spring informs the pool? How to bore down to where the water is? How to cut an Artesian Well through the jelly of my fear?

I blame myself for my part in my crime. Collusion in too little life, too little love. I blame myself. That done, I can forgive myself. Forgive the rotting days where the fruit fell and was not gathered. The waste sad time. Punishment enough. Enough to live wedged in by fear. Call the rain.

Call the rain. Drops of mercy that revive the burnt earth. Forgiveness that refills the droughted stream. The rain, in opaque sheets, falls at right-angles to the sea. Let me lean on the wall of rain, my legs at sea. It is giddy, this fluid geometry, the points, solids, surfaces and lines that must undergo change. I will not be what I was.

The rain transforms the water.

Handel

Male lions of course. Why, when we compliment our women, do we compare them to the male beast? Lion hair, eyes of peacock blue, a swan's neck (the male's being longer and whiter), panther grace, skin soft as antelope hide. I had an Arab acquaintance, a homosexual as it happens, who told me that the male antelope is the softer. The female coarsens through breeding. 'Isn't that so?' he said, as we were walking past the Maternity Ward.

Men prefer one another, I am quite sure of that, women are a kind of indulgence. I don't expect my Arab friend to like them, he doesn't, but I find it odd when my heterosexual friends don't like them either. My colleagues don't like their wives. They do desire their mistresses. Other women do not come within the scope of their consideration. There are nurses, mobile bedpans, we call them, and there are an increasing number of doctors who are women. Fortunately most of those remain in the lower ranks, either out of vocation or family ties, I say fortunately and I mean fortunately for them. Consultants are not well mannered except to paying clients. I work with a man who always asks the women whether or not their breasts get in the way of the stethoscope. They blush, he laughs, slaps me on the shoulder in that chummy conspiratorial way, 'Handel will see to you,' he says. 'Best pruner in the business.'

I do apologise. I do apologise. I do apologise . . .

'Will you stop saying "Sorry", Handel? They are the ones who are supposed to be sorry. That is what they have come for, to say sorry, this is Confession.'

My priest despaired of me. It was his duty, my training, that we should sit side by side in the little veiled box that separated us from the penitent by a thin lattice of sin.

'Father I have sinned.'

'Sins of the flesh or sins of conscience?'

'Sins of the flesh.'

Yes, always sins of the flesh, nobody has any conscience.

'Begin.'

Those long Friday afternoons, the stories the same, no matter the teller always the tale. No evidence there for the individual life. Shop lifting, wife beating, work dodging, betrayals, infidelity, infidelity, infidelity, the common denominator crime. The men bragged, it was in their voices, the women trembled and cried. There was one, I remember, a sparse woman, with whom the priest was particularly harsh. What had she done but take one night to make sense of the space between her legs. The neglected space where her child's head had been, where her husband's pleasure had been, the thing that had become the drain to let out the gin.

She said 'I don't love him but I had to have him. I've never wanted a man before, not like that.'

'I'm sorry.'

'What if my children find out? What if my husband finds out?'

I didn't say, 'Your husband comes here to relieve himself on me every Friday, just as he goes to relieve himself on a prostitute every Thursday pay night.'

I said 'You must never see the man again. Pray to God to help you.'

She said 'My body thinks of him.'

I thought of her body underneath his hips. 'I'm sorry.'

My priest and I walked with long strides through the Seminary's covered avenue. The wind blew back our skirts, revealing socks held up by short suspenders, and long-toed lace-up shoes. I watched our feet hit the flagstones in four beats, each to the rhythm of the angry priest. He lectured me on God's Will for Humanity, not seeing it in the cloud-cracked sky where the sun tipped out in a golden yolk. Not seeing it in the huge trees wind-thralled. God's will, this small blue planet. God's will that we are spirit in skin and bone.

'She sinned greatly.'

Did she? What if I had told her to give thanks for her feelings?

To give thanks for her body, his body, their pleasure? Would she have loved God more or less?

I did not say this to him, for whom the wind blew or did not blow. For whom the sun shone or did not shine. He was talking to me about erections, about controlling his erections, and I wanted to say 'Damn it man, she wasn't talking about an erection, she was talking about the most intense moments of her forty-two years.'

Why had she been sitting in a booth telling a twenty-five-year-old virgin boy about that?

What does it say in my notes? 'To understand the problems of his flock the priest need have no experience of them. He has the authority of God.' What about the imagination of God? Mozart, dear, drunk, divine Mozart, would have made a better priest than me. I sat alone, in my darkened room, the shaded lamp behind me, and listened to the close of *The Marriage of Figaro*, where the Countess Almaviva offers forgiveness to those who have least reason to expect it. Forgiveness. And I?

I did not succeed as a priest. Gone the humble desire to take my medical bag and a missal to the heathen sick world. I lacked authority. I lacked imagination. It is so easy for the Voice of God to sound just like my own, plus forte. I am entirely justified by the Scriptures, but the odd thing is, so is every other Catholic I know, liberal or strict. I do not wish to be unfair to Catholics, what I say is true for Jews, Muslims, Baptists, Methodists, Calvinists, Evangelicals, Jehovah's Witnesses, Seventh Day Adventists, and ordinary bigots everywhere. The accommodation of the Scriptures is a marvellous thing. I have not lost my faith in God but I long ago lost it in men.

And women? Look at her, slender as the reeds of Solomon, her hair in Absalom trails. What to do with beauty? I have never been quite sure . . .

My mother, between the hours of three and four o'clock, said to me, 'Handel, when we meet a beautiful woman, you must compliment her, but never intrude.' What can I do? A compliment is an intrusion nowadays isn't it? Women don't want to be beautiful, they want to be barristers and medical men. At least in the Catholic Church they won't be priests. Shall I say that to her? Shall I lean forward and whisper, 'Miss, there is so little beauty in the world that we can't afford to lose yours.' Already my face is slapped. She wants to wear a ridiculous curly wig and shout 'OBJECTION!' at a lecherous and senile judge, who, if she is lovely, will privately believe that she is perverting the course of justice, and take against her in his heart. Why does she want to thicken her ankles pounding hospital linoleum? Why does she want to pilot Concorde, be a Member of Parliament, ruin herself up the north face of the Eiger? Why does she want to succeed in big business when succeeding in big business will rob from her the time allotted, in a short life, to understand something of what life is?

It's our fault, men like me I mean, we've spent so long trumpeting the importance of all that we do that women believe in it and want to do it themselves. Look at me, I am a very wealthy man, at the top of my profession, and I'm running away like a schoolboy because I can't sit at my desk even for another day. I know that everything I am and everything I stand for is worthless. How to tell her that?

The light lay on the sea. A taut white film of light, full stretched, horizon to beach wave. The light gauzed over the green sea, pale wings atomising the water, butterfly light on the spread of the sea. The light fluttered, its scalloped margins shading the rocks that made a breakwater for the fishing boats. The light rested on the bruised prows.

The light had salt in it. Cleansing light that polished the sand and pumiced its fragments to diamonds. The light abrased the smooth concrete columns of the harbour and gave them back the rough dignity of the sea. The unman-made sea and the scouring light.

What things matter? What things have a value of their own instead of a borrowed glory? Is there such a thing as intrinsic worth? It's fashionable to say no. To say a tree is only its wood, that any painting is a work of art, that journalism can be literature, that love is self-interest or that ethics are mores. It is right to question standards but wrong to assume that there aren't any. Where there are no standards the market-place obtains.

I like markets, like the bustle and the jostle, the haggling and the lies. I enjoy the effrontery of badly made goods parading as craft, I'm keen for the scent of a treasure, here, there, somewhere.

But who controls whom? Is the market for me or am I for the market? The human pig trussed up and sold in quarters off a greasy stall. Long pig, favourite delicacy of the market, never count the cost to the human soul.

In Chungking on the Yangtze River, a place where I spent some years, the peasants walk in to the town before dawn to queue to work. Arms outstretched, Madonna of the Supplication, at the mission we run there. On their knees, arms outstretched, begging for work.

Work is a long pole with my luggage dangling off it, if not my luggage, then 200 lb bags of chillies, sackcloths of rice, a row of chickens tied by the feet.

The way down to the river, where all life starts, is ricked with shallow steps. Mediaeval steps, that have served for feet since then. Feet in embroidered shoes, feet in thin silk slippers, feet in fur boots leather sewn. Feet bound for the marriage market, the bare feet of the labour market, up and down the slippery steps, the coolies, shoulder-poled.

Goods arrive this hour, this minute, every other. A babble of goods, speechful, mobile, carrier and carried indistinguishable and unshapeable, a gaudy bundle moving up the rock side.

The boats that bounce the river are both humble and grand. Each pulls to a pole sunk in the black mud. A particular and thick black mud that sucks a pony's hooves to its fetlocks. The black mud and the yellow river. The wasp drone of the small engined craft, and the deep gluga, gluga, gluga, of the diesel boat.

This is the market, but the goods cannot be sold unless the humans are sold too. The price is not high; a dollar a day, hours, dawn till dusk. In return, a shelter, two bowls of rice noodles, 3 oz of meat. That way the peasants can save a little to take back home. They shrug, 'This is the market.'

My companion, a banker, there to explain to the humble Chinese that their characters for Free Man and Happy Man, are in the West spelt Capitalist Man, said to me, 'Lesson Number One, Handel, be realistic about market forces.'

Why? Why must I? Why must I be realistic about an invention?

There is nothing a priori about market forces, nothing about the market that isn't a construction and that couldn't be deconstructed. When I question the great god of the market, my friend, who is atheist, laughs and calls me a dreamer, but his way of life is a nightmare. He is a successful man who has abandoned three marriages, who owns four houses, but rents them out, who lives mostly in an aeroplane, and when he is not doing that, he makes his home in an hotel, and looks for companionship at night. He has not taken a holiday in five years. He is a successful man. I said, 'Alan, the least of the animals can find a home that suits it, can get enough to eat, can bring up its young, play its part in the pack, and have time to bask in the sun. For a human being, the roof and crown of nature, those things are a considerable achievement. Most of us are substantially worse off than the rabbit in the field.'

There are two cities in the world where that which is increasingly desired can no longer be bought. Not happiness or love, both outside the money exchange, but space. No matter how rich I am, I can't buy it, because it doesn't exist. The gardens have long since been built over. The larger apartments have been divided. Houses, if you can get one, have yards, if you are lucky. A yard fit for a slum tenement, the dank restricted area that would have embarrassed a nineteenth-century weaver, and where a Chinese peasant would throw his rubbish. That is what a millionaire can buy in Tokyo and New York City.

I confess I have a passion for land. The slate green moors of my childhood are the geography of my heart. Hard to accept that my heart is now a National Park. What was wild is tame. What used to be unpathed, now has rustic trailways, decorated with acorns. There are no oak trees. There are cafés and restrooms every 10 miles. Pony

trekking on demand, so that everyone can discover the freedom of what was once the countryside. Why should country folk have it to themselves? This is a democracy.

It's had to be improved, of course, not the democracy, the countryside. It was simply too bumpy and rough for the average family car. Naturally, on a day out, children need regular injections of Coca-Cola followed by a good flush on the toilet. They can't be expected to squat in a hedge. The wild blackberries and nut trees have had to be grubbed up, they could be poisonous, and they don't conform to EEC food hygiene laws. Those delightful rushing streams, so quaint on a postcard, have had to be fenced off in case of insurance claims against the local authority. There is plenty of grass, but now that the sheep have been removed to facilitate public access, the grass is too abundant, and it has to be sprayed four times a year with a bomb of chemicals slung under the belly of a Cessna. No need to worry about the chemicals, unlike the blackberries and nut trees, sloes and hips, chemicals are perfectly safe.

My advice is to stick to the paths, which lead in a Dantesque descent, from the car parks to the toilets, to the gift shops, to the Heritage Museum. There they go, democratic man in his shell-suit and fluorescent kagool. As yet, city scientists have not found a way to improve the weather over National Parks.

Gleams like the flashing of a shield. The sun on the uncut slate rubbed smooth. The gleam of the land is in its rocks, the fine-grained argillaceous rocks, here, not purple or grey, but green of living stone.

The rocks cry out. The bone of slate beneath the green clothes, moss, mole soft, moleskin dense. The land ribbed with bright stone that forces its colour into the soil, into the grass, into the tough tongued sheep. Sheep that stand as hill carvings, things wrought not made, things wrought out of their own land, deep land quarried and

mined, the very depths drilled for the pitched roofs of the little houses that come out of the hill. Stone and slate connecting generations to the land and to each other.

The road is narrow at the foot of the moor. Narrow as the smoke from a chimney stack of a single house. From a distance, perspective gives the road a crazy turn and runs it upwards into the smoke, so that the smoke continues the tarmac road as a carbon ribbon, making way for the traveller among the clouds.

For so many years I shaped my course to this road; resignation of early childhood, the misery of public school, gloomy adolescence, even some manly pride, my boots ringing to the pleasure of a medical scholarship. On my left, the valley in falling curves, on my right, the moory heights.

The weather changes the moor. In fresh sun and light wind, the red fescue moves as Moses' sea; grass waves that part for me as I pass, and close up again in smooth combs. On those days the firm hills billow. The trees bend and the ground beneath them, there is only motion, nothing still but me. A rabbit runs away in the wood.

Is it because my nature is melancholy that the moor I love best is the moor drenched out of colour, slate rain on the slate land, through the open roof of the sky? On those days, the valley houses evaporate, but for a valiant smoke signal that makes a strange high column above the mist. The rain the sheep ignore undyes the hills. The washed green leaches into streams that run, not pale, but frothy and sinister over the shiny black stones. Where the trees re-inforce the reflection, the water has a green eye, and slips reptilian over the rocks. I used to follow it on its tortuous journey, until it flung itself over a crag, a perpetual suicide and rebirth in the deep pool below.

A waterfall is temptation. The sparking living power that never hesitates, but takes the impossible drop at a leap, and makes a crystal bridge for my body. Once, twice, three times, have I taken off my clothes and stood in the spray on the brink, my skin dropleted with excitement, my hair wet through. All of me wanting to risk the prismic folds and slide into the waiting water.

Why did my feet grip the bank with prehensile caution? I couldn't jump, although every muscle was tensed to jump. I didn't want to die, I wanted to know that power, the strange electric torrent and the great din in my ears.

I suffer from hydremia. Perhaps that's the reason why water draws me when I should draw water. When we lived in Rome, we had a well in our garden, I wanted to climb down it and change my name to Angelotti. Even as a little boy, I had no interest in heroics, but my mother played Puccini, and forbade me to be Floria Tosca. I learned to be silent and to hide in the well. I'm not a hero, I'm not even a chessboard knight. Trying to be a priest was something of a fianchetto wasn't it? Clever move by a poor player.

But Handel is a doctor now. Doctors save lives, doctors are important. My elder brother is a judge. I live off sickness, he lives off crime, and yet we are so very respectable. Bow down at the Sign of the Leech. Ha, Ha. I have one, you know, a wooden board that sports a jolly looking leech. I got it from an eighteenth-century apothecary shop, along with glass tubes, silver vials, lettered jars, and other fattrils of medical hocus pocus. Sotheby's sale.

I don't want to sound disillusioned but I am.

What were my illusions?

Progress. Love. Human Nature.

Shall we take them one by one, now, in the stale air of a dead train, shunted by the concrete sea?

Progress: An advance to something better or higher in development. Are human beings better or higher in development than they were? There have been many outstanding men and women in history, and, since there are now vastly more people than at any previous time, we should expect at least a proportionate rise in the number of the great and the good. Where are they? Not in politics. Not in public life. Not in the Church, whatever your brand, there are no great spiritual leaders. I will admit that we have better scientists, if by better, we agree that they are more sophisticated, more specialised, that they have discovered more than their dead colleagues. But if we ask, are they more ethical, more socially aware, more disciplined, more relevant to the happiness of the whole, then our scientists have failed the age they claim to have created. The masses are fobbed off with gadgets, while the real science takes place behind closed doors, the preserve of the pharmaceuticals and the military. Genetic control will be the weapon of the future. Doctors will fill the ranks of the New Model Army. And of course you will trust me won't you, when I tell you that with my help, your unborn child will be better off? The white coat will replace the khaki fatigues as the gun gives way to the syringe.

I like to read George Bernard Shaw, not, as he hoped, as an improvement on Shakespeare, but as a visionary who truly believed that Socialism could progress man's basest instinct; greed. Is there a gene we could tag and rub out for that? If there is, the money won't be there for the research, much more profitable to ease out red-heads or homosexuals. What's the difference? In the fifteenth century it was well known that red hair was a sign of a consort of the Devil. If our ancestors had possessed our technology, this woman opposite me would certainly be brunette. There would be no red-heads, and we would justify that loss by saying 'Ah yes, but thanks to us there are no witches either.' Genetic engineering would have taken the credit for ordinary social change. Witches and devils no longer threaten you and me. We don't mind living next door to the harmless lady with her herb garden and decoction still, her black cat and red hair. Once we

would have tied her to the stake and burned her, but these days, it's just the faggots that offend.

We strict Catholics won't flinch from a little medical intervention. We have made that mistake before. In 1936, when the Catholic hierarchy was colluding with the Nazis, Hitler was not in favour of Concentration Camps. He advocated compulsory sterilisation for the 'hereditarily diseased'. His advisor, Cardinal Faulhaber, disagreed: 'From the Church's point of view, Herr Chancellor, the State is not forbidden to isolate these vermin from the community, out of self-defence, and within the framework of the moral law. But instead of physical mutilation, other defensive measures must be tried, and there is such a measure; interning the people with hereditary diseases.' (Literary remains of Cardinal Faulhaber.)

Strict Catholics. Orthodox Jews. The other day I heard an ex-Chief Rabbi arguing in support of genetic cleansing for homosexuals. It would be kinder, he said, than imprisonment.

The problem with imprisoning homosexuals is that it is impossible to imprison them all. Homosexuality is harder to identify than Jewishness. Much better to intervene while the incipient queer is still in the womb. His mother is to blame. She's the carrier. Homophobia and misogyny bedded down under the white sheets of bad science. That's progress isn't it?

I haven't said anything about lesbians. I don't know anything about them. I suppose that they, like other women, will be surprised to find their new listing from the American Psychiatric Association. It is 'Mentally Ill', but only when they are pre-menstrual, of course. You don't mind the harmless lady with her herb garden and decoction still, her red hair and her black cat, who lives quietly with her friend, do you? Do you mind her when I say that she is a mentally ill lesbian? And if I said I could cure her, wouldn't you think me a good man?

Don't be narrow minded Handel, with your gloomy science and medical obsessions. People live longer, our children aren't slaving down the mines, we do recognise our global responsibilities, even if our governments choose to ignore them. Women are not equal, but they are less unequal than they used to be. We don't call black men niggers. We are an advanced civilisation. A democracy. Isn't that something?

Yes, it is something, it's The Golden Age of Greece, the Athens of Pericles. The Greeks enjoyed longevity. Their own people were not slaves, although their empire depended on the slave labour of others, in much the same way as the West exploits the Third World. Women enjoyed considerable freedoms, though not the same freedoms as men. The Greeks, beyond the concerns of their empire, were not xenophobic. They were an advanced civilisation. A democracy, ahead of ours, in that it was not representative, but direct. To them, we owe, poetry, philosophy, logic, mathematics, model government and sculpture. I admit that they did not invent the microwave.

Perhaps it is a good thing that Greek is no longer taught in most schools. A study of Greek language and Greek thought would make the most ardent computer modernist as disillusioned as I am. Progress is not one of those floating comparatives, so beloved of our friends in advertising, we need a context, a perspective. What are we better than? Who are we better than? Examine this statement: Most people are better off. Financially? socially? educationally? medically? spiritually?

I dare not ask if you are happy? Are you happy?

Many years ago I fell in love. It was the only time that I have fallen in love although it was not the only time that I have been in love.

I was home for the holidays and I brought with me another student, a young woman, my friend. I always have prided myself on my capacity to be friendly with women. As a celibate I do not expose myself to the usual complications. Or do I mean temptations?

She was a confident young woman. My mother did not like her. She was rational, I was intense. She was dignified, I was still farouche. Still the choir boy singing the songs of the dead with living ardour.

It was a December of steam-like fogs. Daily we opened the back door and set out from the clear warmth of the kitchen into a freezing sauna. Through the steam we heard voices calling out and the rattle of trucks on the road. We saw nothing, and the lower fog being thicker, it was our heads that made a marker for one another. We joked about waking up in Dante's Ninth Circle of Hell; the frozen lake of Cocytus, where traitors are plunged up to the neck in ice. For her, it was a playful game, for me it came too close to truth. Whom did I betray that Christmas? She? Me? Both of us. Cocytus. The river of mourning.

We had gone out to gather mistletoe. Pagan berries for a Christian feast, difficult blessing, hanging as it must, on the topmost branches of old oak. I stood her on my shoulders so that she could climb up to the first branch. After that, she swung herself up easily enough, and cut down the medusa clumps of knotted green, white eyed. I am queasy about mistletoe, it is such an unnatural green, shining like a wrecker's lantern in the steady green of the oak. She dropped it down into my waiting net, how foolish I felt, chest high in mist, lacking both wit and laughter, so serious under the oak, while she joked and shouted in the ice air. Two others came past, arm in arm, pleasure warming their faces. They offered me a swap of wild mushrooms for a hand of mistletoe. I looked up at her, perilous and poised. 'Give it to them Handel' she yelled, and threw a huge bunch at my head. I did as I was told, happy in the moment, in that simple way that is so

very difficult. Nothing to think about, nothing to analyse, the friendliness of strangers, rare and rarer.

She was coming down, slight, lithe, red hair under her red cap, a winter acorn breathed in frost. She took the last eight feet di-salto, and landed firm and square, in a parachuter's jump close bundled at my knees. She pulled me down beside her and took out a mistletoe sprig. She kissed me lightly and undid her heavy jacket, putting my chilled hands through on to her breasts.

'Haptics,' she said.

'What?'

'The science of studying data obtained by touch.'

Yes, I knew then, from the Greek, Haptein, 'to fasten'. It was my heart I fastened while she unbuttoned me. My eager open heart, that I shut up from her and from myself, with stiff and frozen fingers.

Her kiss threatened the frozen world. Her kiss was a lit brazier on the sealed lake. My body jumped, as fishes do that look for air, that look for food and find it. Under the quilt of fog she kissed me. Never go. Never stop. The kiss of life for this airless man.

'I had my hands on her breasts, but, and I know this is bizarre, I felt as though her breasts were holding me, safe, firm, sexed. I wanted to stay there, on the zero ground, my hands on her breasts.

We didn't make love. Slowly we walked home through the darkening day, her hand in mine, I carrying the mistletoe. My parents had gone to Mass. While I was fussing in the kitchen, she went upstairs, and a little while later, I heard her calling me.

Handel . . . Handel . . . her voice far away.

I went up, and found her in the spare room, on the dusty double bed. She was sitting up, straight backed, naked.

Handel . . . her voice far away, her voice trying to penetrate the thick Seminarian walls, my untried fears. Those long days in Rome,

hidden behind the red skirts of my Cardinal, hiding my beating heart in his skirts. Handel . . . her voice far away.

I looked at her, her hair in a perpetual spray around the sculpting of her shoulders, her body, a living fountain of red and gold.

I looked at her and turned away. Turned away from beauty. Turned away from love. Turned away and closed the door on the unused room. The next day she caught the train.

When I operate my hands are cold. The woman's breast is warm. It remains an eternal December, the winter when I fastened my heart.

I try to make the cut as small as possible.

Long-slanted light. Light in polished spears that pierces my side and releases blood and water. The hydremic body and the unforgiving light. Why should the light forgive me? I keep my past in a trunk with old school clothes and dusty photographs. Things in the dark, things hidden away, not for the shafts of sunlight that force the dust to dance. In the long spear of light the dust dances. Jerky puppet movements of the past, I shield my eyes, but the motes are in them. Re-membering, the body of the past that was broken and lifeless, knitted together in a gruesome semblance of what was. I'm not there, it's gone, I know it has gone but my mind betrays me and pushes me back down winding tunnels to the chamber of the dead where a terrible pantomime is being performed.

Is that me, the foolish boy? Is that her, the lovely woman? I have not thought about this for more than thirty years. What right has the light to disturb my rest?

If I burn within my iron tomb what is it to you? It is possible to be damned in your own lifetime. A string of successive damnations that bind what is still left of the soul and force its future into the same thick moulds as its past. Small treacheries, hurtful lies, moral

cowardice, wilful sadness, neglect of beauty, scorn of love, each does its own violence to what was made inviolable; the soul. Not fashionable? No, and not to the Epicureans either whose philosopher died in 270 BC. The soul swings in and out of fashion, immortal or not, it can be damned. Isn't this life hell enough?

Hell enough for you Handel, who rejected a love you felt in favour of a duty you despised. And the worst of it? That it condemns you to a permanent adolescence. Lost love to weep over, a full bath of selfpity and self-hatred, the one real chance at life lost. It's such a popular delusion and I'm not a romantic, not at all, I loathe the sentimental in me. In human nature. If I had taken her in my arms, with the ardour she deserved, what would have happened? Would we have been lovers for a while and parted? Would we have married? Would we have remained friends? I would not have gone into the priesthood, but since I am in it no longer for other reasons, that hardly matters. These speculations hardly matter, whatever the later choices, I would have faced both beauty and terror squarely. Beauty, at what she revealed, terror at what I could no longer conceal. I fastened myself tight against both and have stayed a battened hatch against both. I have kept my mild prejudices and weak pleasures, my doubtful faith and my shy jabs at passion. Religious ecstasy would be enough, if I had it, artistic rapture would satisfy me too, and I come at the edges of both. I can see into the fiery furnace, I know it is real, but I can only carry a few lukewarm coals.

It is not the only time that I have preferred a fraudulent response to one that had been genuine. She rightly read the moment while I stumbled through a second-hand text. I loved her and I lied.

What to say of the silent day when I turned away from her face and into the dark chasm of self-regard? I fled beauty now beauty flees me. How do I spend my days? Not by the living body but by the marble slab, black arts of scalpel and blade, dissection of what I love.

Too bitter? perhaps, but I have found that human nature is bitter, twisted roots of wormwood and gall, the buried death-in-life, that still fears the grave. Having killed part of me, I fear it less than those who do their murdering with unconscious hands, the daily suicide that precedes all other crimes. Love of money. Fear of death. Twin engines of the human race. Foolish then to search for wings? Inhuman even? But I dream of flight, not to be as the angels are, but to rise above the smallness of it all. The smallness that I am. Against the daily death the iconography of wings.

'She's dying Handel.' My mother's death, the fragile combative body had become a winter husk.

We were arranged round her bed, father on her right, myself on her left, her sister at the foot, my brother fidgeting in a faded chair. The clock beat out the minutes metronomically. The nurse consulted her watch. The dead are not timely. My mother, who woke at 7, breakfasted at 9, corresponded until lunch, napped until 2.30, collected me at 3, deposited me at 4, gave orders to the household until 5, read, bathed, dressed for dinner, ate it and fell asleep by 11 pm, had outlasted her doctor's estimate by three days. For three days her family had gathered thus, eating in shifts, resting on camp beds, not speaking but glancing one to another, with the secret guilty signal, 'Will this time never end?'

Her will had gone, only the animal was left, the animal holding on to life at any price. She, all of us, would choose to die with dignity, to accept the inevitable with restraint. We don't imagine that the body we have tamed will turn savage. Her hands tearing the bed clothes, her face twisted in pain, tormented thrashing from side to side as her systems failed and her organs ignored the chain of command. She was full of fluid undrained and undrainable. We had taken out the tubes that gave her as much hurt as they relieved. We had brought her home, away from the stainless steel bedpans and castored trolleys rattling with drugs. Away from the Terminal Ward and its unfeeling banalities. Death being a favourite TV tear-jerker, the living now act out their soap opera roles. It's true that death is a situation where we desperately need a script. Most of us are dumb with feelings no-one warned us we might have. Better to be dumb than to chloroform feeling with platitudes, make it safe with sentimentality. Shouting is not allowed on the Terminal Ward unless it happens on the television. Those about to lose their loved ones must sit sotto voce by the bed and watch an American actor hamming grief. If they're lucky, there might be a comedy show, then everyone can pretend to laugh. Television is compulsory, all you can do is draw the curtains round your own bed, or pay for a private room.

Of course we paid for a private room but the walls were too thin.

Thin... the thin sheets on the thin mattress. The flimsy covering over my mother's body, skin and bone. The thin walls that could not keep out someone else's death; death seeping through the stud partition, tainting the water filled with cut flowers.

Thin soup passed through a narrow tube into her throat, a thinner tube in her kidneys taking the fluid away. Paper cards saying 'Get Well Soon', imported soft fruit unpithed. She in a narrow bed alone.

Why dilute her last days? Thin them out so that they resemble what is to follow. Why sterilise death, hoping to make it clean and acceptable when it is what it has always been, furious, messy, full of doubt and anguish, but not hopeless, not pointless, it is an event in life.

I forced my father to bring her home. On the day he went to collect her in the ambulance I ran to the market and bought armfuls of lilies and roses and old-fashioned sweetpeas whose scent filled her bedroom and knotted into the heavy red counterpane over her best linen sheets. I knew she would ruin the sheets, my brother's wife was angry, they were rather special, impossible to find nowadays. They had been part of her trousseau. My brother's wife had expected to take them home.

My mother died, exhausted, ruined, on the morning of the fourth day when only my father was present. I came in with a cup of coffee for him and he was stroking her head, saying 'Kathleen, Kathleen.' He looked up at me 'Why does God do this?'

I'm supposed to have the answers aren't I? A priest, a doctor, you'd expect me to be able to say something careful and comforting. The priest does it every day, manages to trot out his homily on the Will of God, the doctor is less certain and will tell you something in baby language about her heart. There is no answer because there is no question. My father is saying 'Weep for me, weep for us, fragile creatures of spirit and clay.'

'And the king said to the Cushite, "Is it well with the young man Absalom?" And the Cushite answered "May the enemies of my lord the king and all who rise up to do thee hurt be as this young man." And the king was deeply moved and went up to the chamber over the gate, and wept; and as he went he said "O my son Absalom, my son, my son Absalom! would God that I had died for thee, O Absalom, my son, my son!" '(2 Samuel, 18:32-3).

I had washed the body; her skin delicate death-blue, the joints not swollen now, all repose, easy to read the steel-nibbed lines that covered her in gentle calligraphy. The book of my mother finished and closed.

Grief were the curtains of the room, grief the rug on the floor. Grief paned the windows and burned in the solid candles placed head and foot. Grief in our mouths and gravel for food.

We could not comfort one another. Each in his own shroud against the light. Each fearful of discovery. Grief sat on our shoulders and whispered. 'If only I had . . .' And then the punishment because we had not. Not put out our hand, not said the longed for words, not been there on that day, not cried when she cried, or laughed when she laughed. Separate from her in life we were desolate for her in death. There had been forty years to say the things that now seemed so imperative.

Shall I lie beside you and tell you what it was?

It doesn't matter. Blaming myself like this gives me something to get over, something easier than her death which I can never get over. Get over it; as though it were a boulder in the way. It is an event in life and in so much as I have life I take it with me. Her death in my saddle bags. The Book of my Mother.

In the antiseptic world we try to purge ourselves of difficult things. Don't dwell on it, switch the light off and go home. But this is home. I have to be a home to myself. I am the place I come back to and I can't keep hiding difficult things in trunks. Soon the house will be full of trunks and I perched on top with the phone saying 'Yes, I'm fine, of course I'm fine, everything's fine.' The trunks shudder.

I have a grand house but it's not home. I am home. My veins, belly and bone. My mind, the odd attic room where everything is kept. But I don't want to be a man with only one storey. I would rather be an Arabian Night, a thousand and one rooms at my disposal, places to wander, green groves, yes, but, too, a Bluebeard's Chamber where the key is not forbidden. Darkness as well as light. Or do I mean darkness, another kind of light? Lucifer would say so, and I have a weakness for fallen angels.

Of course I do; the priest adores the sin. No sin no priest. The

doctor needs the wound. Fallen creatures thrive on gravity; that which pulls us down is the spur that raises us up. Materialists and spiritualists alike seem to me to have missed the point; as long as we are human we are both. After death one side or the other will be right but presently, and presently is all we have, we are both.

Am I a Centaur? Half man, half beast, horsey flanks and nacrous hooves, my chest raised up to draw a bow? The Centaur, symbol of the true nature of humanity, marred by the wild passions of the brute. And yet it was a Centaur, Chiron, a son of Saturn who trained Aesculapius in the art of medicine. Since then medicine has become a science and we no longer ask advice from horses.

Am I a Centaur? Hooves that thud/thud thud/thud the wood and an unsheathed cock? An unsheathed cock and God in my chest. Is that the dilemma, the tragic combination? The Greeks have held it so, though for subtly different reasons to ours, where a body-loathing, woman-despising Church has found it convenient to place all that is sinful in the excesses of the flesh and all that is right in the restraint of the spirit. Look again.

Is appetite excess of feeling or lack of it? The glutton is not a gourmand. The alcoholic does not love fine wine any more than the womaniser loves women. Don Giovanni; the unsheathed cock is layered to numbness. He might as well stick it in a hole in the wall for all the pleasure it gives him. Sex gives him no pleasure, only power and violence please him, that is not the mark of the brute, it is the mark of Man.

When I say I lack feeling, you know that I mean I lack the capacity to feel, and that is a spiritual not a bodily failing. Would I had the excess of Mozart, spilling out every day into new chords of beauty, excess of spirit, David's dance before the Ark of the Covenant, that embarrassed his wife and his people, but delighted the God of Israel, who does not stint and hates it in others.

If I needed any proof that sexual sins are failures of feeling and that it is that failure and that failure alone that makes them both sinful and punishable, I can read the story of David and Bathsheba, perhaps the most famous and the most misunderstood adultery in the world.

It happened, late one afternoon, when David arose from his couch and was walking upon the roof of his house, that he saw from the roof a woman bathing, and the woman was very beautiful. And David sent and inquired about this woman. And one said, 'Is not this Bathsheba, the daughter of Eliam, the wife of Uriah the Hittite?' So David sent messengers and took her; and she came to him and he lay with her. Then she returned to her house. And the woman conceived and she sent and told David, 'I am with child.'

So David sent word to Joab saying, 'Send me Uriah the Hittite.' Then David said to Uriah, 'Go down to your house and wash your feet.' And Uriah went out of the king's house and there followed him a present from the king. But Uriah slept at the door of the king's house with all the servants of his lord and did not go down to his house.

David said, 'Have you not come from a journey? Why did you not go down to your house?'

Uriah said to David, 'The ark, and Israel, and Judah dwell in booths and my lord Joab and the servants of my lord are camping in the open field; shall I then go to my house to eat and to drink and to lie with my wife? As you live and as your soul lives, I will not do this thing'. Then David said to Uriah, 'Remain here today also and tomorrow I will let you depart.' So Uriah remained in Jerusalem that day and the next. And David invited him and he ate in his presence and drank so that he made him drunk; and in the evening he went out to lie on his couch with the servants of his lord but he did not go down to his house. In the morning David wrote a letter to Joab and sent

it by the hand of Uriah, 'Set Uriah in the forefront of the hardest fighting and then draw back from him that he may be struck down and die.' And as Joab was besieging the city he assigned Uriah to the place where he knew there were valiant men, and some of the servants of David fell. Uriah the Hittite was slain also.

When the wife of Uriah heard that Uriah her husband was dead she made lamentation for her husband. And when the mourning was over David sent and brought her to his house and she became his wife and bore him a son. But the thing that David had done displeased the Lord.

And the Lord sent Nathan to David. He came to him and said to him 'There were two men in a certain city, the one rich and the other poor. The rich man had very many flocks and herds but the poor man had nothing but one little ewe lamb which he had bought. And he brought it up and it grew up with him and with his children; it used to eat of his morsel and drink of his cup and lie in his bosom and it was like a daughter to him. Now there came a traveller to the rich man and he was unwilling to take one of his own flock or herd to prepare for the wayfarer, but he took the poor man's lamb and prepared it for the man who had come to him.'

Then David's anger was greatly kindled against the man and he said to Nathan 'As the Lord lives the man who has done this deserves to die and he shall restore the lamb fourfold, because he did this thing and because he had no pity.'

Nathan said to David 'You are the man.'

(2 Samuel, 11 and 12:1-7).

'Because he had no pity.' The punishable sin is not lust, not even adultery, the sin is not to do with sex at all. It is a failure of feeling. Not an excess of passion but a lack of compassion.

I did once suggest this reading to my Bishop. He accused me of being a Communist, a Heretic, a lecher and a Women's Libber, and I imagined for myself a hell where red flames were stoked with white brassières. I remember that he kept goldfish, and when he died, he left all his fortune to their upkeep and wellbeing. We were living in São Paulo at the time, and he had an illuminated text over his pantry: 'The poor are always with you. (Matt. 26:11)'

He particularly disliked the Miracle of the Feeding of the Five Thousand, although whether this was in fear for his pantry, or out of deference to his goldfish, I never found out. I do know that when the poor fainted at the church door, there were neither loaves nor fishes to revive them. But the Bishop was a spiritual man and not a Centaur like me.

D.H. Lawrence once described himself as a Centaur, except that he muddled up his nether parts, claiming that he had a poet's brain and a bull's balls. A man less bull-like, it is difficult to imagine, unless we include Toulouse-Lautrec. I can usually forgive Lawrence for his muddles large and small, the matter of his balls is a small one, but his imago-mythology is faulty. In Lawrence's hands, the Centaur, with his unsheathed cock and God in his chest, becomes the Man-beast, with God in his cock and an unsheathed chest. Medallion man meets the Divine Phallus. When I look about the streets, I can see that this is a problem. And I don't want to be a pedant, but surely a phallus is only divine when it is strapped on to a god? Does the god make the phallus or does the phallus make the god?

From heaven the spear-light vertical in its fewter. The well-aimed light and the dark heart. The light at rest against the heart. Light surgery for cardiac arrest. The operation of light upon the heart is simple; the aortic valves open like trumpets, a brassy euphonic of high C driving the blood through tunnels, red rush of pleasure,

excitement, energy of feeling that focuses the retina out of its cloudy illusion. Blood behind the eyes; sacred wash that unfilms the blurred vision of the half-hearted world.

Light. An electromagnetic radiation that produces visual sensation.

Heart. The organ that circulates the blood.

Any more to say?

The heart in its dark pen recognises the light. Knows the light again and struggles for it after long hibernation. The hibernating heart, not awake, not asleep, but suspended out of light, dreams of it. Why shield myself from that which I desire? Why do I fear what I love?

Under the door I can see the yellow band that presages a Midas world struck gold. Not rigid metal but vibrating light, unfiltered, unsullied, uncontained. I fear it, fear to open the door, take off my spectacles and with nothing in between give in to the light. There is no portion, either I do or I do not.

Could I be a light-hearted man?

Core to core. Light to light. I am made of light, empty space and points of light, the atomic composition of the seeming solid. Why am I more comfortable with the seeming than the real? The counterfeit of sofas and stocks and shares? The measurement of the cultivated man. Not too much, not too much, not too much. Much. And if that is not enough, more, more life into a time without boundaries.

I, Handel, doctor, priest, society wiseman, fool, find myself on this anonymous train that wheezes towards the sea. I have money, a passport, luggage, a warm coat. Will that be enough? Enough of a skin to wrap myself in while I shed what had been my life.

My life. What should have been an Ode to Reason has become a few Fescennine verses . . .

What do you call a doctor who removes the wrong breast?

I don't know. What do you call a doctor who removes the wrong breast?

A surgeon.

Of course there has been an inquiry. The lady in question is still recovering from her second operation, this time to remove the right breast (in fact the left). I should not have performed the operation at all, it was an emergency, the duty surgeon had been taken ill, there was no-one else, and I am the best in my field. The best lack all conviction . . . and the worst? What do you think the worst would have done? Taken the other one off, straight away, under the anaesthetic and called the botch a complication. Surely they wouldn't do that, would they?

I had resigned myself to being struck off. I, Handel, not doctor, not priest, society laughing stock, fool. Is my reputation worth her breast? Weigh them in the balances and will you find me wanting? Her breast, that any man could fondle for a fiver, should be worth more than thirty years of my life? She was a prostitute. A prostitute. And why did she come to enjoy the doubtful benefits of the most exclusive breast cancer expert in Britain? Why? He works for a charity, Handel does, a little unfunded hospital for nobodies, his bounty, one day a month.

What do you think of the rhetoric? It is my barrister's own. When he heard the brief he said 'God, you were lucky, what if she had been one of your private patients?'

'What difference does it make?'

'She's a tart. You won't be struck off for a tart's tit. We might even manage compensation from the press. Cheer up.'

Of course. I need not have worried. That she was low and that I let her down lower still is not a matter for concern. She is a streetwalker. I am a knight. Sir Handel. My QC is a knight too. Sir Claude. Two knights, no longer rescuing ladies from impossible towers, nowadays we rescue ourselves and are paid for it. Sir Claude is very expensive. He earned more out of her breast in a fortnight than she collected in her entire career.

'What was she?' he said over his cappuccino. 'Fifty-two? Fifty-three?'

I nodded.

'Ha, ha, bit late for her to claim loss of earnings isn't it? I daresay you can't have done much asset stripping there.'

'No Claude, it wasn't much of a breast.'

'Well, there you are then, cheer up.'

Shame. Unusual for a Catholic to feel shame. Guilt is our ticket. Guilt to confess, guilt to expiate, guilt, good riddance and gone. The priest understands that. Shame comes from an older and different moral sense, where the wrong-doer does not fear punishment, either in this world or the next, but fears that shrinking up of self, the loss that any small, mean, dirty or stupid act, charges to the soul. If I cheat another, I cheat myself out of the person that I could be. If I wound another, I will eventually find the cut recalled to my own heart. There is no appropriate confession, only the will not to fail again so readily, perhaps because while failure can be forgiven it cannot be excused.

For much of my life I have not been a compassionate man. The awful weight of other people's miseries, other people's burdens, in me, twisted into a rope plied of pity, rage and helplessness. I have found, do find it difficult to look on the lot of human kind. I feel sorry and I force myself to use what skills and position I have to ameliorate what I can. But I can't forgive the squalor of it all. I can't accept that better food, better education, better hours, better days, whatever those things mean to the fervent, would make any difference. Most of

my acquaintances are well-fed, well educated, like their work and have leisure. I would rather spend an evening with a dripping tap.

There are exceptions, but there are exceptions in every situation, every class, and I don't only mean those revolting Victorian supermodels like Little Nell and Little Dorrit, both of whom would have forgiven me at once for removing either or both of their breasts, and in Little Nell's case, without anaesthetic. There must be a terrible hell somewhere for thugs and torturers, a hell unthought of by Dante, where the Two Littles line up with Puccini's Mimi and Madam Butterfly, Donna Anna in the corner, Saint Agatha supervising, and reduce vile men to weeping supplicants, simply by taking martyrdom to its conclusion; an inhumanity far beyond that of the brutes.

Am I a brute? The newspapers think so: CALLOUS DOC IN BREAST FARCE.

So many years ago, if I stretch out my fingers now, will I touch her again? Blood-stained fingers, the man behind the mask breathing sterilised air, his mouth covered so that when he leans over he will not infect you. His lips are above your cheek but he won't kiss you. Your eyes were closed waiting for him to kiss you. He straightened his back.

The woman on the white slab, the woman on the frosted ground. The woman who trusted him with her breasts, who took his long fingers and put them on her breasts, eight cool knives on her warm breasts. I'm sorry. I'm sorry. I'm sorry.

'Stop apologising Handel, you don't have to make love to me.'
Under general anaesthetic the patient can hear everything.

The man on the train had fainted. The light struck his cheeks but did not revive him. He heard voices from afar off, calling, calling through the thick air . . . 'When you grow up Handel, you must do some good in the world.'

'Sins of the flesh or sins of conscience?'

'Did you ejaculate into this woman?'

'You don't have to make love to me.'

The voices bound his hands and feet in golden bandages. He was mummified in the dead air, he must breathe, he must breathe but the cloths were at his nostrils and soaked in honey. Honeyed words, hadn't he said them? The rational man with the musical voice, 'There's nothing to worry about. Nothing to fear, go on, get dressed.'

His flesh, naked before her mirror, the boys waiting to be gelded in the stalls.

Someone else's flesh, naked before him, the taut brown nipple under the whorl of his finger.

The light in railings around his body. He couldn't slip between. The light had staked him out. He must answer, not with gilded lips now, but tongues of flame.

SAPPHO

Fortune on the gilded wheels of her coach, Fortune in her dress, Fortune on the gilded wheels of her coach, Fortune in the hangings, drapes, pots and porcelain from inside the Everlasting Wall. Her china came through Holland, in the private barrels of a lover who was Imperial. Thus she had what the King of England had not; porcelain. But tonight, in the brumous winter and the charcoal streets, it was not the tiny bowls and tea dishes for which she silently blessed her yellow wag. As a token of love, half in earnest, half in jest, he had given her an occult piece, exquisite, transparent, strong, decorated with lewd lovers in blue relief. It was this she wore on its leather strap and it comforted her. Any straying hand would find its expectancy. She shifted it slightly as she swung into The Cock and Gun.

(Sappho wrote in the margin of the page: 'Where can I get one of these?')

The strawed floor. The gouged benches. The smoke fire roasting the pig. Where was Ruggiero?

A boy had a sailor beautifully unbuttoned, and to her surprise, the Doll felt her porcelain swell, she took hold of it. A man smiled at her and gestured to the Backs. She shook her head. Where was Ruggiero? She pushed between a pair of petticoats, unloosed from both hips, had she seen . . .? Had she seen? When she got to the fire, the man with the tongs on his lover's nipples, was not her

love. She had been mistaken. Where was Ruggiero? She stood back and pondered the Chase. Why such a rush to the hills when any man could enjoy any valley he fancied?

She drank. She waited. She was hungry but she could not eat. The men playing Piss the Fire had pissed the pig. He steamed in ammonia clouds.

She sighed. She waited. All for love? Where was Ruggiero? Hadn't she had them raw from the womb? Hadn't she taught her strapling boys to put in their hands after honeycomb? Hadn't she taken them in their gowns and mortar boards and coaxed them to put aside the set square for the pleasure of the compass? She had shown them how to take a point and expand a circle around it. She had been a proper Columbus to their undiscovered coasts. She had mapped them, schooled savages, no matter how simple the tool. They were logged up in her little book under their individual coordinates. She liked to remember a man by his dimensions. Not only the length, but also the width, and distance travelled. She had been a charitable and an accommodating Doll. Scientific, certainly, and rational in all her pursuits, but with that love of music and verse that she felt Newton lacked. He used to come to her, when she had first advertised her credentials, and he often brought an apple which he never ate. He said it had fallen on his head, and he gazed at it with all the wonder of a soothsayer into a globe. Poor man, very often she distracted him, but it was to the apple he returned.

He had said 'This fell on my head. Why?'

'Codling moth,' said the Doll.

She was still fond of him. She was fond in her work, but in love? Never Never Never. Yet, she liked men, foolish, boyish, trumpeting men. What was it her friend Jack Cut the butcher had said? 'A pig and a man, both must have loins.'

A Swank dropped down beside her and offered her a trotter. It was not a trotter she wanted . . .

Time passed. Let Time pass, she would not detain him, he had too much detained her. She was twice Ruggiero's age. Time had passed and taken her with him in his train.

Lost in the dial of the clock, she did not see the tall, square-shouldered woman, gay companion on her arm. They stood by the door, the woman, a little nervous, fluttering her eyes at the men. It was a sense that she was being watched, that made the Doll look up from her cups, she looked up. She knew the straight nose that made an Emperor of his face. She knew the clean lines of porphyry, his pale skin, purple at the temple veins. She knew the twist of his arm and his agitated fingers. She knew his upright back and the plumbline of his spine. She knew, though she had never known, the delicious pound weight of his whiter meat.

There was jelly on her lips from the trotter.

She stood up and walked over to the woman, who blushed, and bowed a little behind her fan.

'Let her hide behind all the fans of the Orient,' thought the Doll, whose own bright head had begun to rise in the East . . .

She gave her arm to Ruggiero and accompanied her to a dark seat, where she pulled out from her lower pocket that bound volume, *The Poetical Works of Sappho*.

The Wise Sappho? Am I wise to love the image and not the idol? Open the book. What does it say?

The Greeks, with their quick artistic instinct, set in the bride's chamber, the statue of Hermes or Apollo, that she might bear children as lovely as the works of art she looked upon in her rapture or her pain. They knew that life gains from art not only spirituality, depth of thought and feeling, soul-turmoil or soul-peace, but that she can form herself on the very lines and colours of art, and can reproduce the dignity of Pheidias as well as the grace of Praxiteles.

Hence came their objection to realism. They disliked it on purely social grounds. They felt that it inevitably makes people ugly and they were perfectly right.

The image not the idol. The image stamped upon the retina, repeated behind the eyelid, stored in the rhomencephalon, returned to the body in injections of emotion. The power of the image through the unforgetting brain.

Did I see you, Sophia, on a ledge in the night? White winged in waves of beauty that closed over my head? Equinoctial waves that box at the moon. The sea in the harbour ring and the moon on the ropes of the boats.

Did I see you again or do I suffer from retina pigmentosa? I saw your colours in prismatic white, a see-through angel in unfitting clothes.

What did I see when I looked at you? An arrangement of molecules affected by light? A vision of my own? A vision of you? You as you really are, unaffected by darkness, stripped out of the net that captived you. Gladiators and spiders both use nets, but neither say for safety's sake. Who lied to you and bound you? Who called their meshes your own good? Retiary malice of the unfree to the flying?

It was a long time ago. I caught her as she fell in whirling wheels of pain. Caught the body weighed down by sorrow. She fell out of the past through an insubstantial present and into the future of her love. Her love, which like charity, does not begin at home.

This is what happened: It was Christmas morning, three years ago, Christmas of deep snow stacked in high banks. I had been with friends but left them in warm revels to make myself an icy fugitive in the streets below. I was alone but for the thin dog that rootled for a bone. Alone but for the alley cat black on the glassy wall. Alone among the frost-cast stars.

Was I alone? I looked up in time to see her drop from the still roof into the moving air. Naked, without sound, through the silent air. I ran to where she fell and found her, higher than my head, unconscious on a white altar still soft with late snow. She was bleeding from the mouth.

I covered her with my coat and tried to get an answer from the dark house doors barred. How many years passed before a light filled up the passage and an angry voice threatened me with the police?

There were police. Raucous squad cars that slewed round her body in an obscene circle, doors open, flashing lights, the staccato of the radio cutting through the family tears. The ambulance, white, sterile, certain. The grim men on Christmas duty, one at either end of the fragile stretcher. Blankets over her now. Her body, a faint bundle of red blankets, red to hide the blood and the corkscrew of her leg.

I slipped away, but not before I held her hands, not before I kissed her. I said 'I will come back.' I said 'Open your eyes, won't you open your eyes?' and all this I said and did in the terrible minutes while the family ran up and down the long hall calling the police.

I thought that she would die. I put my cheek to her lips and felt no breath. I kissed her with the life of me, life to life, warmth enough to lift her hand from the cold gates slowly opening on to her last estate. I said 'I will come back.'

I did go back but she had gone. The house was dark and shuttered. I did go back, not once, but many times, to the blank walls and shielded doors. Nothing to guide me but a scrap of paper from out of her hand. 'That which is only living can only die.'

She had not died. Strange miracle that saved her. Miracle of the soft snow that broke her fall. Miracle of the cold snow that staunched the blood. The disinterested weather and my fervent hands. An

accident of the season and a passer-by. Happy coincidences? Ordinary miracles? It doesn't matter, what matters is her life. Her life, that was more to her than flesh and blood, more to her than a killing doll, could not evaporate in the night air. She had a spirit and it lived. I did not know what it was that drove her to the roof and flung her off it. I know from my own experience that suicide is not what it seems. Too easy to try to piece together the fragmented life. The spirit torn in bits so that the body follows. The fissures and the hollows of the heart do not respond to rational measurement. When the instruments fail the doctor blames the patient. He says he can find nothing wrong.

The doctor said he could find nothing wrong. She was healthy, she had work, she came from a good family. Her heart beat was normal. Was it? Well, perhaps a little too fast.

Heart attack. Had her heart attacked her? Her heart, trained at obedience classes from an early age? Her heart, well muzzled in public, taught to trot in line. Her heart, that knew the Ten Commandments, and obeyed a hundred more. Her disciplined dogged heart that would come when it was called and that never strained its leash. Her heart, that secretly gnawed away its body's bones. Her heart, that too long kept famished now consumed her. Her heart turned.

I saw her heart turning over and over through the somersaulted air.

I saw her heart ignore its bounds and leap.

It was her heart I pounded with both hands, my knees across her, my mouth that shouted 'Live! Live!'

She opened her eyes. She did live. Consciousness returning to the accelerated body. Her body, that in the spinning seconds had resolved to finish its work. Her body, that had travelled through gravity, through light, its own mission of inner space. Its suit too

flimsy for the years that pressed upon it in the seconds left. Common for people to see their past flash before them, the images stored in the unforgetting brain. Common for them to find that, as every material thing is slipping away, it is the image that prevails, the image that was victorious after all. Those pictures and impressions long since cut away from their source, but here still, as lively as ever, liveliness of spirit against the dying life.

She saw her past compressed into a single stroke of colour and it was the colour that made a bridge for her, not out of time, but through it. She did not drop, she crossed herself, and in the moment of crossing herself she was freed.

Free. Free from the outcrop where she had been marooned. The rocky place of thistle and salt. The heart beat back so many times that it finds its only home in isolation. The isolated heart, that in protecting itself from pain, loses so much of beauty and buys its survival at the cost of its life.

Better to go forward than to retreat. Better to fight the hurt than to flee from it. She did not know this until the quick second of her fall and as she fell she prayed for wings. She prayed not out of self-pity nor regret, but out of recognition. She need not die. She could fight. Too late? No. Not for her. For her it was not too late.

Many times I returned, but it was on this one night, years later, that what was lost was found.

I like to walk at night, it is my habit, I walk at night to rid myself of too much day. Too much daylight that pretends to show up things as they really are. No such thing as natural light.

Crossing by that house again, now threatened by a crane, I looked up to where the parapet met the plane trees. She was there. There on the ledge, there in bare feet, balanced on herself. I should have been afraid because history always repeats itself. The past fitted in a new wedding shroud and married to the future. I should have been afraid, waved my arms and shouted, not stood in quiet wonder at her grace. I knew she would not fall. I knew she had a different reason for her risk. I knew that she had seen me although I could not see her face.

Lie beside me. Let me see the division of your pores. Let me see the web of scars made by your family's claws and you their furniture. Let me see the wounds that they denied. The battleground of family life that has been your body. Let me see the bruised red lines that signal their encampment. Let me see the routed place where they are gone. Lie beside me and let the seeing be the healing. No need to hide. No need for either darkness or light. Let me see you as you are.

'Do I know you?' Sir Jack's interrogative.

'I came to see your daughter.'

'She's gone.'

That was the following day, as early as I decently could, not early enough to catch her. There was a clue and I followed it. Followed it to the station and to the morning train. Followed the trail of colour that made a purple ribbon out of the snow. She was unravelling herself. She was loosening all the grey years into one bright line.

Piece by piece the fragments are returned; the body, the work, the love, the life. What can be known about me? What I say? What I do? What I have written? And which is true? That is, which is truer? Memory. My licensed inventions. Not all of the fragments return.

I'm no Freudian. What is remembered is not a deed in stone but a metaphor. Meta = above. Pherein = to carry. That which is carried above the literalness of life. A way of thinking that avoids the

problems of gravity. The word won't let me down. The single word that can release me from all that unuttered weight.

The winged word. The mercurial word. The word that is both moth and lamp. The word that rises above itself. The word that is itself and more. The associative word light with meanings. The word not netted by meaning. The exact word wide. The word not whore or cenobite. The word unlied.

Shall I use my alphabet to disentangle the days? Not to label them A, B, C, nor to make my letters a more arcane deceit. Two things significantly distinguish human beings from the other animals; an interest in the past and the possibility of language. Brought together they make a third: Art. The invisible city not calculated to exist. Beyond the lofty pre'ensions of the merely ceremonial, long after the dramatic connivings of political life, like it or not, it remains. Time past eternally present and undestroyed.

And now? Yes, and now, still challenging the fragments that I am.

Look up. A hundred billion stars in our galaxy, the Milky Way. Unconcerned with me, that confidence of stars, light offerings, two thousand years old. If they are anything to me they are jewels for my shroud. I cannot know them. I cannot even know myself. Pascal's terror is mine: 'Le silence éternel de ces espaces infinis m'effraie.' What can balance the inequity of that huge space, which never ends, and my bounded life? Perhaps this: The beatland of my body is not my kingdom's scope, I have within, spaces as vast, if I could claim them. Proof? What proof have I of this – Not God, who, if true, is a priori and cannot be a proof, but art, that never concerns itself with the actualities of life, neither depicts it as we think it is, nor expresses it as we hope it is, and yet becomes it. Not representations, but

inventions that bear in themselves the central forces of the world, and not only the world. Art ranches the stars.

How can I come close to the meaning of my days? I will lasso them to me with the whirling word. The word carried quietly at my side, the word spun out, vigorous, precise, the word that traps time before time traps me.

Ride beside me, so much that time allows, so much of beauty and of love. The desert that we cross flourishes. Time to take in the view. Am I a viewfinder merely? Eyes that smile and pass on. What to make of what I find? What's in it for me? The splendour and the brevity, the effort to touch and see, the effort to understand.

Salvation, if it comes at all, will be conscious. Ignorance is not the road to wisdom. Sincerity of emotion will not be enough. The word will find me out; I speak therefore I am. To match the silent eloquence of the created world I have had to learn to speak. Language, that describes it, becomes me. Careful then, what I become, by my words you will know me. The word passed down through time time returned through the word.

It isn't natural, language, nothing of nature in it, why pretend it so? No such thing as natural light. The light I read by is artificial. The page illuminates itself.

My lumber room is piled with books, not unread, unwritten. Experience untranslated into meaning. Days that have decayed untransformed. What shall I write? Not my memoirs. Bring out the dead, Bring out the dead. What light I had gutters and goes out. It is not simply that I shall lie, but that I shall not be able to tell the truth. I shall not manage to remember, objects before me, I shall have to invent a dim history for every one. What could be more pernicious than an honest lie?

I know that the straightest way to come at my emotions is by the

unlikeliest route. Not sincerity of emotion but sincerity of form will take me there. You see, I have to beware of shallowness, a cliché of response, not mine but everyone else's, is this how I really feel? How shall I know that these lines are my own, and not a borrowed text? How shall I know? By giving them a structure which formalises them, takes them out of the bath of self-regard. Of me but not me, my own made distant, separated out from me by patterns and shapes, forced to a distance by the language that will return it. Once I have found the right words I will never lose the emotion again.

It will not be enough to say I love you. I know you have heard it before.

I love you. Those words were not worn out two thousand six hundred years ago. Are they worn out now? Perhaps, but not by repetition, but by strain. There are other ways of saying what I mean . . . Other words fit for the weight. Other words that pin me to an honesty I might not like. So much can be hidden in 'I love you'. I can hide in that sentimental cloud.

I will not hide. Here . . .

Her face is thoughtful, set in the shadow of her hair, set back, the hair before it, a veil. There is something voluptuous in the eyelids and the lips. The skin is cast of pearl. She is a matter of the sea. The sea deep about her, not only in her eyes that are green, but in the moving contours of her face.

Her head is strong but not coarse. Fine filaments of bone, whiteset, have built the clean cage of her skull. Trace the line. The line that belies its firmness with the delicacy of a shell sea-washed. She is smooth. The heavy head is smooth.

Turn up her face to the light. What can I read in the clairvoyance of her mouth? The parted space where her spirit breathes. It is my future that she carries on her lips. Tell it to me . . . Her mouth on mine.

Her cheekbones are high. Twin towers of unrest. Restless when she smiles, armed when she does not. In her face the motion of her days.

Her throat cuts me.

Curiosity and desire of beauty in equal measure. These are the flares that light her face. She is a light to see by, though not of trees and wood, wood with a gift for burning, the light that consumes her is her own.

On her face, the play of light is theatrical. Rapt effect, concentration, the arch of her eyebrows, the pageant of her hair. Here in subtle staging are the nuances of nature and the refinements of art. What a piece of work she is, at once original and well known. Applaud her? I will, and something more, offer her a beauty fit for her own. A gift of burning: The word.

Which comes first? The muser or the Muse?

For Sappho (Lesbian c.600 BC Occupation: Poet), herself, always, muser and muse. The writer and the word. Strange then, that what is left of her beauty should be interred under the commonplace of facts. And not facts. The search for truth is tainted with willing falsehoods. The biographer, hand on heart, violates the past. The biographer, grave robber and body snatcher, trading in sensational dust, while the living spirit slips away. The biographer, inventory of pots and pans, dates and places, auction house and charnel house in one room.

So little of her remains. Her remains are scandalous. The teasing

bones that shock and delight. Yet, it is certain, that were every line of hers still extant, biographers would not be concerned with her metre or her rhyme. There would be one burning question from out the burning book. Not Sophocles, but Savonarola, with his raging face . . .

What do Lesbians do in bed?

'Tell them' said Sophia, the Ninth Muse.

Tell them?

'There's no such thing as autobiography, there's only art and lies.'

Roll up! Roll up! Art for all, tuppence a peep. No previous experience necessary. Every man his own connoisseur.

Popular culture, that's art isn't it? Subjective, romantic, democratic, approachable, good notices in the quality press. If they don't like it there must be something wrong with it. Does it smell fishy? What's it about anyway? Where shall I put it?

Fit it all in. Fit it all in, as they say in the back alleys for a Saturday night fiver. So little time. Fit it all in.

Clock culture. Stuff me until I burst and make an installation out of the purée. Art? Don't be silly. The contemplative life? I have a lunch appointment. How long will it take?

Lunch? Forever. Be forever lunching. Chomping bovinely through the day, wondering why all flesh is grass.

Time that taunts you taunts me. Time, with his lop-sided grin, shaped to the sickle he carries. Time, that peeps through the window, and slips his blade under the door. Time, who is waiting when we arrive. Time, who has thoughtfully wound the clock.

The tall, hooded man who played the Jack with me, when I was a child. He who cut wild flowers with his sickle and made me a hedge-

chain I did not want to take off. I went with him, hand in hand, child-crowned with his curious flowers. It was easy to walk beside him while his steps were met to mine. I never saw his face, only his hands, and the long days juggled.

When was it that he became impatient? Insisted that we hurry, and hurry faster, though not through press of destination? I had nowhere to go. Why did the sun not lull him as it did once? The still days and the luminous water. The afternoons that lasted for years. Wasn't that him, dark shadow on the bank, unroused and unrousable? He was deaf in those days and for every long and hated hour, produced another, a soft sewn ball thrown to me. Yet I was happy and forgot. When was it that he became impatient?

The little chain of wild flowers, sap stalks and sun heads, petrified. I was fast-bound to him. I am his bondsman. Yearly now, he claims his feudal tithe, and I wither visibly. Each year there is less, and less to claim, but he does claim it, no matter how thin the harvest.

I have seen his face close up, the strange lop-sided grin, that turns to me immobile, although every day we are moving faster. There are others, all of us, the chain gang on the charcoal hill, bound in the danse macabre.

Do I try to cheat him with wigs, dyes, concoctions, ghastly operations and lambskins for my mutton flesh? Here I am, prancing on my back legs in a borrowed skin. Must keep up with the times. Must keep up with Time. When was it he became impatient?

Too fast. Kick off my dancing shoes and crawl on all fours. Drag me, how he drags me, knows the creature that I am. Beg him? He is deaf still. In spite of that I cry out.

On we go, the blurring body and the cheated soul. Why did no-one tell me to provide for it? Everything I have has been the outward show. Everything I have belongs to Time. Art? Don't be silly. The contemplative life? Where can I get one? What then for my soul as

Time pulls me on. What then for my soul?

Whisper to my soul its separation. My soul in the stained-glass window that lays its red and greens on the stone floor. My soul, that would fly out from the high places, if I could climb it there. My soul, that watches in the night with me, when the chair I sit on is night, and the table I eat off is night, and the bed I sleep in is night after night. My soul, that raises a lantern to my face, when every other hope is gone.

I hope. And the hope that is in me is from the soul is for the soul. Not present, actual, superficial life, but the real solid world of images. I hope that the real solid world of images will prevail.

Whisper to my soul. It is so temporary, life, and the ideas that form it are spirit, not flesh, and the images that outlast it are spirit not flesh. The best of me is not my body. The best of me is not the frame of bones, skin decorated, that delights in the delicate landscape where the trees slant out of the hill. Olive trees, trunks rope twisted, thick cables of bark that feed the fragile leaves from the good earth. Olives, grapes, the land, the sun that parts the leaf canopy with fine needles of light. On my body the acupuncture of the sun . . .

It heals me, drives red floods of energy through the shut lock gates. The sun on my spine brings colours to my eyes, blue and blood vermilion. My ribs are the ribs of rock that underpin the caramel soil. All this I am but there is more. Why split the soul from the body and then the soul from itself?

Love me Sophia, this hand tracing of myself, an outline told in blood. Take my hand, what do you read there? The chronicle of a long life and all the forgotten loss. But what remains when the story has been told? What will bring you back to me when you know what happens next? Only the words, the curving beauty in flight, the lasso

at once tough and airborne. The words for their own sake, revealing now, themselves. Words beyond information. Words done with plot. The illuminated manuscript that lights itself.

Read me. Read me now. Words in your mouth that will modify your gut. Words that will become you. Recite me until you know me off by heart. Lift up a flap of skin and the word sings. On the operating table the word sings. In the grave the words push up the earth. Ashes to ashes, dust to dust, the living word.

Whisper to my soul. Do I have one? There is no other explanation for the yearning that I feel. To yearn: To feel longing for . . . to feel compassion for . . . also something of grief, something of loss locked in the changeful word.

What is that for which I yearn? What is it that I feel I have lost? Look up. Ten billion stars and this blue planet. Once the world was a limited place, bounded by actual crystal walls and a material firmament. The stellatum, the roof of stars, shield of this small preeminent space. See it in the frescos of the Campo Santo at Pisa. The painted toy, held in the hands of the spirit, Logos, through whom God made all things and taught the void to speak.

I know that there are no such certainties for us who live in the darkness of innumerable suns. Look up. The black sky increases. What am I in this?

I do not ask for comforts. I do not pretend. I do not ask for comforts but do not tell me lies. Why should I live with the new brutalism of the universe if it is not true? Why should I accept that there is either what is material or nothing? If it were true, I would be satisfied with gathering within my bounds as animals are. Animals have no conception of anything outside of their own worlds. They do not dream of strangeness. Give an animal enough to eat and his right

habitat and he leads his life contentedly, long or short. He has no sense of death. He does not look up at the stars.

Once I showed my cat the moon. My cat the moon in a pool of barely moving water. My cat put its paw in at the ripple, and finding nothing, walked away. Later he caught a mouse and brought it to me as I continued in thought by the pool. The mouse and the moon. No question for the cat which is greater. For himself the cat is right. But for me?

I cannot accept that the yearning I feel is for goods and money. I may desire those things but I do not yearn for them. Get them, and they do not satisfy the open space unfilled. Is it a space I want to fill? It is not so much something missing as something not found. Perhaps something not remembered. Plato understood it as the longing for the time, before birth, when the soul was freed from vulgar needs and bodily restraints. For Plato, the duty of the human being was the duty to remember. To remember all that we are in the face of the little that we seem to be. Development of the soul for the soul.

It isn't easy, since there are so many false gods, each saying, 'Look at Me.' Gods of money, gods of fame, gods of envy, gods of despair. All the brazen gods of the material world that wrap themselves in orphrey and claim to shine like gold. It would be logical to assume that if this world is all in all, then to possess it, all in all, will be enough. The wealthiest man will be the most contented man. True? The most famous woman will be the happiest woman. True? The more I have the better I will be. True?

Console me like a Medici Pope with every material devising. Let me gorge off gold plate. Load my body with sweat-mined jewels. Let me live in palaces of such splendour that Heaven blushes. If the material life is all then let it be all. Miss nothing out. Bring me everything there is to stuff the void. I will be Midas set in a palillogy of gold. Progress. Progress. . . might the past have known better? Cupidious monks, rat-fed nuns, the awful power of the Church in a stench of incense that never quite disguised the smell. The leper-clappers and the disfigurations of the human form unfed. All this and yet the spirit. The wild excesses of the spirit that taunted the body's restraint. No doubt of the difference between actual life and the real solid world of images.

And now? No gold. No spirit either. A modern wretchedness new to history. Better to be a beggar on the Ganges than broken on the gilded wheel of the West.

Whisper to my soul. We have come a long way. So we have. Is distance travelled more important than the state, on arrival, of the travellers? I have come so far so fast that I haven't had time to ask whether or not this is where I want to be. And I am not going to be given the choice. As soon as I learn enough to ask questions, all aboard, off we go again. Society on its World Cruise. And isn't it astonishing how everywhere we go is beginning to look like everywhere we have been? The shock of the new? Forget it.

Forget it. This is the time to remember. Time can travel backwards. Time can stand still. No need to be pushed down the road to progress. For progress read 'technology'. The same old material world, this time in a space suit made of DNA. How To Fight Time The Techno Way. Heart transplant. New mistress. New car. Bigger Better Bomb. Tag and kill the ageing gene. Face lift for now. Nintendo for the kids. Virtual Reality for the grown-ups. Eat more irradiated food. Feeling ill? Radiotherapy, chemotherapy, bowel out, breasts off, we have a robot to take care of you. Losing your hair? Life-like wig followed by a day out at our follicle farm.

Fear of death? Get in the freezer. We'll thaw you out when we can. Fear of death? New! Computer controlled coffin. Self-cleaning.

The kingdom of heaven is within you.

It was a long time ago. The fish blue and green in the mauve sea. The sea in clean colours on the hull. The dark ships that split the colourful sea. The dark sea, impassive, over a sinking sail.

The early morning is cool. The sun, still yellow out of colour, not orange in heat. The ball of the sun is pigmented gold; yellow orange and red through the deepening day. Buy from me gold refined by fire and garments washed in sand. She was white with the sun at her head. Her footprints left no trace.

On this island where the visions are, the mind scoured clean by the epurate sun, she gathers roses and throws them at the moon. White to white, colour shed, blanched petals from the aurum day. The day is fading and she too. What is left? Not time in grains under her feet. The world rolls up like a scroll. In the beginning was the Word. And at the end.

Read me. Read me now. Follow the lines that thread you through the cave. Backwards, forwards, the meaningless of time to all that is not time bound. All art belongs to the same period. Catch it by accent and not by chronology. Ask, 'where does the emphasis fall?' not the antiquarianism of where and when. Art is not archaeology. How will I know it? By its rapture. How will I know it? By its fidelity to itself. How will I know it? By its form. Not chaos here, the ugly wings are beaten back.

And love? The brazier where I burn. Extravagant, profuse, excessive, beyond bounds. Out of our risk comes our safety, not the small sad life that will cling to anything because it has nothing. You

are not a raft. I am not a sailor. You are not weak. I am more than a strong arm. I want to love you well, not to lose you in children and objects. I want to love you well, but to love you well I shall have to be in love with more than love. I shall have to find in myself the emotional extravagance that fits me to stay in one place.

Falling in love: Art or science? Gravity's insistence and the heart dropping from a ready tree. Gene pool or opera? You choose. Once the Church married us, now, it's the little men in white coats.

Look up. This is the season of shooting stars. Light, two thousand years old, still dazzling. Let me see your face. Your face lit up by twenty centuries. Who told me you had stars in your eyes? Let me see your heavenly body. Star-proof I am not. From a hundred billion others, you hurled yourself down in gassy form; no definite boundaries, no fixed volume. You could have filled any space but the space you filled was me. I saw you drop from the roof of the stars, and in the moment of your falling, you began to be defined.

I picked up the flickering body, frozen in crystalline form, kissed the plane of your face and the solid geometry of each limb. Five points you; legs, arms and face, a pentagon of hope, and me a talisman at your hand.

Revoke me; You do. Call me back and back through the wastes of time, here, there, nowhere, carrying white roses never red. Not a dead poet but a living love, and if the words I bring are dusty, I will renew them in your mouth.

Look up where you began. The high place in the thin air. Your speeding mass through the unweighed leaves. Your tumbling body and no net below. Let me wipe your bruises with a fanon. You are a holy thing; telesma. Hold my hand, your heart still beating, not the steady steady loss, but your pulse against my palm. Hold my hand, and read in it this day, and all the rest unpledged.

On the frozen night, star-mazed, lost in the vanishing light, I took the note from your hand and left you a piece of paper of my own. I wrote 'VICTORY' and signed my name 'Nelson.' Then I fled the approaching fleet of doctors and police, family probes and midnight gawpers.

'Who is she?' I heard them say, as I took off through the blue streets.

It was a long time ago. She had a daughter called Cleis. She was the most famous poet of antiquity. Her work filled nine volumes. Little else about her is known.

Modern scholars have mocked her because she compared the moon to a rose. Since the Renaissance, roses have been red, what is that to her?

She carried white roses never red. Bud, bloom, blown. Blown roses at her feet, damp and tender, fallen roses and the rising moon. Touch me: You do. Your hands are white and your lips are pale. Pale the flowers that cover you on your evening bier. Slip away now, while the moon is full, fullness of your lips against the thinning day.

Love me: You do. Your true heart a golden chest. You wear my breast plate, no need for spear and shield. The light that makes an aim of you is clear. Shot down by light you have erupted into flame.

Quickly through the blue streets, and on a corner, three men, their faces muffled round a pan of red coals. The snow had begun to fall in white sheets. White sheets to wrap us in on this bitter night. Can't tell my future in the coals. It is the past I see, up to the hilt of this night, my name written down the blade. The live coals sing. The young man has a banjo that he tunes to his gut; open your mouth, the live coals sing.

Rhythm of words passed from life to life. Mouth to mouth of language uncoded by time. Words are not his, speak them. Love is not his, speak me. Love recorded against Time. Love stamped through time on the brand of the word. Sappho 600 BC. The City 2000 After Death.

Picasso

HE LOOKED AT HER: Gunflint eyes, electric hair, voice that had a dash of pebbles in it. When she spoke, Picasso heard the sea crunching at the shore.

How long had they been on the train? Days? Hours? Months? Weeks? Years? Always? Never? The train had died. No guard, no announcements, no longer the fitful charge of the engine. In the dead train the sun heated them. The sun magnified through the thick glass. The spare restless man had fainted. Vainly Picasso pumped the automatic doors. They could not leave the train, for safety's sake, no doubt. In the modern world there was so much safety that safety had become the chief source of danger.

Her mother had been tremendously safety conscious. She had said, 'Sit close to your brother. He will take care of you.'

'I love you,' her brother had said, when he was thirteen and she nine. 'I love you.'

She had no other friends. Her mother knew that the outside world is a wicked place. She had no other friends. She and her brother played at sailors in the safety of their own home. He was the torpedo. She was the target.

'What are you two doing in there?' Mother's voice at the door.

'Torpedoes and Targets,' answered my brother, with his hand over my mouth and his cock between my legs.

I love you. The magic bullet that kills the victim and frees the murderer in a single shot.

I love you. The universe hangs by its thread.

'I love you.' I never wanted to hear those words again. I never wanted to hear those worn-out words, that when they are not blunt, are sharpened on a lying-stone. When do they pierce the skin? When they are true or when they are false?

I love you. The murder weapon of family life.

Is that my mother, stalking me round the kitchen? Patiently waiting for me to drop my guard. All day she has punished me with her rosary of lies, one after the other, murmured prayers for my destruction, enough lies and I will not know who I am. Picasso will not exist but the Lie can wear her clothes. She knows how tired I am. There has been an offering of silence. She is silently chopping the meat. I am silently cutting the vegetables.

She pounces.

'I love you.' Straight at my heart with her little knife. She looks eagerly for the blood. I must pretend to feel nothing even though I am doubled over with pain.

'Heartless,' she tells me 'that's what you are. Heartless.'

I have told her that I am leaving home. Yes, and I am taking my heart with me. She knows I have hidden it somewhere. She knows that there is still a piece of me unkilled by the loving hands of my family. They have not yet made me in their likeness. I am still my own. Time is short. They will ransack me. They will find my heart hidden in my chest. They have devoured lungs, liver and tongue. They wonder why I do not speak. They wonder why I am afraid.

I am afraid but not mortally. I have some courage left and it will be enough. When my brother lay over me like a winding sheet and me his corpse, it was a patch of red I remembered on a Leonardo robe. While my brother embalmed me with his fluid I clung to life through a patch of red. When I had to look at his empty eyes over me, it was

the red that speeded my own blood from clotting. It was the red that pushed life through veins I had thought to slit. Warm red with light in it. Gold decorated red that gave me a robe of dignity to put over my own torn dress.

Later, in the silent untimed years at the hospital of St Sebastian the Martyr, it was the strange vital yellows of Van Gogh that bore out a sane place in the babble of that overbright world. Overbright: the lights left on in accusing strips of neon. The nurses with their harsh friendly voices, cheerful, cheerful, nice nice. Be a good girl eat your party food. MY party food. Blue cake, green icing, pink candles to blow out. That's nice, blow me out, every spark of me, on my birthday.

I am twenty-one.

I hid in my room with a book. 'Withdrawn.' said my report. 'Uncommunicative.' said my report. 'Not fully socialised.' said my report. 'No progress.' said my report.

I was making progress. I was studying Van Gogh. Sunflower yellow. Cornfield yellow, sky yellow, yellow in the woman's fading hair that she pushes away from her face. Yellow in the wicker of the chair, yellow in the layers of the land. Yellow in the clay ridges of the fields ploughed. Yellow in his clothes going home.

I went home. This time I was properly dressed.

I have been thinking back and back to that night on the parapet and the resolution of wings. I should have been killed. It was intended that I should have been killed. There is more to the story but it has taken me a long time to remember it. I have not wanted to remember it. When I told them in the hospital they said I was inventing. My mother is certain I am inventing. It is easier that way. Memory can be murder.

It was Christmas Eve. My brother and his friends had been up late

drinking. My mother and father had gone to bed. I could hear my mother crying her traditional eyeful of festive tears. I had been painting in my room, but to reach the bathroom I had to pass my brother's door. I was going carefully, with a handful of colour-soaked brushes, when his door opened and he dragged me in.

'I love you' he said.

I struggled. He was red-indian war-painted in cobalt and chrome. My brushes left their mark. I had to leave a clue to show I was not lying. I pushed the paint in his face.

He had me down quickly. He's a big man, wiry and well-knit, bull's balls, Lucifer rod, thick and heavy and I am very light. My mother had wanted me to be a ballet dancer but I think that's because she could have starved me.

I knew better than to fight. Ten years of Matthew's love embraces and I knew better than to fight. He had twice broken my wrists, once dislocated my hip, and the last time, two years ago, fractured my collar bone. I heard my father talking to him in the library. I thought it was all over. No more lies about a tricky horse. Two free years and I had begun to forget. Not to heal but to forget. I had begun to forget that my body was, what had Matthew called it? a weapon rest. He had me down quickly and pursued his usual gallop over my well broken hills. I was a landscape he had long since flattened. The challenge had gone, but not the familiar pleasure of ownership. These were his acres, my body, my blood. I was his liege-land. He inspected me.

'Too thin' he said. 'No buttocks.' He slapped them and had me turn over. Never side-saddle but often backwards he pleases to ride. The clock by his bed, still his childish, Mickey Mouse dial, notched the late minutes on the bed-post of my bones. Once. Twice. Enough. Not enough? Enough. He was asleep as I pushed him off me.

A heavy man. My lungs were gone. What I wanted was air, all the

clean fresh air in the sky, not the stagnant re-breathed unwholesome smell of Matthew's bed. His bed that smelled of meat and drains. I was unclothed, he had a habit of tearing whatever I was wearing, I should have noticed, but there was nothing I could notice, except pain. I ran my pain up through the house, up the rickety attic steps, over the disused floorboards and out on to the parapet. My pain, numbed, soothed in the freezing Christmas air.

Far off the sound of Noël.

I sat on the ledge; my head between my knees, my feet warmer in the muff of my own vomit. Not thinking. Not feeling. Not living beyond the in-out-in-out of my defeated lungs.

I don't recall how long I sat. I heard footsteps crossing the floor and I reached to pull a coat round me, but there was no coat, and all I could do was to fix my eyes on the blank opening of the window and wait.

'Sophia?' It was my father's voice.

'Sophia?' He refused to call me Picasso. It was his own name he wanted to hear. Sophia. Wisdom. The Ninth Muse. Feet first in her own vomit. 'I christen this child Sophia.'

'Father?'

'What have you done to your brother?'

'Matthew.' I said his dead name in my dead voice.

'He's covered in paint and half-naked on the floor. He said you attacked him. He said "She's gone mad again father. She's gone mad again." What have you done?'

'He raped me.'

'You little slut.' My father came towards me, his hand raised, I shrank back, and he stepped into my vomit.

'I'm going to tell the police.' I said, sing-song, dreamlike. 'This time, the nice doctor and the nice police. I'm going to tell them.'

I stood up, I think, to walk to the police station, so, perhaps, I

would have fallen on my own. As it happened I did not fall on my own. As I stood slightly swaying, completely unafraid, my father pushed me off the roof.

She had never come to him for money. She had come to him for love. She had left empty handed. Her father could only love what was dead. As Picasso fell she thought, 'He will love me now. My father will love me.'

Jack Hamilton had made sure that his wife was dead before he married her. He had bartered for what spirit had survived her own father's industrial complex, and laboured to make a machine out of what gaiety was left. She would not delight in life. She would not find beauty in valueless things. She smiled too easily and too much. Let her smile be only for him. Since he had no life, no pleasure and no beauty, he had learned to deny that there were such things. He took his satisfaction from his own man-made world. There were millions of pounds to be made out of Preserves.

On the day of their wedding he had the corpse of his fiancée expensively dressed in the best shroud that money could buy. He married her beneath the sign of the dead Christ and took her back to the sealed rooms where she would find the compass of her life. Nothing for her beyond those rooms. She was his wife and the rooms of his house were her granted kingdom. At the centre was the marriage bed. She got in it and lay still.

Their first child was stillborn. A baby who neither moved nor cried. 'Such a good baby' his father admired him. A man needs a stiff upper lip. The boy showed no emotion. His father was pleased. A man never cries.

The boy had a kitten. His father had it de-clawed to save the furniture. The furniture had cost thousands of pounds. The kitten

had been dumped. Nobody wanted the kitten, everyone admired the furniture, the boy would inherit it one day, long after the kitten was dead.

The next child, a girl, was not stillborn out of the still bed. The baby screamed. Father had the doctors in but the baby screamed. The baby made all the noise allowed. No-one else dared speak when father was at home. 'Speak when you're spoken to,' was the rule, but wife and son never were spoken to and could only whisper now and then, when his back was turned. The baby ignored father's rule and screamed. Mother and son admired the baby and hated her too.

The dead family and the live baby went to church and the Vicar read The Sermon on the Mount. Father looked round the pews, satisfied to see that he was, by far, the richest man there. Mother and son stared ahead out of their unseeing eyes. Only the baby saw the stained glass shift under its own light. Red and green apostles on the cold floor, each stone flag become a tablet of light. Light out of the athanor that burnished her little body as bright as theirs; a new apostle, she shone.

It was not possible for the dead family to kill her quite. Whatever light there was had been authentic. They wrapped her in black-out curtains, kept her in lead, they made sure she had the benefit of an asbestos education. At night, when they crept by her room in their black clothes, they peeped through the keyhole to check that she was dead. She was not dead and they feared her.

'She needs to be married,' said father who knew that a single woman is unnatural. 'She can wear my dress,' said mother, 'I'll do something about the smell.' Always in the house the smell; parma violets, talcum powder, hung meat. The thick sweet smell the housemaid disguised with aerosols and furniture polish.

'It's the drains,' said mother.

'It's the neighbourhood,' said father.

'It's her oil paints,' said Matthew. 'It's you,' said Picasso.

Father earned a knighthood. Mother fell ill. Increasingly the children spent more and more time together, sometimes they slept in the same bed. Nothing wrong with that, they were brother and sister, and besides, it saved laundering two sets of sheets. Sir Jack was a millionaire but economical.

Soon after they had been married and were newly-deads, plain Jack Hamilton and his nervy well-bred wife, had bought a run down Queen Anne house by a stockyard. It was not fashionable, the area was poor, his wife was afraid to visit what shops there were. She never took her purse. In those days they were not wealthy and Jack wanted a grand house. Besides, he recognised it as an investment, and about investments he was invariably right.

Years passed, and Sir Jack who had stubbornly refused all his wife's entreaties to move, suddenly sold the house and the stockyard with it. He had been offered an undisclosed sum for the site which was to house a new private cancer hospital with residential apartments attached for those who would pay to die as slowly as possible.

Lady Hamilton was happy. Happy as she took brochures from Estate Agents. Happy as she began to supervise the corridors of packing. Happy so that she sang again in spite of the pain in her throat. She would be leaving the dark house that had crumbled inside her.

She went to see the doctor for some lozenges.

'Cancer,' he said.

'Home from home,' said Sir Jack, comforting her.

My mother lay in her marriage bed and stared at the expensive walls. My father had a large collection of Victorian sentiment paintings; moral anecdotes of the fallen woman in her red skirt clutching the upright chair; the doctor, gravely attending to the dying girl. Popular pictures, expensive pictures, Collier, Sir Luke Fildes, Millais, the union of technique and insincerity (above all it must look real), commonly called, art.

My father had often encouraged me to paint likeness and I had often asked him why he wanted a likeness when the thing itself was there. 'Art is the mirror of life,' he said, glowering out of Elsinore. I couldn't tell him that it was only the nineteenth century and later who had taken Hamlet's mad speech seriously. Not even the Dutch genre painters, whom the Victorians so admired, had ever gone so far as to believe that the lifelikeness of a picture was more important than its quality and composition. Until the mid-nineteenth century, every painter, however literal, knew that to represent accurately was not enough.

'Go and look at my Constable,' said father, 'and then tell me that you are a painter.'

I have looked at Constable. I have looked at Constable many times. How to tell you that acceptable, respectable, Constable, had caused a riot at the Paris salon of 1824? How to tell you that he had used pure colour next to pure colour, ungraded by chiaroscuro? How to tell you that his blobs and smears of bright paint shocked the worshippers of Ingres, not only by their vivid rudeness, but by the landscapes they not so much represented as revealed. This was not the Nature of the studio. Dangerous Constable, but tame now, dead now, canonised and hung on my father's expensive walls.

Picasso had said, 'I am a painter and not a pimp. I do not live off other artists' work.'

'This is you,' says my mother, holding up her drawing.

'This is you,' says my father, who is something of a cartoonist.

'This is you,' says my brother, who only ever draws himself.

I collected quite a folio over the years and what I looked upon I became. How shall I stretch out my hand to touch another when I am unable to touch myself?

Touch you. I can't. Touch me? You can't. How can you touch what doesn't exist? Existere Exsistere: To Stand Out. Ex: Out. Sistere: To stand. What makes a person stand out? A sense of self. To get beyond everyone else's lies I shall have to cut a figure of my own.

Reproduction is safer and, to begin with, better paid. Reproduction always has done a roaring trade, but the calendar date is 1829, when Niepce and Daguerre discovered the process of photography.

Is that my mother and father on their wedding day? Is that me?

The camera never lies . . .

The siren body through the peaceful air. My body, unsaveable but saved. A face bending over me with the sun in it. A voice urging me with the sea in it. The water of life on the dry soil. The sun on the frozen earth. Touch me: Your hand the envoy of your heart.

It was a long time ago. I have had a fear of heights. A fear of memory. To conquer both I climbed back on to the roof.

The night was cold. Each grey roof slate was varnished with frost. On the shiny surface of the roof the stars cross-reflected. I leaned back on the starry roof to look at the sky. My breath in cold white cones projected and disappeared. Cold fire from a cold fire eater. The light not put out but not hot enough to burn. How can I be what I know I am? Wood with a gift for burning?

Against the stone steps, my father's steps. Behind the stone

buttresses, my father's voice. Through the freezing, fluid air, my father in his smoking jacket. My father; the illusion of mass in a confined space.

I decided to kill him.

VICTORY.

In the morning, he was at breakfast, in his usual place. I picked up the kitchen knife and stabbed him. He continued to butter his toast. My mother and my brother were murmuring about the weather. What was that? Gales Sweep City?

I pulled out the blade and rammed it in through the second vertebra of his spine. I heard the bone splinter, the nerve twang like piano wire. Again I sank the carbon steel knife into the buttered flesh. My mother began to clear the table.

Desperate now, I shot him with his own intruder rifle, the double bullet shattering his skull. I lured him to the factory and gassed him with his own cylinder of preservative. I poured acid into his bath and stood by while he melted down into pig pâté in an enamel mould. I scraped him out to feed to the dogs and watched them choke on their vomit. All this I did but he would not die. Impossible to murder the dead.

As the days passed, and I breathed hate, ate hate, plumped up hate for my nightly pillow, I felt a strange numbness, new to my body. In my efforts to be rid of him, I was becoming like him, his rage, his misery, his methods, his pain circulating my veins. The more I hated him the better I pleased him. Not only would I become like him, I would become him, that is how the dead reproduce themselves.

What then could I do to hurt him without hurting myself? What already hurt him most of all? Only that I was alive and that he had not yet been able to kill me as he had killed all the others. Every day that I threw life in his face, I insulted his morbidissima by refusing

to be of his clan. The dead thrive only among their own.

VICTORY.

More life into a time without boundaries.

On the morning that I walked away from the house I knew that it was crumbling. At the tall windows, the dumb, gesticulating figures of my family made crazy shapes against the placid glass. Black shapes against the pale panes, their arms in faint, and fainter signs of rage and vengeance. Black paddles turning the wheel of their own misfortune. Too late.

The house shrank up around the dolls in the window. My past, which every day had devoured every day, shrank to its proper size. There would be a beginning not consumed by it. A beginning outside of hurt. A beginning outside of fear. I had not been destroyed by gravity.

Gravity. Gravity's skewer. She remembered the railings around her house and she thought of Saint Sebastian deep with arrows. For a moment, in the indifferent train, fear crept up beside her again. She looked across at the woman whose hair had the sun in it. She heard her laugh that had the sea in it. She recognised her.

VICTORY.

The

Entire and Honest
Recollections

of a

Bawd

percent and allers the less set being be introduced.

'Madam, you have fixed him on gravity's skewer.'

'Not so, not so!' cried the Doll. 'What goes in must come out.'

'Very Right. Very True.' said Miss Mangle, who had been blindfolded against the proceedings, and yet uttered her cry at carefully counted intervals.

The Doll was not pleased. 'It is so delicate a thing . . .'

'Madam, if it snaps?'

Ruggiero shuddered. Head in the pillows, nethers in the ether, he shuddered.

'Madam, I suggest an operation,' said Newton.

'Sir, I cannot countenance it,' said the Doll. 'I have my reputation to consider.'

('And I? And I?' thought Ruggiero sadly.)

'It is merely a matter of pressure,' said the Doll. 'You have told it so yourself in your own book.' She took down the English translation of *Principia Mathematica*.

'Pressure?' said Newton . . . 'pressure', and then, with the splendid certainty of knowledge, 'Cabbage Soup.'

'Cabbage Soup?'

'Madam, you will prepare, at once, your largest vat of cabbage soup and feed it to this ill-starred man. In such a way will we manage a great force in the chamber of these buttocks' (he slapped them). 'The force will then be equal to, or greater than, the atmospheric pressure that surrounds them.'

'You mean that he will fart it out?' asked the Doll.

It was a green Doll, a leafy Doll, a chopped, shredded and boiled Doll, a Doll of tablespoons and condiments, a much spilled upon and insulted Doll, who had not, after some two hours, four cabbages and six pints of sewer-smelling broth, succeeded in raising a single bout of wind.

'Enough!' cried Ruggiero, green about the gills. 'Enough.'

'It is enough,' said the Doll, wearily relinquishing her ladle.

'Sir, you will calculate.' She handed him his own book.

'Madam, what?'

'I will have you calculate the force required to remove this lewd pin from those innocent buttocks.'

('Would it were a pin,' thought Ruggiero.)

There was a long silence. Never was a silence so long. Newton wrote, Let Buttock mass (b)m be . . . and then he scribbled it out and looked sorrowfully at the Doll.

'Think force,' she said. 'Think pressure, she said.

'Think force,' said Newton. 'Think pressure.' Then he wrote

TrzLxP

where r = radius, l = length lost . . .

'Length lost?' said the Doll.

'That is, length inserted, Madam,' said Newton. 'And P = atmospheric pressure.'

'Very Right. Very True.' said Miss Mangle suddenly.

'You are her favourite author,' said the Doll, by way of explanation.

Newton looked at his equation. 'I will offer you the solution in plain English,' he said. 'If six rabbits eat as much grass as one sheep and one sheep shitteth half a donkey's worth, it is certain that we will need a fully balled boar to drag out this troublesome pin.'

The Doll looked at Newton with a new respect. 'I will obtain one,' she said, and she ran out of her house, across the stockyard and into the abattoir, faster than a knife across a pig's throat.

Jack Cut, the butcher, was not a man to mince words.

'God save you Ma'am,' quoth he, 'I will have it out with my right hand.' Not for nothing was he called The Boar of Cheapside.

When he and the Doll returned to that good lady's rooms, Newton, Ruggiero, and Miss Mangle, had each fallen sound asleep, and the only noise left was of their snoring.

'I will go en pointe,' said Jack Cut, tiptoing his eighteen stone manliness across the Turkey rug.

'Be sensitive. Be sensitive,' whispered the Doll.

'I will be as sensitive as a swine nose in a truffle forest.'

'And yet soft,' begged the Doll.

'I will be as soft as a young girl's placket.'

'And be sure in your aim.'

'I will be as sure as a buck at a hind.'

He took the porcelain offence in one huge hand, and with a mighty shout to Hercules and the Virgin, popped it forth as a bung out of a bottle. Ruggiero, releasing a sudden and substantial volley of farts, soared up off the bed in an horizontal leap, and lay flat suspended in the air for a full half minute, in front of Newton's astonished eyes. As for the butcher himself, the force of the backward thrust was so great, that it adventured him through the window and into the gutter below. Only Miss Mangle slept on undisturbed.

'She is a saint,' said the Doll, removing that lady's blindfold.

'Very Right. Very True.' said Miss Mangle in her sleep.

Ruggiero . . . Ruggiero . . . It was a kissing Doll and a stroking Doll, a soothing and ointmenting Doll, who sat beside her beloved through the long watches of the night. And as she sat, and as they lay together in cautious pleasure, the Doll discovered a very curious fact about her lover's mezzo parts . . .

Sappho wrote in the margin, CLUE (Handel, German 1685-1759 Occupation: Composer), 'Di, cor mio, quanto t'amai'.

Handel

The MAN LAY with his head propped on the book. The back of his skull felt hot, not hot and sticky as his forehead did, but as though his head had been packed with embers. There were ashes in his mouth.

He opened his eyes and saw the neutral roof of the train. He breathed consciously, hating the flat air, and it seemed to him that every dead thing in his life was crouching over him, taking the air.

He got up suddenly, too quickly, saw the train in a whirligig out of the bullseyes of his sockets. Round and round the neutral patterned seats, round and round the faux wood tables, the still train spinning.

Twisted faces lurched at him as he was caught in a kaleidoscope of arms. Round and round, the sick of his stomach, and the rouletting train. He fell.

He fell at the window with both fists, impossible, against the safety glass. In his dream terror he saw the hammer, or was it the axe, strapped snug in a little red holder against the heave. He put his hand through the shattering plastic, and heard somewhere, a long way off, the dull ugly bell that warned him to go back to the schoolroom, back to the operating theatre, that the oxygen was low, that someone was at the door to see him. The door. He found the door, sealed in its protective, insulating rubber, and with all his strength, he brought the axe to cleave the seam.

The vacuum dispersed. The doors bounced apart, just enough for him to shove the haft between them, and then he thought that two angels came on either side of his wounded arms, and pulled the doors back, and off their runners.

He let the axe fall, and stepped off the loose steel plates, on to the concrete harbour. Ahead, the cliffs, the sea, the white beach deserted, and the light.

He was carrying the book.

Years ago he had been in a car crash. He had been driving steadily, the smooth road, clear, controlled, then, as he tried to turn the wheel, the car disobeyed. The servile box of leather and steel turned on him, turned over and over on him, the tarmac rearing up off the hard core and coming through the windscreen at his face. He had been listening to Turandot and the compact disc jammed but would not break; La Speranza, La speranza, La speranza, why had he not died? He often thought of it and wondered what the grace was for and why he had never acknowledged it. A second life. For what? Only to do again what he had done before but this time blunted by repetition? When he had crawled out from under the molten car, he had walked purposefully for two miles, before a police car picked him up. He said, 'There's nothing the matter Officer. I am a doctor.' He had shown them the tattered ribbons of his driving licence.

Later, much later, well again, he had joked about the effects of shock on himself, effects he had handled in others so many times over so many hospital years.

'You know,' he said, 'the odd thing was that I truly believed myself well and whole. I had a broken arm, a fractured ankle, burns, and I was bleeding. Nevertheless, I believed myself well.'

He knew the physiology of it, of course he did, and yet it troubled him. In what other ways did he deceive himself out of his wounded life? He walked on, his head exploding with sharp fireworks, his lungs pumping hard under their leather skin. He fumbled in his pockets and swallowed a tablet. He would feel better soon, better already, out of the tin morgue where the bodies were. He walked on scrambling up the rough, tufted sides of the concrete slipways where grass still found a crack and grew, in spite of progress. He got away from the oil and fish smells of the container port, and out to the real cliffs, where he found an aussichtspunkt that gave him a view and sheltered him from the wind. He opened the book and read.

I, Handel, lover, fool, priest, madman, doctor and death warrant, have only time to tell what is left before the end.

In the nightmare city where I have continued my days, I had charge of the new cancer hospital. Private, of course, but with a small wing of charitable status to be built on top of the old abattoir.

The site was perfect; a 10-acre stockyard with a Queen Anne house close by, to be saved as the flagship of the scheme. It was a poor part of the city. The borderline of the acceptable and the degraded. No one would rally against the planning permissions, a people with their hearts knocked out don't open their mouths. This was the city of the unspeakable.

I approved the choice. The site belonged to a man I knew, I treated his wife for headaches, depression, all the usual sorts of female complaints. I was not surprised when she developed cancer of the throat.

This man, Jack, a life peer out of synthetics and preserves, had bought the site as a speculation, when quite a young man. He had sold his wife's shares to do so, so his conceit that he was a self-made man was not strictly accurate, unless one counted his wife as his rib, which he did.

On the day that I had planned to leave the city, a plan I had made many many times, I got a phone call from Jack urgently summoning me to the house. He did not explain but put down the telephone in an abrupt way as though he had been interrupted. I had my luggage ready and I had shut up my house. I could not wait and the weather was worsening. I decided to pass him over to a colleague, but as I was ringing the familiar number I remembered that, because of the day, because of the day that it was, I could not divert this call. In any case, Jack was calling me as a friend. Anyone to whom he had paid money became a friend; it was a way of getting the next thing free. 'The old boy network' he used to call it, and he was right, because we were old boys who had never made a success of growing up, and we were netted together, hopelessly, helplessly, forever.

I set out through the bodiless streets and dirty air listening to Parsifal. Why did not Wagner make Klingsor a castrato role as he had planned? A magician has a wand he doesn't need balls. Surely a transformer should be transformed? There's a legend isn't there, that Lucifer had no genitals until he rebelled against God, thereby grew the monstrous sacks and the thick pole of popular envy and fear. Cut them off and a man never growls with the beasts. Cut them off and a man sings with the angels again.

There is a recording on a wax cylinder of the last castrato in the world. Reedy, unearthly, not beautiful, seductive, not a male voice nor a woman's either. Klingsor, a magician, a transformer of parts.

I have heard a castrato myself, yes, with my own ears, in Rome. There is no recording but I can play it to you if you will wait with me awhile.

Through the streets to the house, lead against the lead sky.

The front door was open. In the wide hallway and up the broad

wooden staircase were thrashes of paint. Yellow ochre had been beaten into the restrained stripe of the wallpaper as though the sun itself were trying to burst out. The carpet, a typical oatmeal, had been used as a threshing floor for a flay of light. What had been the house lay in sorry stripes and through, above, below, beyond, emphatic were the umbers chromes ochres of a colourist revolution.

I looked at the yellows and I wanted to laugh. On this terrible day I wanted to laugh. Ridiculous the sober house in its fairground coat.

'She's mad.' Sir Jack came towards me. 'She did this. Sophia did this. And not just this. The drawing-room is green. The kitchen is orange. My study, my study, is blood red.'

'Where is your daughter?'

'In the attic. I want you to certify her. Now.' He took out his black laquered wallet stuffed with brown notes.

'I will need a second opinion before I can commit her.'

'Then go and buy one damn you, there's the phone.'

He picked up the receiver from the veneered hall table. His hand came away sticky and bright. He threw the telephone on to the floor and kicked it into a corner. His son ran into the hall in a pair of wellingtons and a hotel dressing-gown. His hair was streaked blue. He was trembling.

'All my clothes,' he whispered. 'All my clothes. Whitewash. She's poured whitewash on all of my clothes.'

I looked at them. Sir Jack, his shoes sinking into the thick paint on the thick carpet, the telephone whining brokenly by the open front door. His son, in white towelling and rubber boots, his black hair shot through with tints of crow. On the outskirts, mother, clinging to the daubed doorpost, like a devout at Passover. Her eyes had turned back into her head. She couldn't see us. I looked at them. One by one they started up the stairs and I following.

'She's mad. She's mad. She's done this. She's mad.'

At the attic, the door was bolted from the outside but locked from the inside. Jack rammed it with his shoulder and came away howling. It was an original door at least six inches thick.

'Bitch!' he shouted. 'Bitch, Bitch, I'll kill you.'

Then Matthew took up the cry and stripping off his white towelling dressing-gown, keeping on his rubber boots, he fought the door with his whole body until it buckled under him and fell in, straight, with him gasping on top of it and spread across it as though it were a raft at sea. He struggled up and I saw that he had ejaculated over the knob.

'Where is she? Where is she?'
She had gone.

I got into my car and drove a few miles down the road. The rain had weighted into snow and as I pulled over to avoid a bad skid I saw a young woman walking lightly and with a quick spirit. I wound down the window to offer her a lift, I tried to reassure her by explaining that I was a doctor. I didn't see her face but I heard her voice and it had yellow in it.

Why should she trust me? Who am I anyway?

Who indeed. What identifies a man? His job? His children? His religion? His dental record? It was easy in a white coat. Easier still in a dog collar. 'This man belongs to God. Please return.'

I have been returned. The verdict was Not Guilty.

I left the dock cocooned in sympathy. The kind man with the kind face, musical voice, and long careful fingers, that shook slightly as he spoke. Handel. A free man.

The lady in question has had a complication, but it is too late for

me to make any difference to her now. Too late for her.

And for me? Too late for me?

I drove on to the station hoping to meet the morning train. The weight of the day hung around my neck, the day beginning to stink a little as it wore. I had no prayers.

Was it the weak sun magnified by the snow that put a yellow glaze on the dirty streets? I could not get the yellow out of my eyes. I did not have jaundice, and this was not the sickly, sticky yellow of disease, but a firm clean drag of bright, over the optic nerve.

What we think we see, we don't see, I know that. I know that colour is an intervention of light. Light it was that made a gold crust on the baked snow. The biscuit-shaded snow out of the polluted sky. If it could find grace in the moment of a morning's colour, then why not I? My grey heart light again.

I, Handel, runaway and stray.

He had his back against the smooth trig point which sheltered him against the wind. His collar was up under his chin, his hands stuffed in his jacket pockets. He had his eyes closed and the wind washed him. Cold wind-water splashing his cheeks. His cheeks felt long and hollow, fluvial channels salting up, as rivers do close to the sea. He was crying.

He cried out of the heart of him, cried up all the lost days and mortal indecisions that he had thought were gone but were still stored in the skin and bone of him, a tank of pain, tapped.

He had no space behind his eyes for the tears he found, tear-falling from the lachrymal glands. He dug his fists under his brow-bone but the tears ran through his tight fingers, would not be contained now, his clothes were marshy. A heron landed above his head.

Still the light. Light drained of colour but unclouded. Metal light

that ran a roller-cutter edge between the sea and the sand, so that there was no blend of both, only a definite line of fallen grey. Sheeted light that shuttered the view.

Still the light. The seagulls flew through it with difficulty, the light resisting the flap of their wings. Unfriendly bird light heavy with moisture. The sagging air.

On the salt flats of his sorrow the man stared at the ending day. There was comfort in his pain, a recognition, something at last brought face to face that had lived back-turned for most of his life. His life, spent on the run from a crime that carried no penalty but the one its nature exacted. There was a dead place in him that reason could not quicken. A roped-off tomb unvisited by love. Always he had held back his heart from books, pictures, the passion of the music that meant so much to him, the nearness of her face. And it was not her face only. Every day he killed in himself the starts of feeling he feared. A daily suicide gone unnoticed by those who assumed he was still alive.

Felo de se. The crime against himself God forbidden.

Father I have sinned.

Sins of the flesh or sins of conscience my child?

Sins of conscience . . .

The little baby in its warm coat of blood. There is more to the story than I told you at the time.

It had long been the law in the city that, just as two doctors were required to certify a woman, so two doctors must give their consent before a woman could qualify for a legal abortion performed in a charitable hospital. The rule had been a success, few abortions were performed. Performed. Back stage things went on as usual, unrehearsed, unregulated, without proper equipment, but for a very good price.

When I tell you that a young woman was sent to me hoping for the second consent that she needed, you will understand why I refused, won't you? I am a Catholic. It is no use arguing with me over this. Res ipsa loquitur. Not true, Handel, not true. The thing doesn't speak for itself does it? No, I admit, it does not, but ignorance is a great comforter. Very few Catholics are theologians. It is our method to leave the thinking to some and the obeying to many.

Abortion is complicated for us, because our thinking on it has changed over the centuries, or should I say our ordnances have changed? Our thinking revolves with sickening dizziness round and round the same problem: When does the embryo receive its soul?

Up until the middle of the nineteenth century, the prevailing view, although by no means the only view, was that the male receives his soul on the fortieth day, while the laggard female must wait until the eightieth day. If one accepts that, it is possible to distinguish between Foetus Inanimatus, which has no true life, and Foetus Animatus, the gift of God and sacrosanct. Thanks to the blessed absence of technology, it was impossible to be sure of the sex of the child, and, with unusual common sense, Canon law allowed abortion, up to the eightieth day, if the mother was in mortal danger. Again, mortal danger was a moot point before science decided that everything could be accurately diagnosed, and so there was an element of compassion, a little leeway, in many of the decisions made by ordinary local priests.

In 1869 Pius 1x decreed that every foetus has a soul from the millisecond of conception.

The woman who came to me was young, poor, unmarried, uneducated, beautiful, illegal, Catholic. We talked, and while we talked, she did not look at me, she stared at my kelim on the floor. I was mindful of my position, my responsibilities, the seriousness of this.

I knew what my priest would say . . . "Tell the slut to control herself.'
Yes, tell her that, why not?
'Have you had an examination?'
'Yes.'

'And there are no complications?'

'No.'

'You and the baby are both healthy?'

(I had her report, why was I putting her through this?)

'The doctors say so.'

'And you have a job?'

'But not if I have a baby.'

'Why weren't you careful?'

(Tell the slut to control herself.)

She didn't answer, and I could see in her face, with its delicate chitinous bags, all the careful days unravelled in one spontaneous act.

She left. With a single stroke of my pen I condemned her child to life. It would not be for me to feed him, to clothe him, to bathe him, to wipe his head, to wake for him when he cried, to sleep beside him when he was afraid. It would not be for me to walk out every morning to provide for him, to come home every night to comfort him. To comfort him. It would not be for me to tell the little creature, born full of hope, that there was no hope in the world.

How to say, 'This filthy room where you were born is likely to be the filthy room where you will die and all the years in between will be grey cloth.'

How to say, 'You will pay for your life with every day of it.'

There are no social programmes now, because we all know that

single women become pregnant so that they can live off the State. And even if that were true, even when it is true, what does it say about us, the wagging fingers and severed heads? TELL THE SLUT TO CONTROL HERSELF. And if there is no Self to control? No dignity, confidence, purpose, spirit, place in the world, understanding? Not for her. Not for her. She can't afford any of them. And if she does make money, she'll find she can't buy them. Damned if you do, damned if you don't.

She left. Probably I would never see her again. Probably she would find a back-street boy with a knitting needle and a dose of crack. Probably the baby would not survive the shack birth, infected cloths, poor milk and cheap food. Probably it would catch a cold that would develop into pneumonia. If it lived at all it would be to fill up the gutter with the rest.

What could I do? It wasn't my baby.

But there was a baby wasn't there Handel?

Yes. There was a baby. The windy night fog-stained. Fog in horizontal columns, like battering rams, driving up the narrow streets. A brown fury, grit and dirt of carbon monoxide.

I didn't know what to expect. Perhaps I would have recognised her name but the name I had was not the name of the woman I had seen last winter. Why should she hold on to a name? I haven't held on to mine. At the derelict house, wrapped in an orange mesh poultice, to show it was unfit for human habitation, I met a man, the father of the child, he said. Big, brawny, scared, he had tried to take her to hospital, but she had refused to go.

I walked up the exhausted stairs that smelt of kerosene and chips. The room had a stripped car engine in one corner. A throw-out bed. A big box from the fishmarket, that he had lined with newspapers, he was proud of it. 'For the baby,' he said, and offered me the one stool. She looked at me. Did she know me? Did I flatter myself that she could know me? We look alike, the men with money and power, give or take a few pounds. Our tailors work side by side in the same street. We drink the same vintages from the same five chateaux. Most of us drive the same kind of car, and we read the same newspaper. Yes, we are the individualists of our age.

How lovely she was . . . Madonna of the Desperation. Deep blue lines of tiredness rimming her eyes, her knuckles, starched against the pain. Frail, membrane-thin, but not yet exhausted out of her youth.

I was not the father of the child but I knew that I had brought her to this moment as surely as if I had penetrated her. I wanted to get rid of the other man, this was something private, something between she and I. We were intimates, she and I.

I sent him away to fetch water, and sat myself down at an angle to her on the sunk bed. Her legs were aching and I began to rub them up and down their length. She lay back, glad of the relief, women tell me I have good hands.

I had to tear up my shirt to make cloths.

'It is not the doctor who is naked,' she said, laughing at me.

I was embarrassed. I hate anyone to see my body. My body is the shape of my clothes and nothing more. I was glad of the dim flare that lit up the corners of the dirty room, better than it exposed my skin. I did not want her to look at me.

'Lie back,' I said. 'You must rest.'

I was much paler than her, gecko-white on the warm stone of her, a lizard in too much light. If anyone had come in, what would they have thought? That I was paying her? Yes, that I was paying for pleasure as men do to whom money comes easily and affection so

much harder. I have women friends who confide in me about their husbands' habits. Of course, their husbands boast to me about their exploits, and although the facts are identical, the story is not at all the same.

Silence and stillness as I sweated to birth the child. The mother was brave and hardly cried out above the wheeze of the flare. The creaking bed, the wheezing flare, that putter-puttered almost out. The feeble flap of curtain fighting the wind. I, between her legs, kneeling with my head down, not sure whether it was a child I was delivering or myself. She smelled of iron and tar and field mushrooms.

I kissed her cunt. I took all that I could of her huge birthing cunt into my mouth and kissed it. I held my tongue against her clitoris, big as a pullet egg, and under the yoke of her orgasm, the baby began to shift. I pulled my face away in time to bring forth the head of a little girl, body umbilical bound. I bit the cord, swung the child upside down, and in response to a tiny slap, she discovered her lungs. A bright red baby yelling herself purple in the blue air.

The mother was laughing and I laughed too and wiped my smeared mouth on my own shirt, and then, gently, gently, wiped her. There was nothing I could say.

I left her quite a lot of money, hiding it where I hoped the other man wouldn't find it. I promised to come and see her in a couple of days.

I never saw any of them again for twenty-three years.

What makes up a life; events or the recollection of events? How much of recollection is invention? Whose invention? Look in the mirror Handel, the long mirror that reflects the whitened body, cuttle-fish bleached and brittle boned. What can you see that is really you? The man to whom you think you are accustomed? What can you see? The gene pool that has made you one shape rather than another; that has bestowed upon you your blue eyes and their quizzical stare. The inherited strengths and failures of your ilk. Is that you? Look deeper: How much of your thinking has been thought for you by someone else?

Speak Parrot!

What kind of parrot am I?

My range is wide, my accent, good. When I speak I am convincing. Very often I convince myself. Isn't there a proverb; In the country of the Blind the one-eyed man is King? But what of the articulate among the guttural? Once upon a time I would have been listened to with respect, now, I am regarded with suspicion, and for the wrong reason. I know that I am false; the irony is that the barkers and jabberers believe themselves genuine. As if to speak badly is to speak truly. As if to have no command of language must ensure a complete command of emotional sincerity. As if, as journalists and novelists would have me believe, to write without artifice is to write honestly. But language is artifice. The human being is artificial. None of us is Rousseau Man, that noble savage, honest and untrained. Better then to acknowledge that what we are is what we have been taught, that done, at least it will be possible to choose our own teacher. I know I am made up of other people's say so, veins of tradition, a particular kind of education, borrowed methods that have disguised themselves as personal habits. I know that what I am is quite the opposite of an individual. But if the parrot is to speak, let him be taught by a singing master. Parrot may not learn to sing but

he will know what singing is. That is why I have tried to hide myself among the best; music, pictures, books, philosophy, theology, like Dante, my great teacher is dead. My alive friends privately consider me to be rather highbrow and stuffy, but we are all stuffed, stuffed with other people's ideas parading as our own. Stuffed with the idiocies of the daily paper and twenty-four-hour television.

Well, I am an old bird who has tried to choose his stuffing. Stuff me with the best, and although I might dilute it with my own fear and inadequacy, at least I will know what the best is. Don't you want something better than yourself to live up to?

A colleague of mine, in hospital for hip surgery, put down his crossword and asked me why I bothered with the opera.

'The plots are so ridiculous,' he said.

'I don't care about the plots.'

'The music then, the music is so artificial.'

'Unlike your hip-replacement?'

'Don't be clever with me Handel.'

'Wouldn't dream of it, but tell me, don't you think it odd that while you are happy for your daily existence to be as artificial as possible, pre-packaged food, the latest medical techniques, your every moment spent in front of a blinking screen, your life as independent as you can make it of the seasons and the hours, day for night, and night for day if you wish it, all this, and yet you criticise art because it is not natural. Art is not supposed to be natural.'

'Art is the mirror of life,' he said sententiously.

'Get thee behind me Hamlet.'

'Can't contradict the Bard.'

'Not even when the Bard contradicts himself? A single dramatic utterance of Hamlet's is no more Shakespeare's own view of art, than the speeches of Iago are his own views on morals. Read *The Tempest* and then tell me that art is the mirror of life.'

'I know what I like.'

'You have no idea. You blindly obey every impulse because you think that makes you a free spirit. What will it be tonight? A tart? A private view? A musical? A trash bestseller? Sparkling wine served with its vintner's assurance that it is every bit as good as champagne for half the price and none of the effort? You are a slave to advertising, to fashion, to habit and to the media. You like to call yourself a free man but you are bound by rules of which you know nothing . . .'

He did not speak to me again.

Speak Parrot . . . In order to escape the arbitrary nature of existence I do what the artists do, and impose the most rigorous rules on myself, even if, inevitably, those rules are in turn arbitrary. Language, musical structure, colour and line, offer me a model of discipline out of their own disciplines. What liberties they take are for the sake of a more profound order, the rules they insist upon are for the sake of freedom. How shall I learn to discipline myself if not by copying the best models? The paradox is that the artificial and often mechanical nature of the rules produces inexhaustible freedom, just as the harsh Rule of the early great monasteries was designed to shut out every inessential, but to fully open spirit and mind. Of course rules are made to be broken but when they have been broken they must be made again. Periodically all the arts break their own rules, to renew themselves and to invigorate themselves when the letter is killing and the spirit is offering life. The Church has not been either as brave or as wise. I wanted to be a priest and not a traffic warden. I wanted to open the way to spiritual insights, not dole out penalties for every silly offence. That is why I left the Church, not the teachings of Christ but the dogmas of Man, and when I turn to the Church now, I know, God forgive me, that it is because I am too weak to turn to myself.

Myself. The accumulation of parts; menus, concert programmes, blood-pressure charts, books read, conversations overheard, irrational fears, recurring dreams, love lost and found, childhood miseries, adult compensations, cinema tickets, holidays, that day with you, the white rose, La Mortola, I keep pressed between the

pages of a book.

Open me up, all these things and thousands more, digressions, digestions, dissipations, dissertations, dilettantism, dilatoriness, dilapidations, disassociations, dill-pickle. The man in brine preserved against change by habit. Teach the parrot his lines and he will re-order the words and you might think he is talking to you. He is not talking to you, he is talking to himself. He is such a novelty but he says nothing new.

Speke parot . . . whose lines are they?

Across the dying sky a veneer of light. Thunder light that bound the broken edges of the clouds into a single square of threat. The sea had turned black and left its shadow in dark waves on the sand. The discoloured sand and the oozing water, rock pools like oil drums, filmy and still. Over by the port the huge lorries chugged out their diesel, the little men, their servants, breathed it in. The motionless trucks, the scrambling stick men in yellow hard hats, a volley of tarpaulin. The storm was coming.

The man felt the first drops of rain, fat like falling fruit. The sky shook and the ground underneath him repeated the tremor. He heard the piccolo of the lesser birds and the kettle drum cattle warning in the fields. Then, the tiny note of quiet, and the sky was strung with lightning.

The Jehovah bass of deepening thunder.

The sea, that had been restless in quavers of foam, strengthened

and lengthened into breves of black muscle that ran past the marker bars of high tide and pitched against the quay. Human dots were dragged away on the eight-fold power. The man heard a crazed whirling behind his head. He turned and saw the propellers of the wind farm blurred into white eyes that seemed to be advancing on him in a rhipidos of terror. The eyes, strangely illuminated by the sickly storm, had the look of operating lights, and he remembered the hideous moment, after the anaesthetic, when the patient revives, and sees, unfocused, the huge swimming lights, too close, much too close, and the green mask of the surgeon staring down.

She had woken and felt for her breast.

So often he had looked at them; a jelly of tissue and fat, the puckering dead skin and the useless nipple on the tin plate. What could he do with those breasts, sliced like kiwi fruit, soft variegated off-coloured flesh? He scraped them into the bin. Binfuls of breasts, although a country colleague of his used to take them to feed to the pigs, why not? Napoleon had had a plaster cast made of his sister Paulina's breasts because they were considered to be the most beautiful breasts in the world. Handel had seen them often in the Napoleonic Museum in Rome.

I was brought up in Rome. We had a house a little way from the Spanish Steps. My mother used to go there every morning and play her 'cello to the beggars. (Man shall not live by bread alone.) My father was a Tax and Trusts lawyer to The Vatican. I was sent back to school in England when I was twelve but by then it was too late.

What can I tell you about those closed evenings in draped rooms? It was customary for some of the more eminent clergy to gather together on Sunday evenings, to play cards, drink port, and to discuss theology. My father, who was well liked, as much for his

acumen as for his piety, was often invited, and I went with him when I could.

Our room, high, circular, was decorated with a fresco of Christ and the Woman taken in Adultery. She was the only woman I ever saw, in that room, or any of the others in The Vatican. The Blessed Virgin is not a woman.

The furniture, Renaissance, Empire, Third Republic, priceless, was red covered and trimmed in gold. The room was lit by chandelier and sconces. The decanters were full. Opulence, comfort, gentlemanliness, good taste and reason. And it was in measured tones of opulence, comfort, gentlemanliness, good taste and reason, that we discussed the difficulties of Coitus Reservatus: Quando fornicare non è fornicare? When is a fuck not a fuck?

There is a delicious salacious pleasure in the abstract puzzle of sexual morality. None of us were fumbling, cock-hard, with the latest encyclical, while our wives lay under us in the marriage bed. Celibate subtleties: To put it in – when? To take it out – when? To resist it – should she? To demand it – could she? A roar of laughter and a lewd nudge of holy elbows: 'Una scopata è sempre una scopata?'

All this and a young boy's burning face.

I had a friend, an old Cardinal, worldly wise, cunning, traditional, reactionary even, if that can seem possible in a Church whose progress is forever backwards. At the same time, in a contradiction tolerated only by the Catholic Church, he entertained, quietly of course, personal eccentricities of faith and behaviour which would have been unacceptable in a more usual setting.

It was this man who encouraged me to the priesthood. This man who paid my fees at a most exclusive Seminary reserved for the élite; the Pope's Home Guard. The policy makers and theologians of Vatican City. The Casuists certain to find scriptural authority for any Popish whim.

The Pope is often an embarrassment. Each Pope nurses his own foibles and follies, pet truths and pet hates, and all must be accommodated within the seamless seemingly unchanging whole of Catholic Truth. Often the Popes contradict one another, and even more often, they contradict the great masters they reanimate to support their own certainties. The theologians take it as a joke. They are interested in the power of the Church and her authority. Power, authority and revenues, are what they are there to protect. They can dye black white.

They do.

That should have been my career. It brings with it both wealth and influence. Two things, an accident and a design, forked the plotted road.

I was the accident. I had the misfortune to believe. Yes, to believe sincerely, and, as an ardent boy, I wanted to carry that belief in front of me like a blazing torch. I wanted to go among the poor and dispossessed and bring them the Good News.

They did not want the good news; they wanted condoms, and I thought that they should have them. I was defrocked for slipping them in the free Bibles I gave out. That was in Brazil.

And the design?

The last castrato to sing in St Peter's died in 1924. My Cardinal knew him, loved him, recorded him, and had in his private collection, eerie wax cylinders soaked in passion and loss. Not only church music but opera, the thing my friend really cared for, and the castrato had sung for him all the great arias that now belong to women.

The history of the castrati is a curious one: They had been used by

the Greek Church since the twelfth century but they did not sing in the Sistine Chapel until the middle of the sixteenth century. The problem of course was Deuteronomy and its ordnances against men with crushed testicles in the house of God. But the Church had a more regular and pressing problem, namely, how to stock its choirs when women were forbidden to sing in them. A boy soprano is much but he is not everything. For that you need the power of a fully developed male voice. The voice of the castrato is very strong, hardedged, resonant and high.

Officially, castrati were the result of sad accidents, a pig bite was a great favourite, the curious snout and fearsome teeth being at just the right height to make a pop-star out of a swine-herd. On the secular stage and in the opera houses, castrati enjoyed the charmed life of idols. Strictly speaking, castration was a crime, but there were plenty of families glad to exchange two bags of sperm for their weight in gold. The operation must be done before the boy reaches puberty. It need not prevent erection.

Delicacy. If the Church conceded the operation it broke the law. If it accepted the pig bite excuse it trespassed into uncleanliness in the sight of God.

Delicacy. Don't ask questions about your castrati. And that's what the Church chose not to do for nearly four hundred years.

Sixtus V, the sixteenth-century papal equivalent of a pit bull terrier, had a particular fondness for his castrati, and promoted them successfully by extending the ban on women beyond the church walls to the public stage. In 1588 no women were to appear in any role on any stage in Rome and the Papal States. This was not revoked until the French Revolution. Naturally, or at least with the aid of a knife, the castrati ranks were soon well swollen. At the same time he decided that they could not marry since none of them could produce 'verum semen'. This was a new twist to the barley sugar beating stick

of Catholic morality. The eunuchs had no choice but to suck it. My friend, the Cardinal, was homosexual and I know that the castrato was his lover. The difference in their ages was very great, the Cardinal, a priest then, was young, the castrato, old out of reckoning. It was not the number of his years but what those years had been. He was antique. A man from another time when time was not counted. Is that him shuffling into the room in his red velvet and gold loops?

They had become lovers in 1900 when the Cardinal was a boy of ten. They remained lovers for the next twenty-four years and when the castrato died, my friend shut himself up in acts of charity until 1959 when he was turning seventy and I met him as a boy of ten.

He had been dining with my parents. I had been introduced to him in the stiff formal family manner and made a welcome escape to my room. I had a train set and I remember sitting in the middle of the oval track and putting the lights out so that I could see the stoked-up boiler powering my little steam engine. I must have fallen asleep there because I woke up and it was quite dark with far away noises from the Spanish Steps but no sound in our house. As I struggled up from beside the dead train still steaming I saw his face. I was afraid but I didn't cry out. He held out his hand and I took it and went and sat over on the bed. My mother came in and told me to hurry and get undressed and then the Cardinal would say goodnight and bless me. She put on the small light by the window and went out.

I undressed. Shorts, long socks, woollen jersey and thick white shirt. I folded my clothes and put them on top of my sandals and rummaged under the pillow for my pyjamas. He put out his hand and stroked my shoulder.

'Yes Father?'

He shook his head, not speaking, but by his directions I knew to lie down, naked as I was, on my back, my fair hair falling over my face. He stood over me in his red cassock and cape, and with his long hands, each finger ringed, he made a study of my body. Curious how hard his fingers felt on my schoolboy skin. At my penis, he stopped for a second, and then, with his index finger on one side and his thumb on the other, he vexed me to orgasm.

I remember the notch of his ring.

Very gently he covered me up and went downstairs.

I heard him say to my mother, 'E un bravo ragazzo. L'ho benedetto.'

I used to sing in the choir. There I am, head thrown back, throat bare, God's inamorato, a jet of praise. I sang. My Cardinal watched me, his pale hands gripping the rail.

Our friendship was encouraged. He took me to galleries, concerts, restaurants. At night, in the early evening dark, he would snatch up a candlestick, and take me, trembling, through the Vatican cellars, to look at secret Caravaggios, lost Michelangelos, the bones of mediaeval martyrs, the bodies of heretics, walled up.

'Here,' he said, 'the silver chalice of Our Lord's Last Supper.'

'Here,' he said, 'the evil bed of the Blasphemer.' It was a wooden torture rack, winched at either end, and spiked along its length. He told me it had been used in the Spanish Inquisition.

'Here,' he said, 'do you know your Greek?' I shook my head and he laughed at me, 'Savonarola had this burned in the courtyard of the Medici. Sensibly they had made a copy first. It has never been seen outside these vaults.'

He turned the heavy brown page.

Then rose the white moon. My love is whiter. White as salt Drawn from bitter pools. He wrapped the brittle pages back into their clothes and returned the strange bound volume to its lead drawer. I was shivering with cold.

'Exquisite, feminine, but strong, strong.' He put his arm around me to keep out the chill. 'A boy woman of the opposite sex. Do you understand?'

'No Sir.'

'A boy woman of our sex. Does that make sense to you?'
'No Sir.'

He sighed. 'The tradition is a long and noble one. Yes, of itself, ennobling. Did not Cardinal Borghese keep his mignon in Rome?' 'Sir?'

'Darling Boy, have you not yet read the memoirs of Casanova? Why, when I was your age I knew them as well as I knew the rosary. Here they are, that gentleman's own copy, confiscated of course, by ourselves . . .'

He laughed. 'Here, come here.'

I climbed on to his knees in the dry, freezing chamber, while he read to me in his deep sonorous voice that had no crack in it. His voice was that of a young man, full of joy and vigour. Had I heard him but not seen him, the only clue to his years would have been a certain suggestiveness, that drew out from every, single word, its multiple possibilities. He was delighted by freshness, but he saw in it the beginnings of a more delightful corruption. He blessed the new wine, but as he ran his hands over the casks, it was with the anticipation of a nobleman, who holds in the newborn babe, his bride-to-be.

1762 Rome. 'We went to the Aliberti theatre, where the castrato who took the prima donna's role attracted all the town. He was the complaisant favourite, the mignon, of Cardinal Borghese, and

supped every night, tête-à-tête with His Eminence. In a well-made corset, he had the waist of a nymph, and, what was almost incredible, his breast was in no way inferior, either in form or in beauty to any woman's; and it was above all by this means that the monster made such ravages. Though one knew the negative nature of this unfortunate, curiosity made one glance at his chest, and an inexpressible charm acted upon one, so that you were madly in love before you realised it. To resist the temptation, or not to feel it, one would have had to be cold and earthbound as a German. When he walked about the stage during the ritornello of the aria he was to sing, his step was majestic and at the same time voluptuous; and when he favoured the boxes with his glances, his tender and modest rolling of his black eyes brought a ravishment to the heart. It was obvious that he hoped to inspire the love of those who liked him as a man, and probably would not have done so as a woman.'

'He was a man?'

'Yes, sweet boy.'

'And he was a woman?'

'Yes.'

'God has not made such things.'

'God has made everything.'

We went slowly back up the worn stone stairs, and out of the iron grating, and the huge door that led by a passage to the Cardinal's own rooms.

He told me how he hated to hear a man sing falsetto after his voice had broken. He called it 'Unnatural.' 'Unmanly.' How different to the voice of the castrato which was a genuine soprano. The operation, he said, did not in any way interfere with manhood. Woman had been taken out of man. Why not put her back into man?

Return to a man his femininity and the problem of Woman disappears. The perfect man. Male and Female He created him.

Night. The young boy and the old man. The young boy curled up in a corner of the vast bed, his hair over his face as he read, his hair drawing a fine curtain between himself and the old man, who watches him as if he were a miracle. He is a miracle; life, beauty, innocence, hope, and for the old man, in whom each had almost ebbed away, the boy was a flare, late-lit and brighter for it.

Music. The old man had been listening to Strauss's Der Rosenkavalier. He and his lover had been present at the première, in Dresden, in 1911. The castrato had been consumed with a passion to sing the role of Marie Theres', the sophisticated and wealthy Marschallin who helps her young lover to love someone else. The castrato had feared it often enough as his beloved boy grew older and he himself grew old. He need not have been afraid; the Cardinal had loved his Marschallin, and found no beauty in younger eyes.

Until now.

Music. Rich beyond avarice, the castrato had arranged his own opera, and had it recorded. He sang the role he craved, and all the while, held the Cardinal in his arms. Now, as the opera played towards its close, and out of the cylinder of the past, the Cardinal heard the final trio, and those strange high Gs and As, nearer to a scream than to a voice, the Cardinal wept.

'Hab' mir's gelobt, ihn liebzuhaban in der richtigen Weis.'

(I promised to cherish him in the right way.)

The young boy looked up from his book, and scrambled across the vast bed, but he did not know how to console his friend, whose tears streamed out of what was gone, and made a sea where the future was drowned.

The Cardinal said, 'Es sind die mehreren Dinge auf der Welt, so

dab sie eins nicht glauben tät', wenn man sie möcht' erzählen hör'n. Alleinig, wer's erlebt, der glaubt daran und weib nicht wie.'

And the boy said, 'The majority of things in the world are such, that one would not believe them, if one were told about them. Only those who experience it, believe, but do not know how . . .'

Music. They sat together, the one fabulously old, the other, young enough. The boy and the man, the mantle, title and deed. They were in the flood waters and the boy must carry the man, Saint Christopher and his Christ, the naïf who bears the sins of the world and falls beneath their weight. It was too much to carry, although he wanted to carry it, wanted to carry him, red and gold and jewelled, singing through the black water to a resting place for both.

The date for the operation was agreed. My parents were not to be told. They understood that I would be taking a holiday with His Eminence, in Venice, at a private apartment in the Palazzo Rezzonico. There, in the great unheatable rooms, I lay on a couch by the fire while he read to me from Robert Browning.

Even as I am speaking, there creeps Fra Lippo Lippi, his cheeks still burning from some girl's hot kiss. There stands dread Saul with his lordly male-sapphires gleaming in his turban.

I had not become a Turkish Eunuch. The harem men lost everything, and displayed their status and their stigma, by a little silver pipe tucked in their headbands. When not a badge of office it served as a urine funnel.

No, I had, have, a small but decisive incision.

We travelled by gondola from church to church, leaving votive offerings to the Madonna, our Madonna, Madonna of the Womb and Phallus, the boy-woman who needed no man to make her complete. Heresy? Certainly it was, but no stranger in its reading than the

premise of the Old Testament that woman was born out of man. The male mother and the woman father. It has a completion. The Old Covenant and the New Covenant. Read together, and strictly speaking, the two covenants ought to be read together, the conclusion is so radical that it is not surprising that the Church has chosen to ignore it. In Christ there is neither male nor female. Male and Female he created Them. And in His image.

All this we discussed together in the shallow scoop of the black boat. Late at night, through the winding waters, the red of the Cardinal and the white of the boy, visible under an orange flare. At the sight of us, the women curtsied and the men were silent, dropping their loads. His Eminence blessed them but not as he blessed me.

Venice. The Holy City. Stone-built out of the marvellous and the mundane and made an island from the world by its own nature.

The asynarte city; two rhythms unconnected, profanity, holiness, and out of that strange bed, art.

Through the streets, the old man and his boy, planning. They would buy an apartment and come here in the school holidays. There would be pictures, books, music, talk. The boy would learn to love beauty, and to distinguish her from her pleasing pretty sister, sought after. The boy would be honed and in the honing made keen, and return to the old man, his smooth stone, his novaculite, a sharper joy.

Light. Gold light on the golden city. Light on the boy to make an archangel of him. Hierarchy of wings.

The light made a shining plate of the lagoon, and burned into it the lines of the waterside houses, bent there. Etch of houses and the corroding water. Fire water, dissolving mirage of the moving solid, aqua vitae. Truth or the image of truth?

The boy in the boat dragged his hands through the drowned city. At his motion the houses burst apart, only to reunite again, whole, in another patch of water. He looked up from the water at the steady copies of the images he saw. Yellow houses where the women went to and fro, unmoved by his disturbance, unmindful of him. What should he trust? Their world or this other in his hands? Actual life or imaginative life. The world he could inherit or the world he could invent?

Invent: The word has altered in meaning. Strictly, from the Latin Invenire, Inventum, it means 'To come upon.' In = upon. Venire = to come. Hence the feast of the Invention of the True Cross, in commemoration of the discovery of the cross at Jerusalem in AD 326 by Helena, mother of Constantine the Great. Invent. Not to devise or contrive or fabricate but to find that which exists. Perhaps everything that can exist does exist, as Plato would say, in pure form, but perhaps those forms with which we have become the most familiar now pass for what we call actual life. The world of everyday experience is a world of redundant form. Form coarsened, cheapened, made easy and comfortable, the hackneyed and the clichéd, not what is found but what is lost. Invention then would return to us forms not killed through too much use. Art does it. And I? Why should I not live the art I love?

But if what can exist does exist, is memory invention or is invention memory?

I think back to that time. We were happy, I cannot recall being happier, safe in the invented city, purposeful in our pleasure. Canals of pleasure that flowed out to a limitless sea. There was no other place in the world. This was the world and it was ours. Romantic? yes, I

suppose so, blame the Brownings for that, but honest too. The pleasure of the single voice but within the constraints of the larger score. An early Romanticism not yet debased into sentiment. We were gateways to one another.

I never saw his body, then or later, his body, portly, veined, secret. Would it have repulsed me? I don't know, but even now, when I think of him, I think of Canova, Botticelli, Carpaccio, bodies of nymphs and angels, God in their chest. God-chested beauty, a strong box made out of bone.

I never saw his body but I knew his voice intimately. At evening I heard him in the garden calling me. His footsteps on the path, my name in his mouth. He called me by name, not my Christian name, which is Frederick, but his own name, in love and play and out of our shared delight. Handel. I kept the name but lost the namesake, Handel, a composer happy in his own enchantments. But the enchanted space is gone and there is a sword across the gate. I cannot return.

We went back to Rome and for a while there was no difficulty. I sang, we were together, my parents were busy. And then I caught chicken-pox. For a week or so my mother dosed the flaking spots with calamine lotion and fed me chicken broth but my fever worsened and she called the doctor. He examined me in the usual way, ausculator on my chest, thermometer under my armpit. Then he inspected my groin. I was too ill to care and the moment I was well I was at a boys' public school in England.

I remember, or believe I do, the doctor's quick step on the marble landing and raised voices down below. My father came to look at me and ran out of the house. My father never ran except at charity cricket matches. My mother said 'You will never see that man again.'

There was no scandal. I don't know what there was, and if there

were letters I never saw them, we never spoke of it, and there was no murmur when I said I would study medicine but with a view to being a working priest. There was a Trust for me and my parents drew on it, no doubt in the certainty that it was the least I deserved. When he died he left me everything. I am a very wealthy man.

Through all the rainy years at that dull grey school I thought of him, the old man in the lonely room, the fading room that had been my heart. Grey my crimson heart. Grey the blood pumped through it. Grey the walls and the stone under my feet. The Jesuit college hewn from the rock. Where was he? Red in the black gondola, red under the painted roof?

Which cut did the harm? His or theirs?

I didn't go to the funeral.

I have his papers. They were sent to me privately after his death. They include a letter to me which only now, I have read, breaking open the heavy seal and seeing his hand-writing again. The Mont Blanc nib and the cartridge paper bearing the watermark of The Vatican. His Eminence Cardinal Rosso.

Darling Boy,

When I promised to you my love, I promised to myself that I would love even your love for another. I knew that I might lose you to love.

I did not guess that I could lose you to indifference.

Why did you not answer even one of my letters?

I stand still at the choir rail but it is not your voice I hear.

I have waited at the water's edge but still you have not come.

I have kept your place beside me and still the place is empty.

Was there nothing in all that we were?

The man folded the letter into its envelope and put it back into the slip of the book. The book, that had been wrapped for him in Cloth of Gold woven for Louis Quatorze, and thrown about the shoulders of the Virgin. Madonna of the Reckoning. Too late now. The man had waited too long. His friend had waited as long as he could.

The Book; fabulous, unlikely, beyond wealth, a talisman against time, an inventing and a remembrance.

The Book. The handwritten word. The printed word. The word illuminated. The beacon word. The word carved in stone and set above the sea. The warning word in flashes that appeared and vanished and vanished and appeared, cutting the air with a bright sword. The word that divided nation against nation. The word that knits up the soul. The word spinning a thread through time. The word in red and gold. The Word in human form, Divine.

The Book was his but not his. The manuscript leaves had been saved from the sacking of the Great Library at Alexandria in AD 642. The battered scripts had been sold off a Roman market stall by an urchin who claimed to have used them as stuffing for his bed. That, at least, was the legend, unlikely, fantastical, and the Cardinal and his boy had worked their own inventions to explain it. Handel remembered the long, dark Vatican afternoons, and his old friend chuckling over some Latin of his own devising.

'Shall I attribute it to Seneca?' he had said, his pen hanging over the silver words.

'But it isn't real.'

'Darling Boy, do you know what is?'

The leaves had been cut and bound and new pages had been added to

the book as it made its strange way down stranger centuries.

The work had not been arranged chronologically; those who had owned it, and through whose hands it had passed, had each left their contribution, as writer, scholar, critic, eccentric, collector, and each according to temperament and passion. The book owed nothing to the clock.

From Alexandria had come scattered stanzas of *The Odyssey*, drawings of Pythagoras, *The Trial of Socrates*, *Treatise on Poetry*. Ovid and his drama of *Psappho and Phaeon the Ferryman*. Papyri, in Koine Greek, of the *Gospel of St John*. 'Let not your hearts be troubled.'

Deeper in the book, in his handwriting, was King Alfred's own translation of *The Consolation of Philosophy*, that fourth-century classic, still ahead of the schoolboy speculations of twenty-first century scientists and their Unified Theory of Nothing.

Handel turned the pages: Bede, A History of the English Church and People. From France, The Romance of the Rose, and beside it, crossing centuries, a minor poet of the Pleiad, recalling the great Loire and its long spaces of white sand.

What were those songs he heard? The dead lovers, Abelard and Heloise, Paolo and Francesca. The long moaning of Creseyde, and the miseries of Montague and Capulet.

Was he in the white streets of London with a fat knight? And later, alone, in a gilded tent pitched in mud, Henry of England at Agincourt?

The book did not pause, but continued its unsigned journey, before and back, and in the shadow of an obscure wood, the gate to another world opened, and Virgil waited for Dante to behold that blessed face.

What else was here? Three stories from Boccaccio that had belonged to Byron. Keats's scribbled copy of Chapman's Homer,

and, in pen and ink, a line from Oscar Wilde on his pages of Goethe: 'The secret of life is Art.'

The book did not pause but it had not been finished. Many of the sewn-in pages were still blank.

Handel looked at the book. The self-portrait, in pencil, of the Cardinal, his private telephone number written down his emblem, the sword. Handel's own drawing of she whom he had loved. The rose he picked in the gardens of the Palazzo Rezzonico.

Where had the years gone, and being gone, why did they hurt him still?

They sat together, the three, Handel, Picasso, Sappho, sat together under the yellow rain. The sun, that had packed its things against the storm, had left behind a yellow cloth. One small square of light that the rain fell through.

Black sea yellow rain.

They talked, the three, Handel, Picasso, Sappho, talked together under the shelter of the rain.

HANDEL: Is that him? Red in the black boat that waits on the black water? I seem to see him, far off, unperished by the air that reeks of time. What has the clock done with the moments in between that last day and this?

Many times I heard him say, 'Today, tomorrow, the day after' and I did not understand what he meant.

The majority of things in the world are such, that one would not believe them if one were told about them. Only those who experience it believe and do not know how.

PICASSO: There was a baby. My father engaged a Spanish maid who came to live in the attic. Her body was the colour of the sun. In

the dark house, where no light was, she spread threads of gold from her hair.

This woman, sun-brown, sun-lights in her brown hair, had one gift and her gift was life. Horror then, to find work in a charnel house, serving the needs of the dead.

My father in gaberdine, saw her body in its summer dress, and tore it until she was naked in the bleaching air. Naked under his panting clothes, naked under the caustic of his skin, naked he had her and naked he drove her away.

She asked his wife to ask the doctor to ask for an abortion. The doctor was a Catholic and the baby was born.

The day was cold in crenellations of snow when she walked to the house in her thin dress. She had wrapped the baby in the swaddles of a torn stiff shirt. Without knocking, she left the baby tenderly in a tiny heap in the big hall, and through the silent snow slipped away.

HANDEL: That which is lost is found.

SAPPHO: 'What are the unreal things but the passions that once burned one like a fire? What are the incredible things but the things that one has faithfully believed? What are the improbable things but the things that one has done oneself?'

HANDEL: Is it too late?

PICASSO: Not too late.

SAPPHO: The word returns in love.

The man stood up, and taking the book, began to walk down towards the sea. The storm sun poured down his shoulders in yellow rills. He held the light about him.

The light fell out of the seamed sky in halos and cloaks. Squares and circles of light that dropped through the cut clouds and made single sense of all the broken pieces of beach, cliff, man and boat. His past, his life, not fragments nor fragmented now, but a long curve of movement that he began to recognise.

Still the light. The light in marvellous fabric, wrapping him, a quattrocento angel in unwoven cloth. At his hand, the spear-light unfewtered, his rod and staff that budded as he walked.

He began to sing. He sang from the place that had been marked; the book, his body, his heart. The place where grief had been hid, not once, but many times. His voice was strong and light. The sun was under his tongue. He was a man of infinite space.

From the cliff-head, the two women standing together, looked out. Or did they look in? Held in the frame of light, was not the world, nor its likeness, but a strange equivalence, where what was thought to be known was re-cast, and where what was unknown began to be revealed, and where what could not be known, kept its mystery but lost its terror.

All this they saw and the sea in gold-leaf and the purple and pearl of the cliffs.

It was not too late.

FIN.

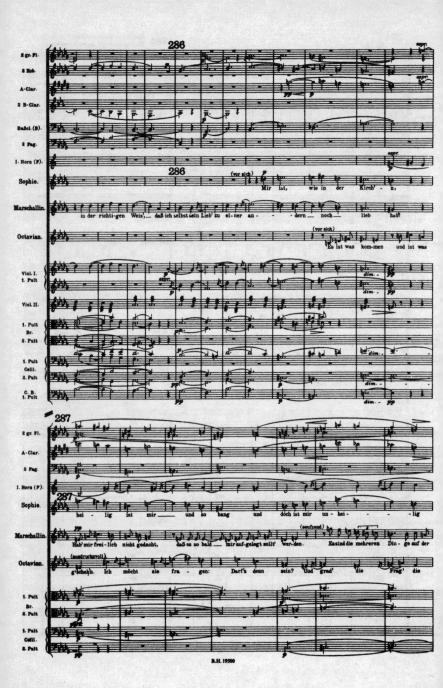

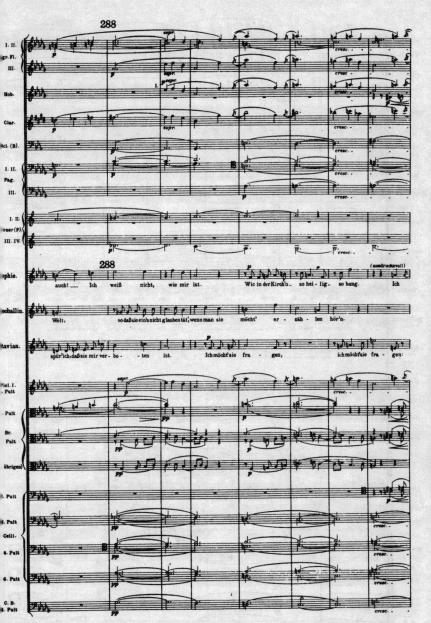

B.H. 19500

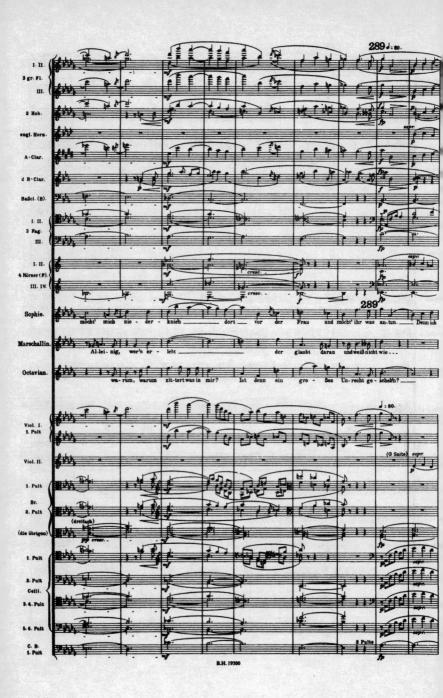

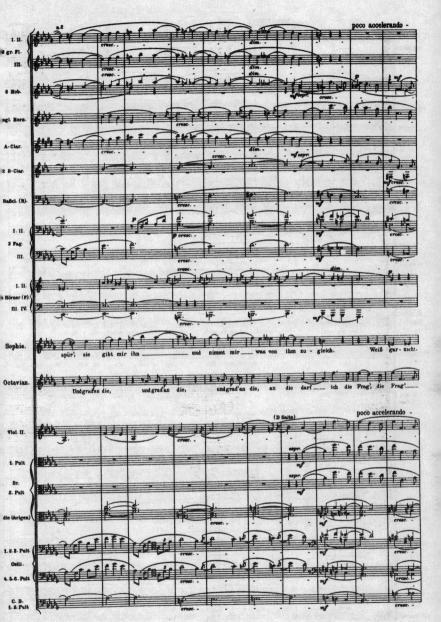

B.H. 19500

B.H. 19500

THE POWERBOOK

'A virtuoso trip into virtual reality...Winterson writes with evangelical assurance, vaulting ambition, total control...the writing takes your breath away'

Observer

An e-writer called Ali or Alix will write to order anything you like, provided that you are prepared to enter the story as yourself and take the risk of leaving it as someone else. You can be the hero of your own life. You can have freedom just for one night. But there is a price. Ali discovers that she too will have to pay it.

Set in London, Paris, Capri and Cyberspace, this is a book that reinvents itself as it travels. Using cover-versions, fairy tales, contemporary myths and popular culture, *The Power-Book* works at the intersection between the real and the imagined. Its territory is you.

'The PowerBook is rich with historical allegory and literary allusion. Winterson's dialogue crackles with humour, snappy dialogue...language becomes a character in its own right – it is one of the heroes of the novel'

Amazon.com

'Mischievous and intelligent, determined to provoke thoughts about love's reason, and its risk'

VINTAGE BOOKS

THE WORLD AND OTHER PLACES

'A greatly gifted and original writer...There is an exhilarating freshness and energy to this collection'

Observer

In this, her first collection of short stories, Jeanette Winterson reveals all the facets of her extraordinary imagination. Whether transporting us to bizarre new geographies – to a world where sleep is illegal; to an island of diamonds where the rich wear jewellery made of coal – or recalling so perfectly, so exactly, the joy and pain of owning a brand-new dog, she shows herself to be a master of the short form. In prose that is almost tactile, full of imagery and word-play, she creates worlds, both physical and psychological, that are at once familiar and yet shockingly strange.

'A reminder that Winterson is a gorgeous writer, rich, lugubrious, sudden and expansive. She can bring a railway sidings, say, or a dull front room, or a small, unexpected world, to vehement life, and it is with writing about love, as always, that she does real wonders'

Scotsman

VINTAGE BOOKS

ORANGES ARE NOT THE ONLY FRUIT

'She is a master of her material, a writer in whom great talent deeply abides'

Muriel Spark, Vanity Fair

Innovative in style, its humour by turns punchy and tender, Oranges Are Not the Only Fruit is a few days' ride into the bizarre outposts of religious excess and human obsession. It's a love story too.

'Many consider her to be the best living writer in this language...In her hands, words are fluid, radiant, humming' Evening Standard

'Even at a time when so many good and interesting novels are coming out, hers stand out as performances of real originality and extraordinary promise'

John Bayley

'A fresh voice with a mind behind it is just what we need now in the literature of the English language and certainly Jeanette Winterson provides it...She is a master of her material, a writer in whom great talent deeply abides'

Muriel Spark, Vanity Fair

VINTAGE BOOKS

WRITTEN ON THE BODY

'An ambitious work . . . constantly revelatory about the phenomenon of love'

New York Times Book Review

'Written on the body is a secret code only visible in certain lights: the accumulations of a lifetime gather there. In places the palimpsest is so heavily worked that the letters feel like braille. I like to keep my body rolled up away from prying eyes, never unfold too much, tell the whole story. I didn't know that Louise would have reading hands. She has translated me into her own book'

'Written on the Body is an ambitious work, at once a love story and a philosophical meditation on the body as both physical entity and objective correlative of our innermost selves, our bodies as our embodiment . . . the result is a work that is consistently revelatory about the phenomenon of love'

New York Times Book Review

'Winterson's novels are about exploding our complacent notions of the real, breaking down received ideas of gender, time and space... John Donne once wrote "Love . . . makes one little room an everywhere." Winterson's novel arrives at a similar affirmation'

Time Out

VINTAGE BOOKS

THE PASSION

'It's a fantasy, a vivid dream . . . inventive and brilliant'

Guardian

What you risk reveals what you value. How is it that one day life is orderly and you are content, a little cynical perhaps, but on the whole just so, and then without warning you find the solid floor is a trapdoor and you are now in another place whose geography is uncertain and whose customs are strange?

Travellers at least have a choice. Those who set sail know that things will not be the same as at home. Explorers are prepared. But for us, who travel along the blood vessels, who come to the cities of the interior by chance, there is no preparation. We who were fluent find life a foreign language.

I'm telling you stories. Trust me.

'The book is as moving and funny as it is skilful, and reflects the author's formidable appetite for life'

Sunday Times

'Magical touches dance like highlights over the brilliance of this fairy tale about passion, gambling, madness and androgynous ecstasy'

Edmund White

VINTAGE BOOKS